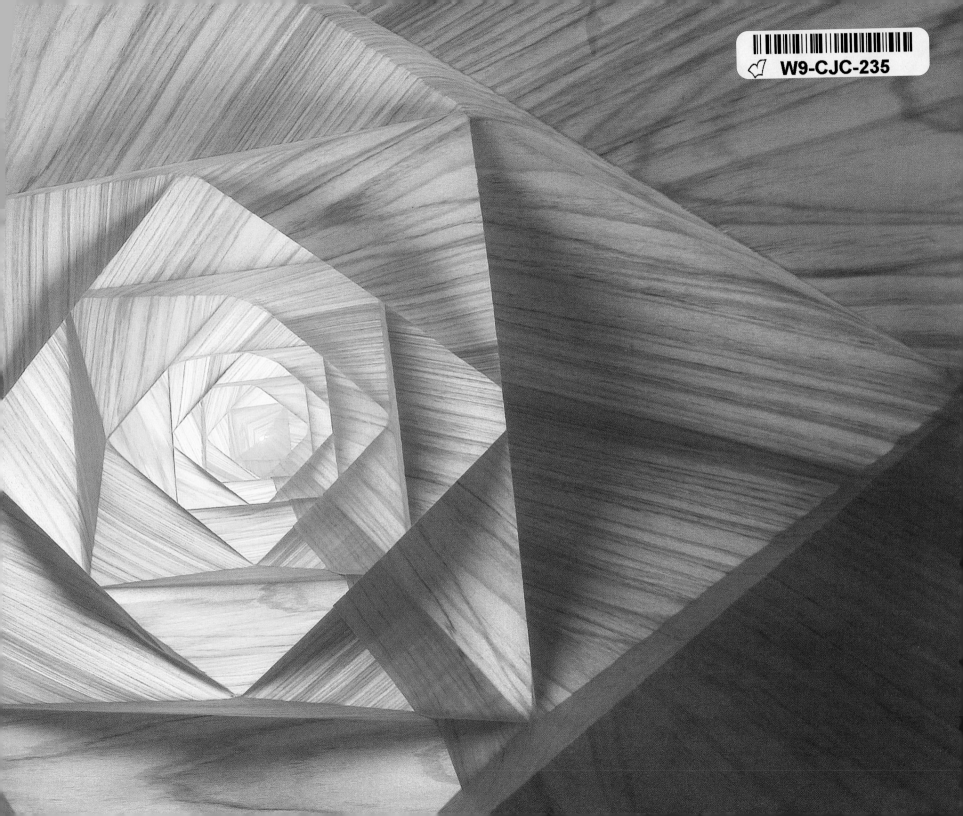

Front book jacket *Floating Fire*
Erik and Martin Demaine, Canada/USA
2013, Canson Mi-Teintes watercolor paper
(*Photo by the artists*)

Front endpapers *Spiral Towers*
Tomoko Fuse, Japan
2012, Takeo Mermaid Ripple paper
(*Photo by Herbert Bungartz, Freising. Published in SPIRAL:
ORIGAMI | ART | DESIGN by Tomoko Fuse, Viereck Verlag*)

Back endpapers *I Want to Fly*
Giang Dinh, Vietnam/USA
2005, watercolor paper
(*Photo by the artist*)

Opposite *Frog on a Leaf*
Bernie Peyton, USA, 2007
leaf paper: one rectangular sheet of Fabriano backed with
mango paper; frog: one square sheet of back-coated *Shikibu
Gampi Shi*; armature: wood, acrylic, nylon thread, magnets
(*Photo by Robert Bloomberg*)

Next spread *Dreamer*
Giang Dinh, Vietnam/USA
Designed 2010, folded 2014, watercolor paper
(*Photo by the artist*)

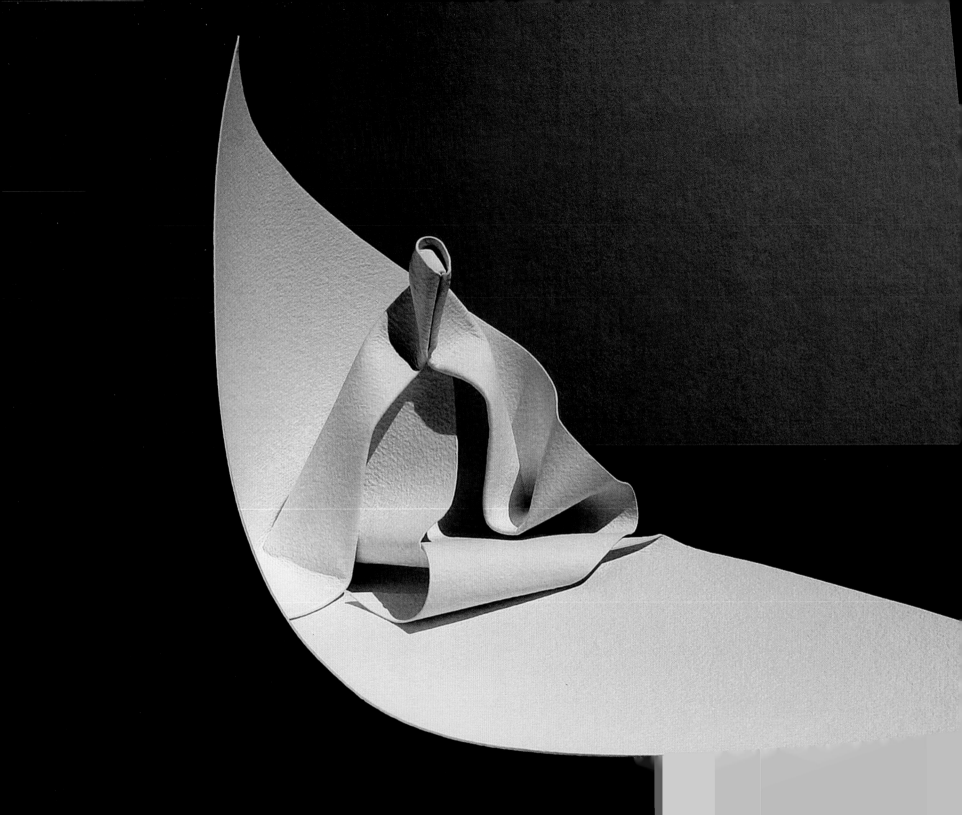

new expressions in
origami art

Masterworks from 25 Leading Paper Artists

Meher McArthur

Foreword by Robert J. Lang

TUTTLE Publishing

Tokyo | Rutland, Vermont | Singapore

Above **Stars and Stripes, Opus 500** Robert J. Lang, USA, 2007
one uncut square of Wyndstone Marble paper (*Photo by the artist*)

Right **White Elephant (artist and model)** Sipho Mabona, South
Africa/Switzerland, 2014, paper (*Photo by Philipp Schmidli*)

Below **Untitled (Seed)** Richard Sweeney, UK, 2011
watercolor paper, adhesive (*Photo by the artist*)

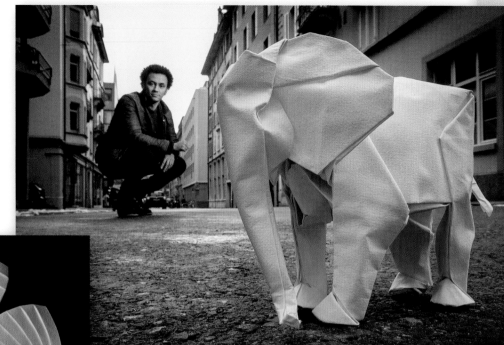

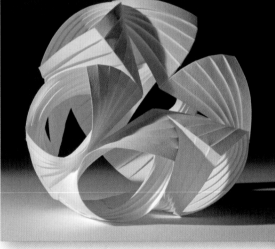

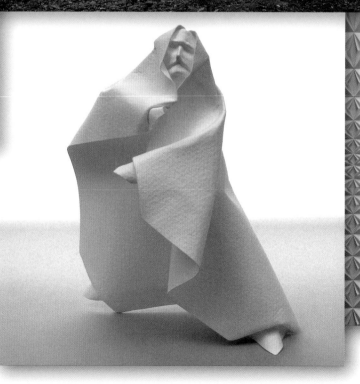

Left **Cyclomatus metallifer, Opus 562**
Robert J. Lang, USA
2010, one uncut square of Korean *hanji* paper
(*Photo by the artist*)

Right **Taichi**
Giang Dinh, Vietnam/USA
2007, watercolor paper
(*Photo by the artist*)

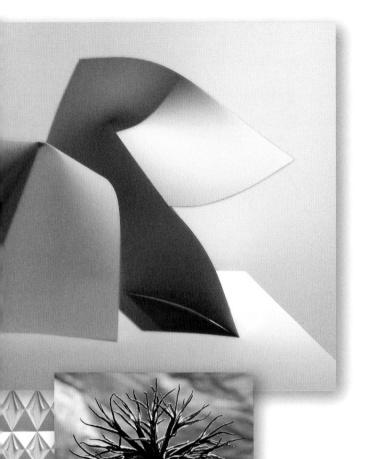

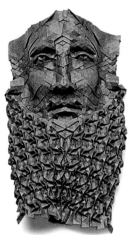

CONTENTS

Above *Blue Coral*
Vincent Floderer, France
2005, Japanese Tengujoshi paper
(*Photo by Romain Chevrier*)

Left *Wave* (detail)
Yuko Nishimura, Japan
2013, paper
(*Photo by Yousuke Otomo*)

Above *Cyrus*
Joel Cooper, USA
2010, paper, metallic pigment,
craquelure glaze, shellac
(*Photo by the artist*)

Right *Hedgehog*
Beth Johnson, USA
2011, elephant hide paper
(*Photo by Dave Brenner*)

ORIGAMI CONNECTIONS

Photo by Miri Golan

No other art combines the severity of constraint with an extravagance of expression like origami. So just what, exactly, is origami? Narrowly defined, it is the folding of brightly colored squares of paper into simple birds, fish and flowers. Broadly defined, it is a sculptural art in which the primary means of creating the form is folding. I and my fellow artists in this book take the broad view: we use folding as the springboard to express nature, philosophical ideas, mathematical concepts, even political statements. And yet, there is a thread of continuity that connects our diverse art with that of other artists, with the Japanese craft with which it bears kinship, and with the centuries-old manipulations of paper we find throughout the world.

Folding of paper-like materials exists in many cultures in Europe, Asia and the Americas. However, the deepest roots of the folding arts arise from within the Japanese folding tradition, and that is why most of us use the Japanese word "origami" to describe what we do. Those of us who do use the word "origami" recognize that it is a relatively recent term and an imperfect fit to the modern practice. The important thing is not the word: the important thing is what the various expressions of the art share with one another. Origami is a conservative art, in which material is neither added nor removed, but transformed. This transformation establishes a thread of continuity and integrity that connects the simplicity of the starting shape—commonly one or more squares or rectangles—with the folded form, be it representational or abstract. The finished form triggers our perceptions and evokes images and emotions, but that thread of continuity binds our experience of the finished work to the pristine initial shape. In the artist's mind, there was an idea and a sheet of paper before any folding took place. In the finished work, the sheet of paper remains continuous and uninterrupted as it began, but with the artist's concept now layered within the folds.

We transform via folding, but even folding is to be taken broadly. Folding is creasing, bending, curving, scoring, by hand, by fingernail, by folding bone, even by blade and laser. Folding preserves the paper's initial shape, but at the microscopic level it imparts permanent change: breaking fibers, infinitesimally delaminating layers, and, if the technique of wet folding is applied, rearranging hydrogen bonds between adjacent polymeric strands. Folding can be mechanically precise, formed according to artistic judgment, or, in the case of "crumple" folding, formed as the realization of a stochastic process. However folds are created, they ultimately join together with the mechanical properties of the paper—stiffness, springiness, relaxation—and the intricacies of human perception in the observer to create a connection. Origami is about connections: between the fibers of the paper or folding medium, between the creases that join into intricate networks, but most of all between the artist and the observer of the finished work. As you explore the works in this book, I encourage you to examine the connections within the works displayed, both explicit and implied, and establish your own connections with this fascinating art.

ROBERT J. LANG
origami artist/consultant, physicist and author of Origami Design Secrets

INTRODUCTION

Dwarf
Eric Joisel, France
2003, paper
(*Photo courtesy of the
artist's family*)

Origami—the Japanese art of paper folding—has become so popular that it is now being practiced all around the world, and not only by children but by many highly innovative artists. Since the 1950s, when Japanese origami artist Akira Yoshizawa began using wet folding to model original, realistic forms, artists all over the world have been inspired to push the boundaries of paper folding. Some began their artistic journey with traditional origami and have found ways to fold increasingly complex and sculptural forms, while others were sculptors who discovered that folding paper presented them with a whole new world of possibilities. The result has been the emergence of a unique type of sculptural art that begins in two dimensions and ends in three.

By experimenting with new techniques such as wet folding, curved creasing and tessellations, and using a wide variety of papers, artists from all over the world have been following their own aesthetic, poetic and political inclinations, elevating paper folding into a sophisticated global art form that now comprises many different styles and genres. Although folded birds, insects and animals remain a key element in this evolution, origami art now includes works of abstract sculpture, large-scale installations, street art and conceptual works that express contemporary social, political and aesthetic ideas. Origami has become a multifaceted method of artistic expression.

The origami artists featured here are some of the most innovative working today (save for Eric Joisel, recently deceased, but whose spirit is still felt strongly). They have been vigorously pushing the boundaries of origami in new directions in terms of style, scale, materials, subject and concept. Fueled by their boundless imagination and formed with remarkable skill, their origami creations are increasing in size, with larger single sheets or multiple modules being assembled into large-scale sculptures that blend geometry and grace. They are creasing and crumpling paper to create fantastic new worlds inhabited by lifelike organisms. They are folding sheets of paper along curved lines so that they twist and swirl in unexpected directions. They are combining their folded paper creations with other media, even encasing them inside vessels of glass. They are folding paper as a way of expressing their concerns about religious, social and political issues. Now, we are not only awed by the intricacy of their folding and the beauty of their folded forms, but we are also moved by the power of the message contained in the work.

The artists featured in this book are from eleven different countries on four continents. Many of them know, and have been inspired by each other. Some have been active in the origami community for years, while others have only recently discovered the community of other paper folders out there. Some are inspired solely by aesthetics, while others use their art to make a political or social point. What they share is a place in an important moment in the history of origami, when what was once considered Japanese has become truly global and what was once only seen as a craft is being recognized as an art form—and one with infinite modes of expression.

Meher McArthur

MEHER MCARTHUR
independent Asian art curator, educator and co-author of Folding Paper: The Infinite Possibilities of Origami

of molecules and masks

Photo by Jane Araújo

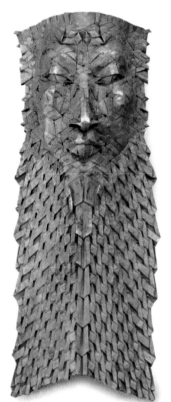

Left *Sargon*
Joel Cooper, USA
2014, paper, metallic pigment,
craquelure glaze, shellac
(*Photo by the artist*)

Opposite *Caliban*
Joel Cooper, USA
2014, elephant hide paper,
shellac
(*Photo by the artist*)

Since the year 2000, a number of origami artists have been exploring the artistic potential of tessellation, a series of forms that are repeated to create a pattern that fills a plane with no gaps or overlaps. The term derives from the Latin word *tessera*, the name for the individual tiles used to make mosaics. In origami tessellations, pleats are used to connect "molecules," such as twist folds, together in a repeating fashion. Japanese origami artist Shuzo Fujimoto first explored the technique systematically in the 1960s, leaving dozens of patterns that established the genre among origami enthusiasts. In the United States around the same time, artist and computer scientist Ron Resch also patented some tessellation patterns, but it took until the 1980s for his work to became known in the origami community. Now, origami artists throughout the world are using tessellation to create spectacular works of 2-D, relief and 3-D paper sculpture. Most of these are abstract and geometric in their patterning and formations. However,

American artist Joel Cooper (b.1970) has discovered that he can employ the technique to create highly detailed and expressive masks portraying historical and imaginary figures.

Cooper was born in San Francisco but grew up in Kansas, where he lives today. When he was about eight years old he first became interested in origami, devouring the first book that his parents bought for him on the subject. Although he was also interested in math and science, he decided to major in Fine Arts at college, studying oil painting, bronze casting, stone carving, ceramics and other traditional media, while continuing origami as a hobby on the side. In 2000, many years after he graduated, he was browsing websites on geometry and discovered origami tessellations. As he investigated tessellation techniques, he found what had been missing for him in the traditional art forms he had studied at college. "I could create art with geometry in a very direct way that I could not do with any other media," explains Cooper. "Traditional origami may use geometry in an almost incidental way as a means to an end, but with origami tessellation the geometry is explicit." Using this technique, Cooper was able to bring together his love of origami, his fascination with geometry and his experience of sculpture to make a new art form that was uniquely his own.

While most artists who have been exploring this technique have focused on the seemingly infinite variety of geometric patterning possible through tessellation, Cooper saw the potential for modeling figures and faces in the systematic folding made up of pleats and twists. "I found that manipulations of these shapes can create deformations in the plane of the paper, three-dimensional shapes, which is how I use origami to create these masks." In his sculptural technique, the key is "transforming a surface rather than building a form from the inside out." For the past fifteen years, he has been experimenting with the technique,

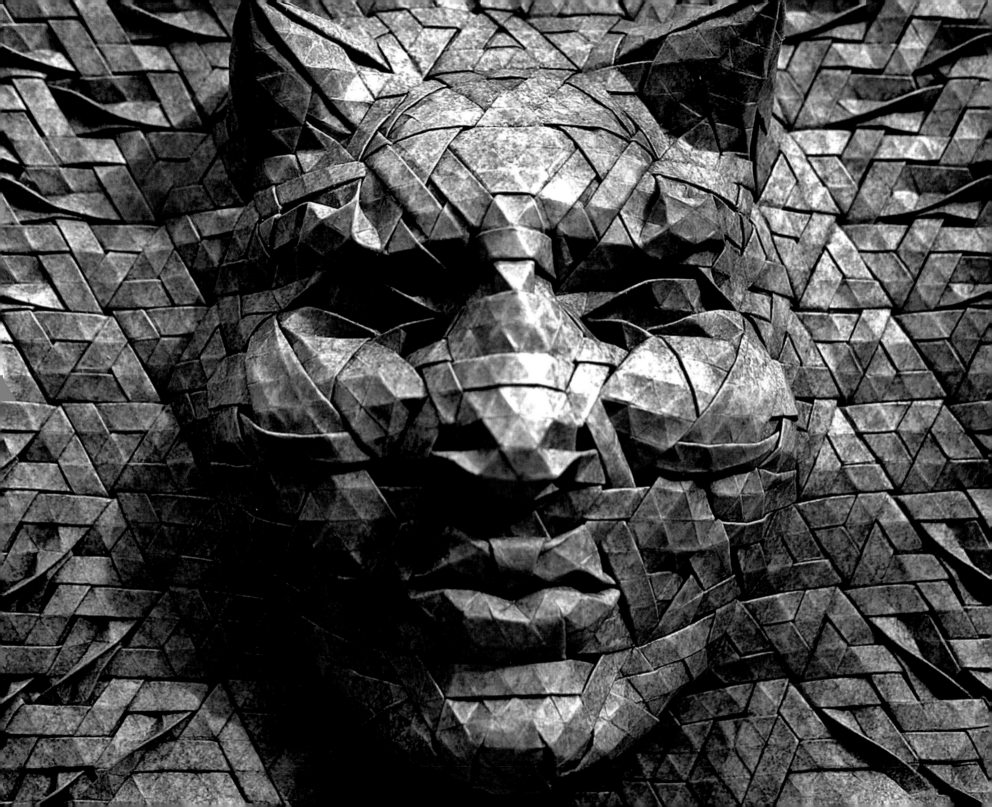

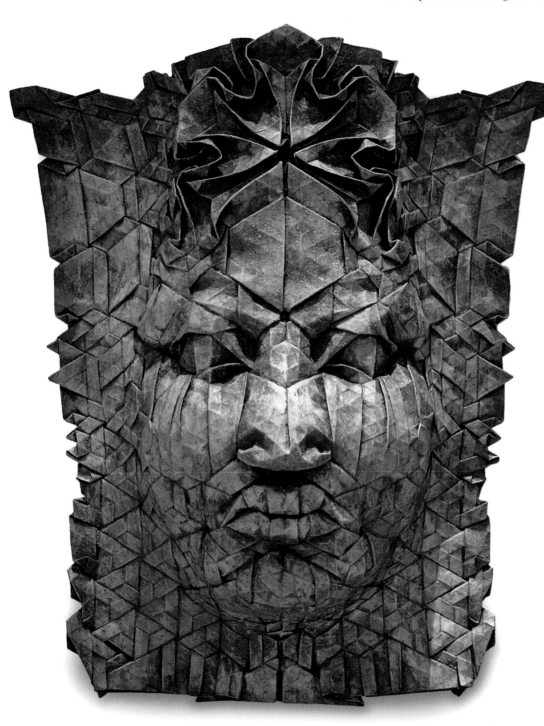

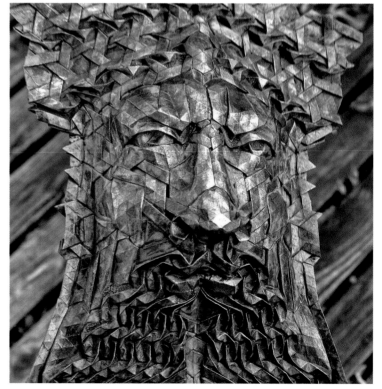

Left *Hierophant*
Joel Cooper, USA
2013, elephant hide paper,
glaze, shellac
(*Photo by the artist*)

Below *Iron Aelfred*
Joel Cooper, USA
2014, elephant hide paper,
micaceous paint, iron oxide,
shellac
(*Photo by the artist*)

different types of paper and finishes to create a series of folded relief portraits that deceive the eye and confound the brain of most viewers. In his work entitled simply *Mask* (2010), a perfectly formed face of a young man or woman seems to push itself through what appears to be a woven green fiber surface. But in reality, the work is folded, not woven, from a single sheet of paper using a pleated tessellation pattern. By manipulating and modeling the central area and flattening out the plaits, Cooper formed the face in relief. The green finish and sheen of the paper lends it a patina that reminds us of ancient bronze sculptures, further tricking our brains into forgetting the piece is formed from paper.

In his work *Cyrus* (2010), Cooper has folded a portrait of Cyrus the Great, founder and first king of the Persian Achaemenid Empire. Although created from paper using a highly geometric folding pattern, he was able to stylistically emulate Achaemenid sculptures from the sixth century BC, and very specifically the relief sculpture of a bearded man found carved onto a column capital that was excavated from a building at Persepolis, the ancient capital of Persia. Through meticulous folding, followed by wetting and shaping the paper, Cooper sculpted the high cheekbones, long nose and sensuous lips, and by using a tessellated pleat pattern, he emulated the snail-curl beard treatment found in many early Persian, Greek and Assyrian sculptures. Finally, his choice of gray paper evokes stone sculptures of this period, imbuing the sculpture with an ancient regality and gravitas.

In many of his sculptural portraits of historical and mythical figures, Cooper coats his paper to create the sheen and patina of ancient metalwork. In his sculpture of Creon, King of Thebes in Greek mythology, the figure has an expressive face and detailed headdress. However, it is the finish applied to the paper that gives it an ancient look. Cooper folded the mask from a single sheet of dark green elephant hide paper, which was then

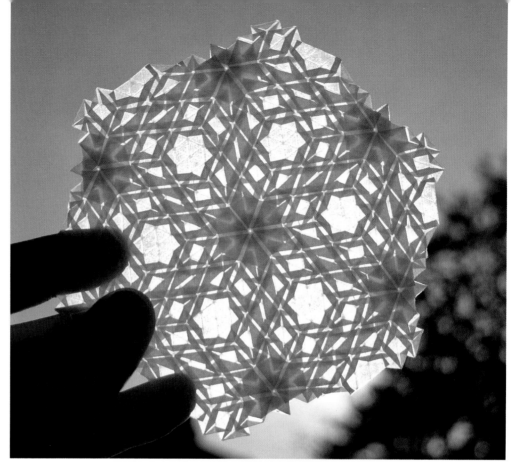

Above **White Tessellation**
Joel Cooper, USA
2013, elephant hide paper
(Photo by the artist)

Right **Pink Tessellation**
Joel Cooper, USA
2013, elephant hide paper
(Photo by the artist)

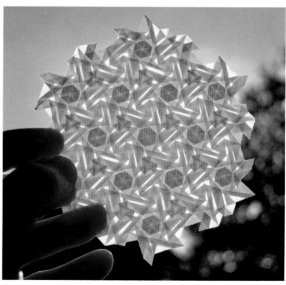

painted with a combination of interference paint and iridescent gold and copper paints. It was then given a final coat of tinted shellac to deepen the color. The effect is one of bright brass with a verdigris patina. On a recent work, *Aelfred II* (2014), which depicts the ninth-century English king Alfred the Great, he achieved an ancient-looking surface patina using a technique he learned from fellow origami artist Joseph

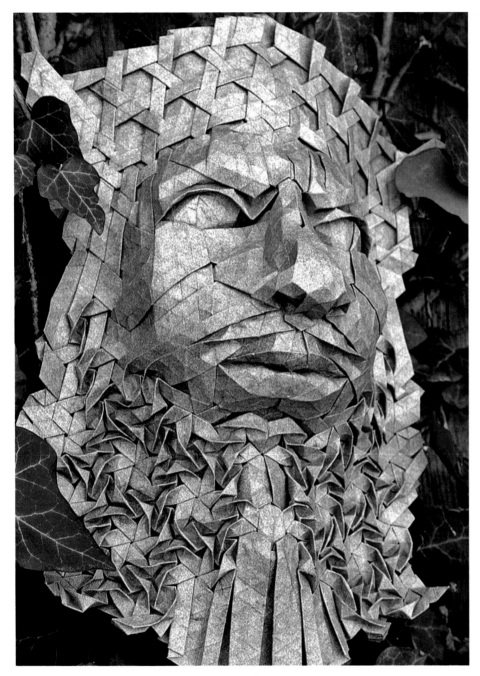

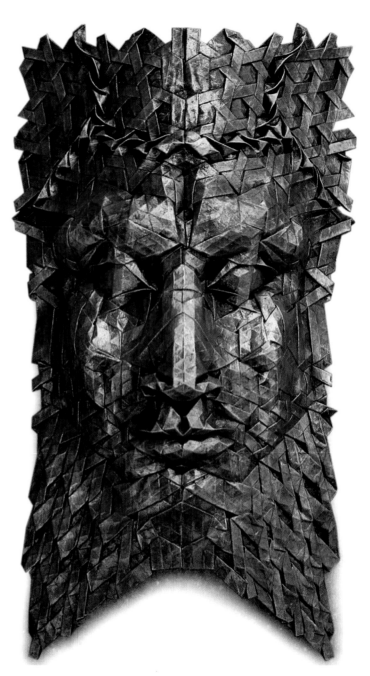

Gnome King
Joel Cooper, USA
2011, elephant hide paper, shellac
(*Photo by the artist*)

12

Rex
Joel Cooper, USA
2015, elephant hide paper, glaze, shellac
(*Photo by the artist*)

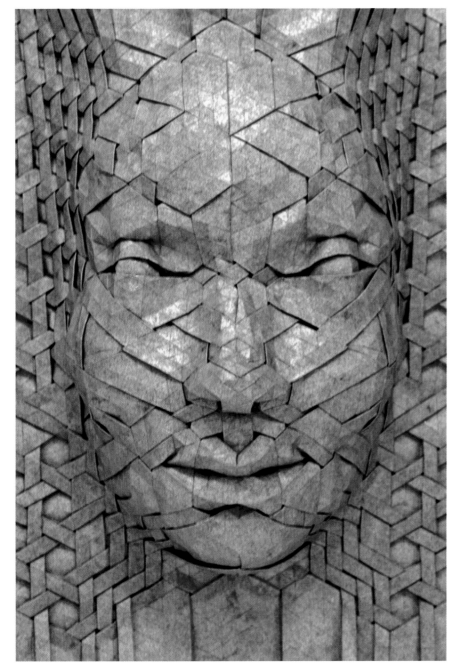

Green Face
Joel Cooper, USA
2010, elephant hide paper, shellac
(*Photo by the artist*)

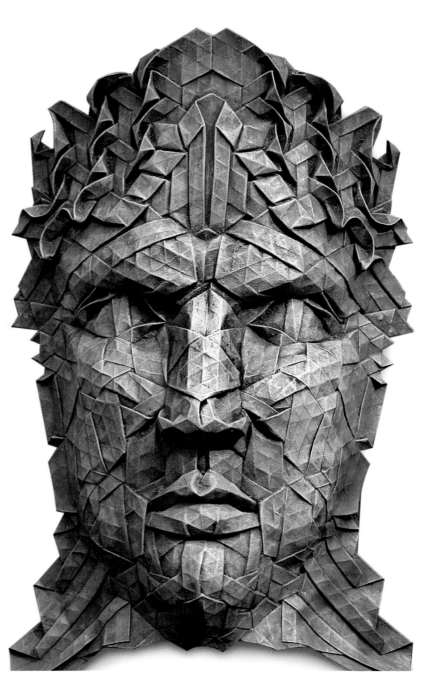

Constantine
Joel Cooper, USA
2015, elephant hide pape, shellac
(*Photo by the artist*)

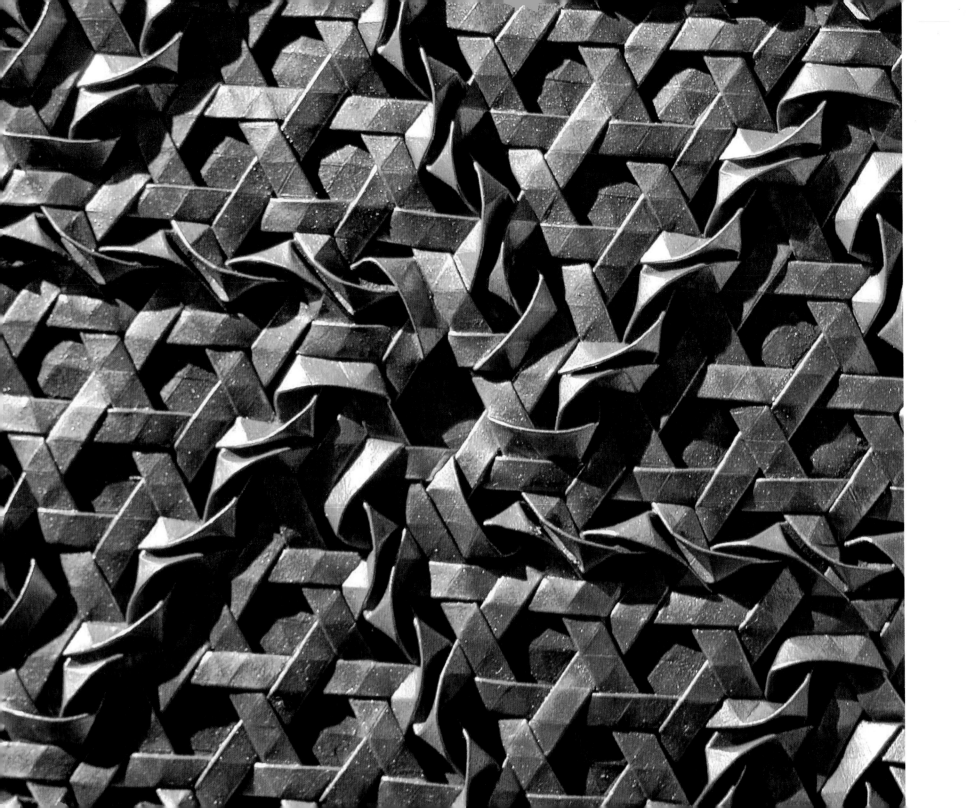

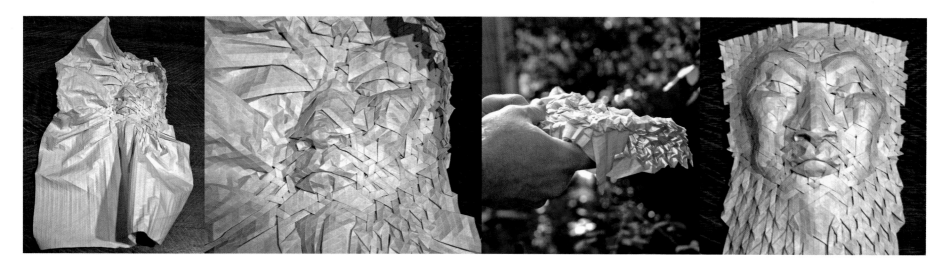

Left *Iron Tessellation* **(detail)**
Joel Cooper, USA
2015, elephant hide paper, micaceous paint, shellac
(*Photo by the artist*)

Below *Elf King*
Joel Cooper, USA
2014, elephant hide paper
(*Photo by the artist*)

Above, from left to right
Mask Folding Process
Joel Cooper, USA
2014, elephant hide paper
(*Photos by the artist*)

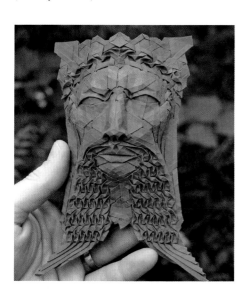

Wu. By applying Kroma Crackle, a semi-opaque acrylic gel, to the paper after folding, he created texture and simulated the age and the oxidation of metal, giving the sculpture the appearance of being cast from bronze many centuries ago.

Joel Cooper's work is not limited to tessellated origami masks. He has also designed many two- and three-dimensional geometric tessellations that are exceptional works of complex patterning, including his *Fujimoto Lampshade* (2006), an illuminated tessellation named for Shuzo Fujimoto, the originator of the technique. However, it is Cooper's masks that have earned him the greatest amount of attention in the origami world and beyond. As well as demonstrating Cooper's interest in mathematics and his skill in the

plastic arts, his works also reveal a fascination with the concept of history—and not just the ancient history that he is depicting in his mask portrayals of ancient kings, but also in the history of the creation of the objects themselves. When asked what draws him to tessellation as a style of origami, he replies, "All of the folds are visible, right there on the surface. The finished model is not just an object but also a sort of chronicle of its own creation. The appeal of origami art is not just in the finished piece, but awareness of how that piece is created." With each and every molecule of his folded masks, Joel Cooper shares with us tessellated tales of not only how we have evolved over the centuries as humans, but also how we continue to evolve as creative, artistic beings.

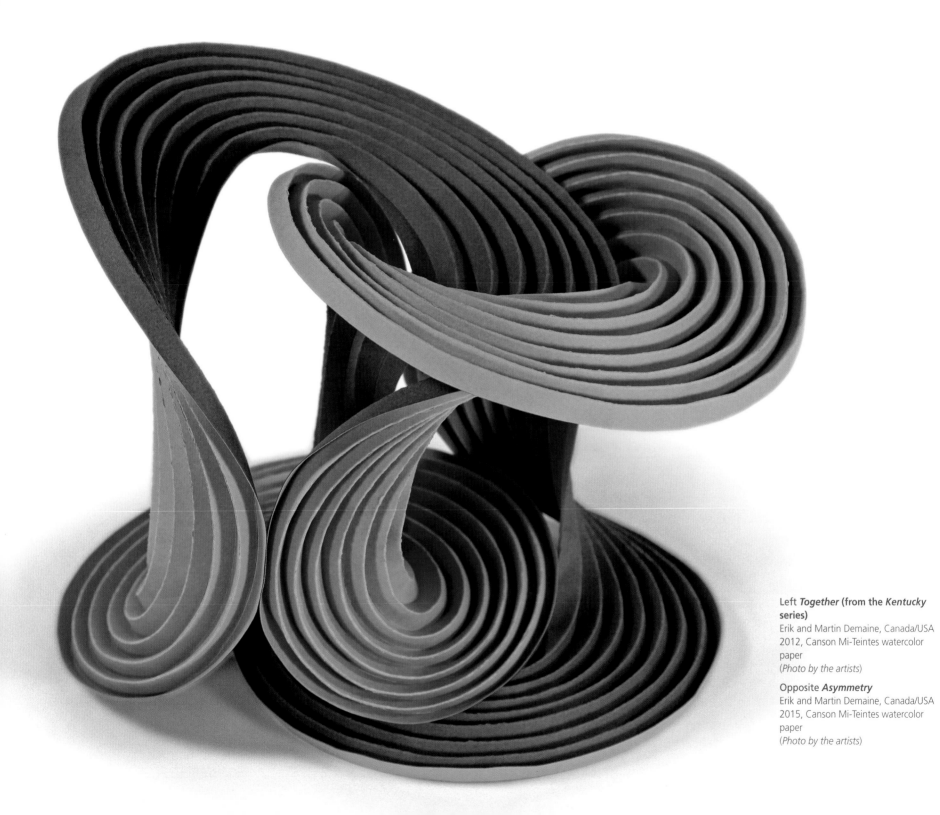

Left *Together* (from the *Kentucky* series)
Erik and Martin Demaine, Canada/USA
2012, Canson Mi-Teintes watercolor
paper
(*Photo by the artists*)

Opposite *Asymmetry*
Erik and Martin Demaine, Canada/USA
2015, Canson Mi-Teintes watercolor
paper
(*Photo by the artists*)

ahead of the curve

THE COLLABORATIVE MIXED-MEDIA WORKS OF ERIK DEMAINE AND MARTIN DEMAINE

Erik and Martin Demaine are a father–son artistic partnership whose work has been integral in elevating origami to the status of fine art. Their origami sculptures have been exhibited and collected by the Museum of Modern Art (MoMA) in New York, featured in sculpture magazines, and purchased by several private collectors. Although Martin is a professional artist, Erik is a professor at the Massachusetts Institute of Technology (MIT) and is one of the world's leading experts on computational origami and origami mathematics, so his success as a fine artist may seem surprising to some. However, there is much about the origami creations of this father–son team that is unexpected, extraordinary and ahead of the curve in the realm of origami and in art in general. Their artistic collaboration is bi-generational and bi-cultural, their works fuse together art and science and mix media like paper, blown glass and books. And their origami is not angular—it curves.

Martin Demaine (b.1942) studied glass blowing in England and then moved to New Brunswick, Canada, where he established Canada's first glass blowing studio in the 1970s. His work is in the permanent collections of many museums, including the National Gallery of

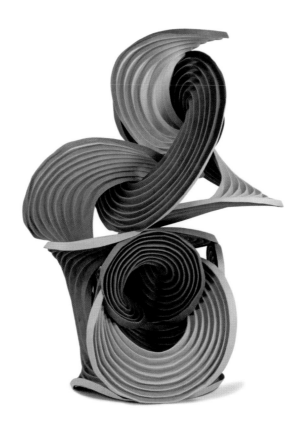

Canada, and he is currently an artist-in-residence at MIT in Boston. He home schooled his son Erik (b.1981), who completed his BSc degree at fourteen and his PhD at twenty. Erik's dissertation on computational origami received national awards and won him a MacArthur Fellowship. Since joining the MIT faculty in 2001 as their youngest ever professor, Erik has been the leading theoretician in origami mathematics— the study of what can be done with a folded sheet of paper—and he is exploring origami applications to architecture, robotics and molecular biology.

In the world of origami, the Demaines are best known for their "Curved Crease Sculptures," dynamic swirling forms created by folding paper along curved creases. Curved paper folding has its origins in the experiments of Bauhaus artists Josef Albers in the 1920s and 1930s and Irene Schawinsky in the 1940s. In the 1970s, artist and computer scientist Ron Resch (1939–2009) and David Huffman (1925–99), an electrical engineer and computational origami pioneer, both experimented with the technique, as did origami artists Thoki Yenn (1919–2004) and Kunihiko Kasahara (b.1941) in the 1980s and 1990s. Martin Demaine had explored curved crease sculpture as early as the 1960s,

and in 1998 he and Erik combined their artistic and mathematical knowledge to delve more deeply into the technique. Using mathematical algorithms to probe the potential of curved crease concentric circles, ellipses and parabola, they produced increasingly complex and beautiful folded paper forms.

Over several years, their work evolved into a series of "Curved Crease Sculptures," in which the artists connect multiple sheets of folded circular paper and then allow the paper to shape itself into a natural equilibrium form, in a type of self-folding origami. According to the Demaines, the title of these modular works "refers to our underlying algorithmic goal of determining the mathematical curved surface that results from different kinds of pleated folding. This kind of 'self-folding origami' may have applications to deployable structures that can compress very small by folding tightly and later relax into its natural curved form. To control this process, we must understand what forms result from different pleatings, and how to design pleatings that make desired forms." Around 2007, the Demaines' experimentation with curved creases began to attract the attention of contemporary art museums and galleries, a rare but highly significant occurrence for an origami artist. In 2008, their series entitled *Computational Origami*, folded from ivory-colored elephant hide paper, was displayed at the Museum of Modern Art in New York in the exhibition *Design and the Elastic Mind*, and is now in the museum's permanent collection. The only other origami artist featured in this exhibition was Robert J. Lang.

Since the MoMA exhibition, the Demaines have continued to experiment with curved creases, producing a similar series of five sculptures in elephant hide paper called *Waves* for an art gallery in Belgium in 2009. Even more lyrical than the *Computational Origami* series, these sculptures were made from multiple circular sheets of paper with a hole in the

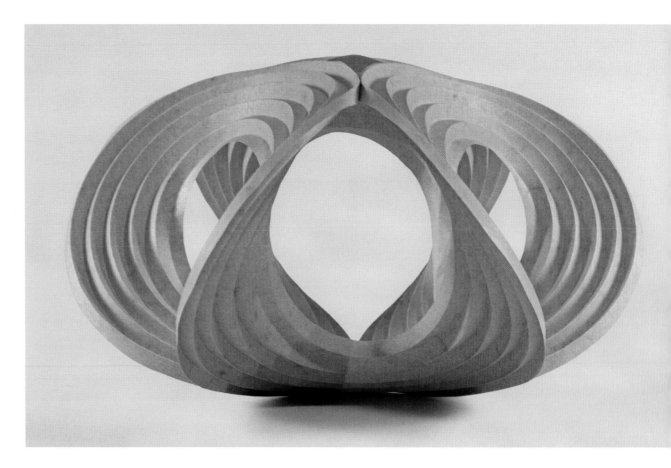

center. The sheets, each textured with hand-scored concentric circular creases, were then joined together at a few key points to change the equilibrium form. The following year, the Demaines took the bold step of combining origami and glass in a spectacular mixed-media series that evolved from the *Waves* series. Their *Waves in Glass* series examines the communication between folded paper and blown glass, both in process and form. Paper is a material that relies on touch. Glass is untouchable when it is being worked at temperatures of over 2,000° F; glass blowers rely on visual cues to communicate and shape it. To relate the two media,

Three Waves Meeting
Erik and Martin Demaine, Canada/USA
2009, Zanders elephant hide paper
(*Photo by the artists*)

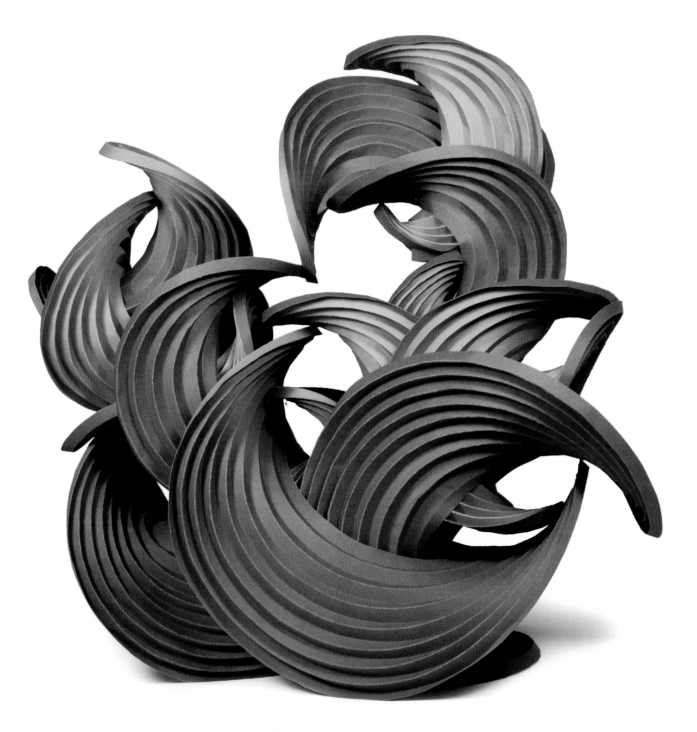

0264b (from the *Earthtone* series)
Erik and Martin Demaine, Canada/USA
2012, Canson Mi-Teintes watercolor
paper
(*Photo by the artists*)

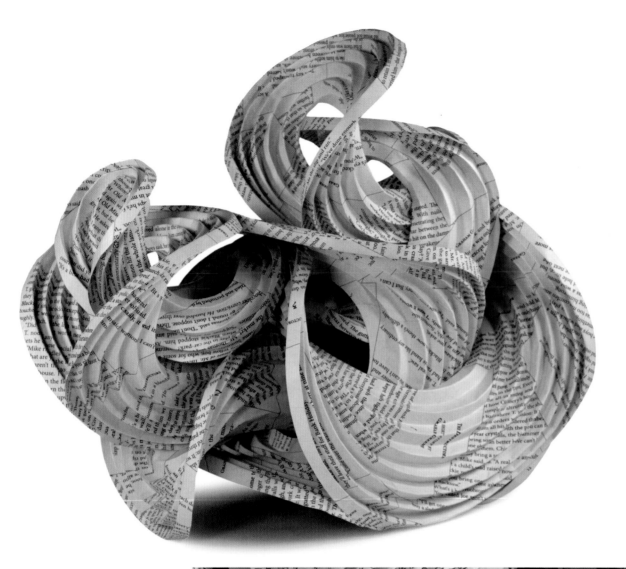

Left (and details below)
Destructors III (from the
Destructors series)
Erik and Martin Demaine,
Canada/USA
2013, elephant hide paper
(*Photos by the artists*)

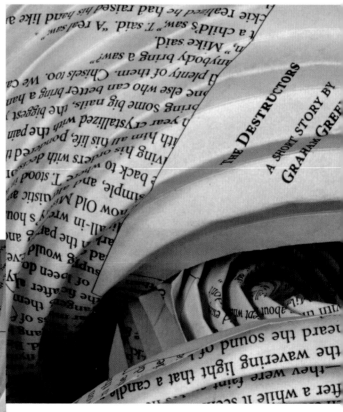

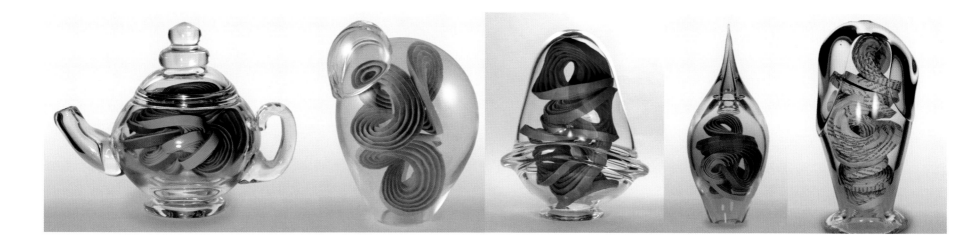

Above, left to right
Green Tea
Erik and Martin Demaine, Canada/USA
2014, Canson Mi-Teintes watercolor
paper, hand-blown glass
(*Photo by the artists*)

Waves in Glass I (from the Waves in Glass series)
Erik and Martin Demaine, Canada/USA
2010, Canson Mi-Teintes watercolor
paper, hand-blown glass
(*Photo by the artists*)

Velvet Ring
Erik and Martin Demaine, Canada/USA
2015, velvet paper, hand-blown glass
(*Photo by the artists*)

Pinnacle
Erik and Martin Demaine, Canada/USA
2014, Canson Mi-Teintes watercolor
paper, hand-blown glass
(*Photo by the artists*)

Donnie Darko
Erik and Martin Demaine, Canada/USA
2014, elephant hide pape, hand-blown
glass
(*Photo by the artists*)

the Demaines originally blew the glass blindfolded, leaving touch as the only way for them to communicate with the material through a thin layer of wet paper. In this series of works, the paper is folded and then inserted into head-shaped glass vessels. Once inside the glass, the folded paper expands to find new equilibrium forms, which could not exist without the communication between the two materials.

For many of their works over the last few years, the Demaines have experimented with different types and colors of paper to create sculptures that are often highly organic, such as their *Green Waterfall* series, made in 2011 for the Fuller Craft Museum in Massachusetts using Canson Mi-Teintes watercolor paper. The two slightly different shades on the front and reverse of the intertwining folded green sheets give the sculptures the rich, lavish tone and texture of tropical plants twisting upward from the floor of a rainforest as they seek out rays of sunlight. In the *Stone Series*, folded in 2013 for the Art Museum at the University of Kentucky, circles of a similar gray watercolor paper twist and turn boldly to form sculptures that somehow convey the solidity of granite rock.

In 2013, the Demaines also created their *Destructors* series. These sculptures depart in a new direction artistically from earlier series by combining folded paper with printed text to create a relationship between folded paper sculpture and works of literature. As in their earlier series, the sculptures are modular combinations of three or more interacting sheets of paper, but the sheets were printed with overlapping pages from Graham Greene's "The Destructors" (1954), the short story that inspired the 2001 film *Donnie Darko*. To create this series, the artists cut each sheet into a circle with a circular hole, scored centric circular creases and folded the circles by hand, alternating between mountains and valleys. Once the paper had found its natural equilibrium, they "wove" the pieces together by squeezing one piece to fit inside the hole of another. Then, they let the pieces relax into a natural resting state and glued them to prevent shifting. The result is an unreadable book, echoing the central tenet of the story that "destruction after all is a form of creation."

In their newest series, *QR Series* (2014–15), readability, this time of computer code, is again

distorted, but with a much lighter touch. Circular sheets are printed with a black-and-white QR code pattern that originally read "Folding Error" when the paper was flat. By folding the sheets, they create a beautiful sculpture, but they also destroy the code—and with it the error message. In this clever new series, we can see all the key elements of the Demaines' extraordinary father–son artistic partnership—aesthetic grace and balance in the swirling design of the sculptures, mathematical and technological sophistication in the printed code pattern and the continued evolution of their curved folding technique, and a wry sense of humor that will ensure the Demaines many more years of creativity to come.

Below left **0261c (from the *Earthtone* series)**
Erik and Martin Demaine, USA
2012, Canson Mi-Teintes watercolor paper
(*Photo by the artists*)

Below **0316-02 (from the *Ocean* series)**
Erik and Martin Demaine, Canada/USA
2012, Canson Mi-Teintes watercolor paper
(*Photo by the artists*)

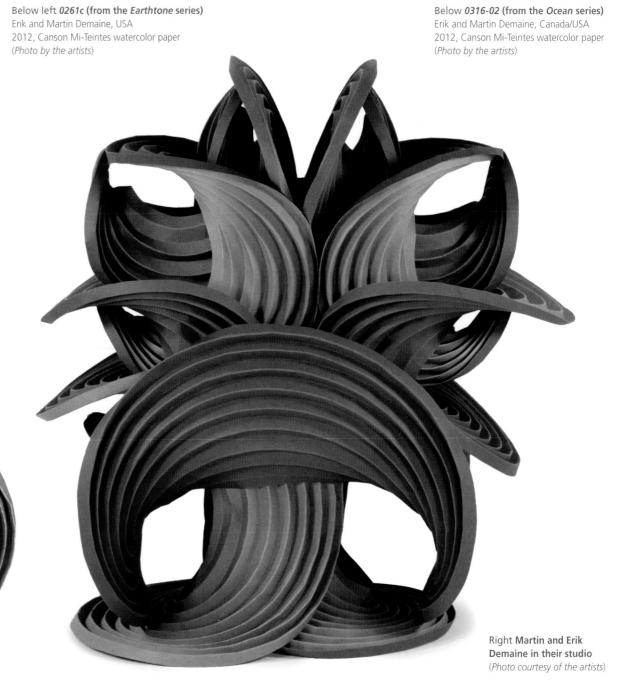

Right **Martin and Erik Demaine in their studio**
(*Photo courtesy of the artists*)

simplicity and serenity

IN THE ORIGAMI OF GIANG DINH

Dinh Truong Giang, known better as Giang Dinh (b.1966), is a Vietnamese artist living in the United States whose stylized figures of humans, animals and faces are among the most lyrical and spiritual of today's origami art works. The spiritualism in his work is often Buddhist in inspiration, but in many of his works unidentifiable human figures are simply praying or dreaming or dancing. They could be Buddhist monks, Christian priests or Sufi mystics seeking a connection with the Divine. Although folded from paper and with a minimalist approach that renders them semi-abstract in style, Dinh's figures, even his animals, are astonishingly expressive. Using a few well-placed folds, he is able to evoke exuberance, melancholy and even humor. In both the Zen-like simplicity of his folding style and the choice of Buddhist subjects for some of his work, we sense in his origami figures a serenity and a reverence for spiritual ideals, practices and beliefs that is rare in the often scientific and mathematical world of origami.

Born in 1966 in Hue in central Vietnam, Dinh spent his childhood in Vietnam. Although not a practicing Buddhist, he and his family do occasionally worship the Buddha in their home, and he has memories of family friends who were Buddhist monks and of visits to pagodas when he was a child in Hue. Dinh studied architecture in Vietnam and moved to the United States in 1989, where he continued his architectural studies. In 1998, he started creating origami, and for the last couple of decades he has been working as an architect, painter and origami artist. In all areas of his artistic work, he embraces simplicity and elegance. But it is in the realm of origami where Dinh is a true innovator.

Unlike most origami artists who use thin custom-made origami paper that can be folded many times, Dinh chooses to use thicker paper, such as watercolor paper, which is much harder to fold. However, once folded, this heavier paper will hold the slightest fold and allow him to model semi-abstract forms that are at once simple and highly expressive. Dinh compares the crisp, sharp folds that define many origami sculptures to drawings rendered in ink. By choosing to softly—and sometimes only partially—fold his pieces, he instead evokes the softer and more subtle lines of a pencil drawing. This thoughtful approach to folding often produces animal and human figures that are gentle and meditative, such as the figure *White* (2011), a simple, elegant female figure who almost appears to have been carved from marble or alabaster.

Dinh is highly admired by many in the origami community and beyond for his ability to convey the essence of a creature or person in just a few gentle folds, in the same way that a Zen ink painting can depict the essence of a monk or a monkey with just a few well-placed brush strokes. Typically, Dinh works in plain white paper in order to concentrate on the pure form and shadow of the work. Many of his works are wet folded, a technique developed in the mid-twentieth

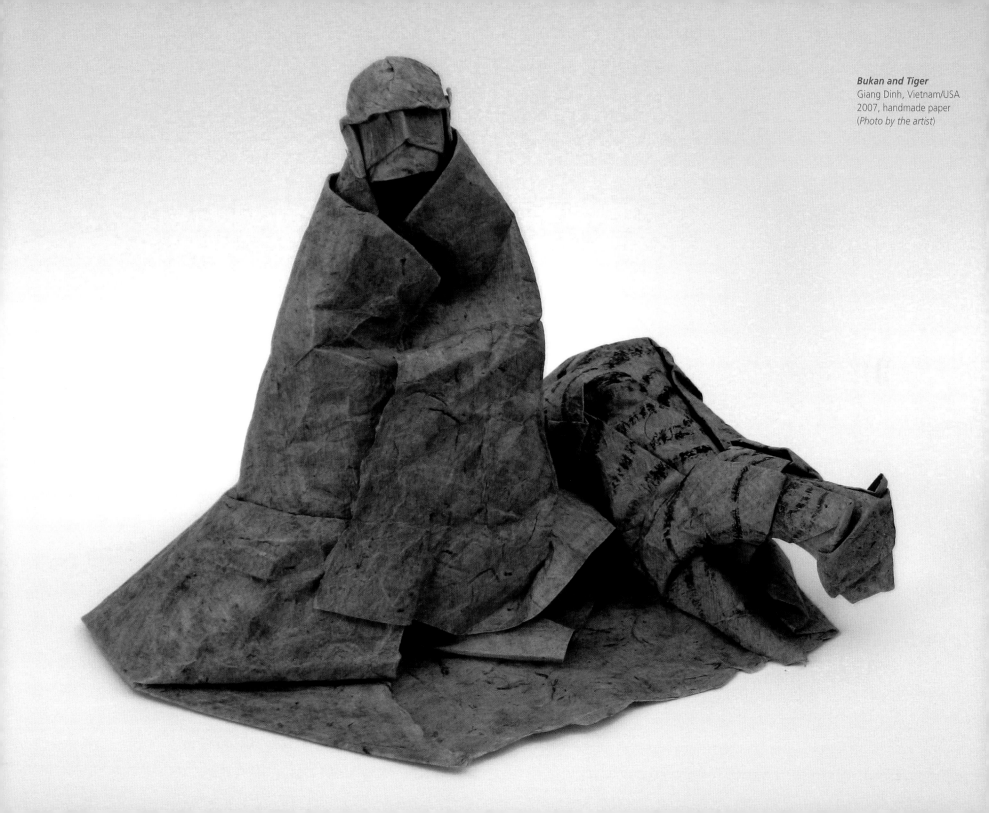

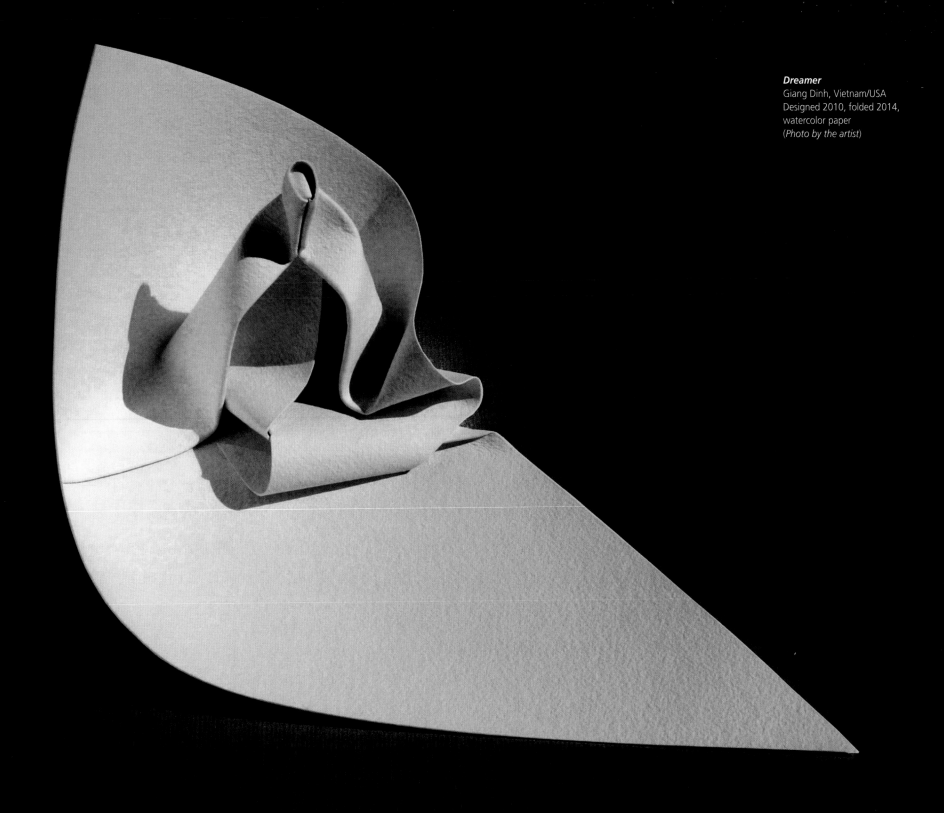

Dreamer
Giang Dinh, Vietnam/USA
Designed 2010, folded 2014,
watercolor paper
(*Photo by the artist*)

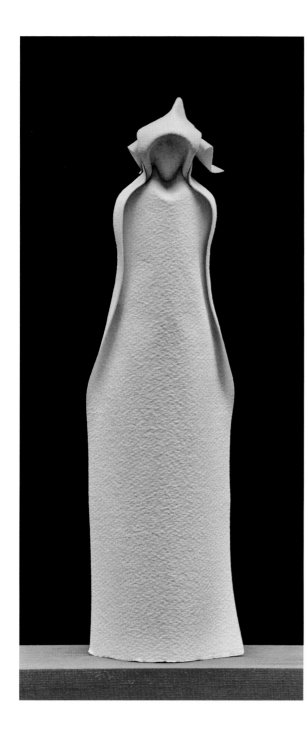

Left *White*
Giang Dinh, Vietnam/USA
2011, watercolor paper
(*Photo by the artist*)

Right *Fly*
Giang Dinh, Vietnam/USA
2010, watercolor paper
(*Photo by the artist*)

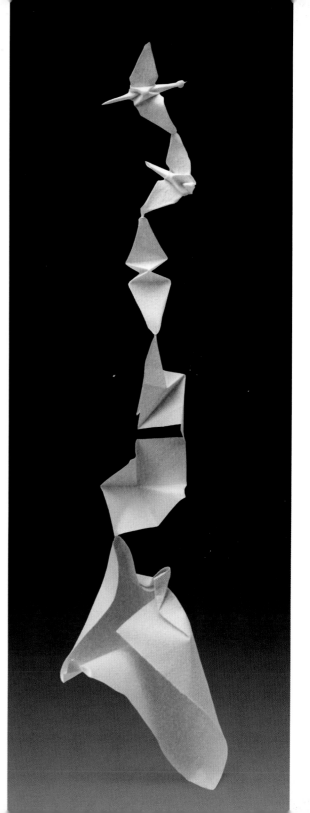

century that involves moistening the paper slightly in order to smooth down points and angles and create more naturalistic, sculptural forms. Whereas many origami artists tend to fold animals, abstract forms and geometric patterns, Giang Dinh has excelled in creating human figures engaged in dancing, praying or even taking flight as they transform into angels. All of his works—his animals, humans and deities—radiate a warm and gentle spirit that he seems to have released from the paper through the act of folding. His bears, in particular his lonely looking *Polar Bear* (2011), evoke a great empathy in the viewer for a majestic beast whose existence is threatened by human activity.

To describe his artistic process, Dinh has quoted Antoine de Saint Exupéry, who wrote, "Perfection is achieved, not when there is nothing more to add, but when there is nothing left to take away." This perfection through simplicity is exquisitely apparent in his work *Prayer* (2010), in which he employs a few simple folds to create the image of a robed figure praying, the most tightly folded element of the form being the hands clasped in prayer. "You can say that the simplicity aspect of my work is inspired by Zen's art and philosophy. I love Haiku," admits Dinh. However, he also points out other artistic influences. "I love the works of Brancusi, Henry Moore, Isamu Noguchi...." In another work, *Dreamer* (designed 2010, folded 2014), a semi-

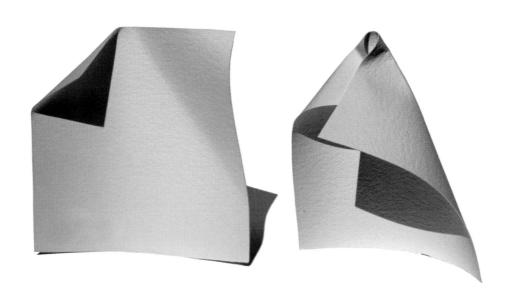

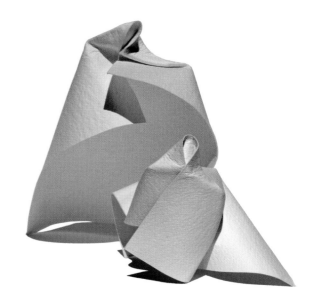

Right *Dance*
Giang Dinh, Vietnam/
USA
2009, watercolor paper
(*Photo by the artist*)

abstracted figure is seated in the lotus position, apparently in meditation, his whole form merging with the ground on which he sits.

Some of Dinh's most captivating works are those in which a series of figures seemingly evolve from separate sheets of paper. In his series of *Dancers* and *Dreamers*, each of the elements is slightly more folded than the previous one, giving the viewer a sense of his artistic process as he gradually dampens and models the watercolor paper to give the figures three-dimensional form. In *I Want to Fly* (2005), which he created for the landmark origami exhibition *Masters of Origami* at the Hangar-7 Gallery in Salzburg, Austria, in 2005, his figures not only evolve from the paper sheet. They grow wings and take flight as angels. In the wittiest of these series, *Fly* (2010), Dinh depicts a legendary Japanese wizard-like character, Abe no Seimei, who folds a paper bird and then uses his magical powers to transform it into a real bird, which then flies away. Japan's most celebrated artist, Katsushika Hokusai (1760–1849),

captured the scene in one of his popular *Manga* painting manuals, in which he depicted sheets of folded paper transforming magically into egrets. It was this image that inspired Dinh to create the whole scene as an origami sculpture. In Dinh's masterpiece of origami engineering, the squares of paper are connected at the corners and are hung from the ceiling. As the work moves with the air, the bird genuinely seems to take flight.

Among his human figures, legendary Buddhist characters are well represented. Perhaps the most iconic of Dinh's images is his *Buddha* (2010), folded from cream-colored watercolor paper in the form of the head of the Buddha, recognizable by his *ushnisha*, or cranial protuberance, and his elongated earlobes, but created without any facial details. This powerful, faceless image reminds us of the Zen Buddhist rejection of icons in favor of focusing on the actual teachings of the Buddha. Dinh left the head faceless in the hope that everyone will see their own face in empty surface and see the Buddha in themselves. "We must always remind

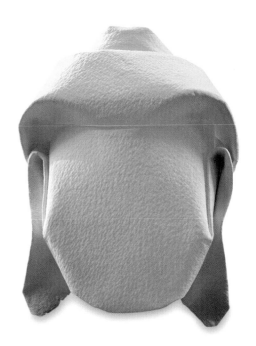

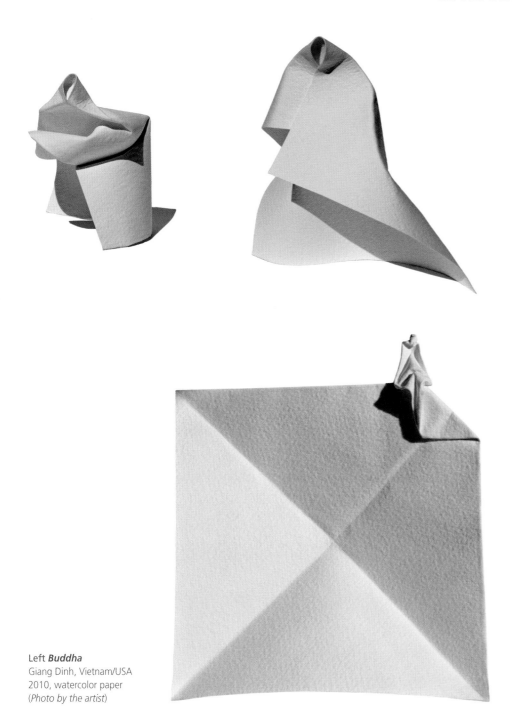

Bear
Giang Dinh, Vietnam/USA
2012, bronze
(*Photo by the artist*)

Left *Buddha*
Giang Dinh, Vietnam/USA
2010, watercolor paper
(*Photo by the artist*)

Solitude
Giang Dinh, Vietnam/USA
2014, watercolor paper
(*Photo by the artist*)

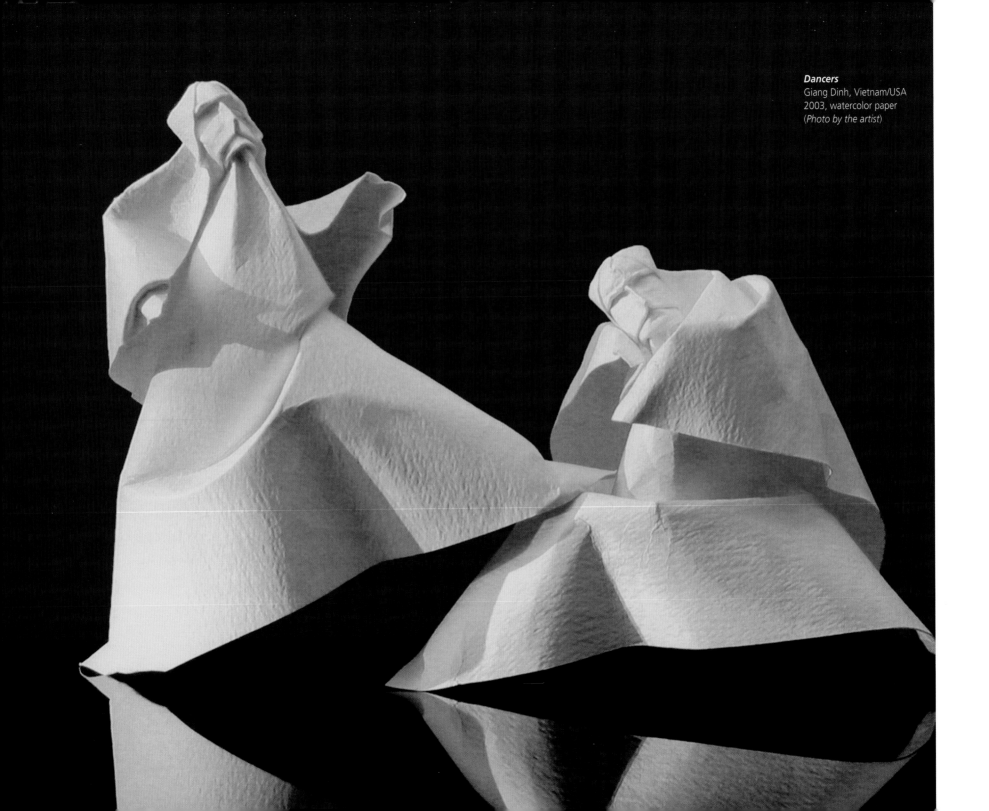

Dancers
Giang Dinh, Vietnam/USA
2003, watercolor paper
(*Photo by the artist*)

Mother and Child
Giang Dinh, Vietnam/USA
2005, watercolor paper
(*Photo by the artist*)

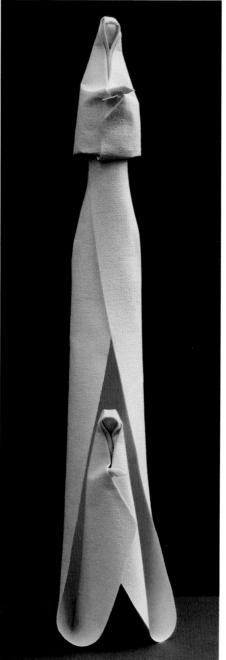

Bodhidharma (detail)
Giang Dinh, Vietnam/USA
2004, watercolor paper
(*Photo by the artist*)

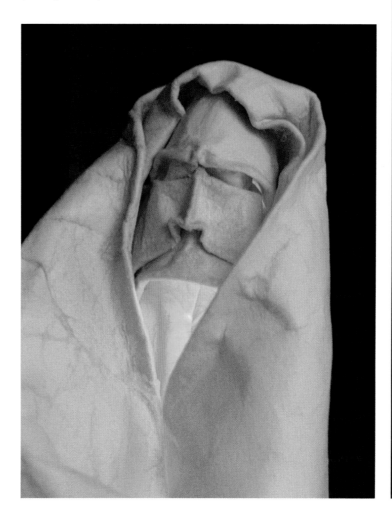

ourselves," he explains, "of the good nature and innocence that we were born with." His figure of *Bodhidharma* (2004), the patriarch of meditational Zen Buddhism, is almost as mysterious, a tall form that is mostly hood, with a rugged face peering out from a single opening. Through precise folding, Dinh succeeds in conveying the sullen expression—complete with bulging eyes—that is often portrayed in Zen paintings of this legendary teacher.

In another Buddhist figure, *Bukan and Tiger* (2007), Dinh depicts the Chinese Chan/Zen Master Feng Gan seated on a mat accompanied by his pet tiger. Executed with a few simple folds in humble brown paper, the sculpture possesses the tenderness and humor that is typical of Zen portraiture in other media, including the ink paintings on which this piece was modeled. The sensitivity of his delicate folding here exemplifies Dinh's brilliance as an origami artist and his deep affinity for the spiritual nature of the subject he is depicting. "I do read about Buddhism and Zen, and feel very close to Buddhism's principal teaching," explains Dinh. "I can imagine myself to be a Buddhist monk."

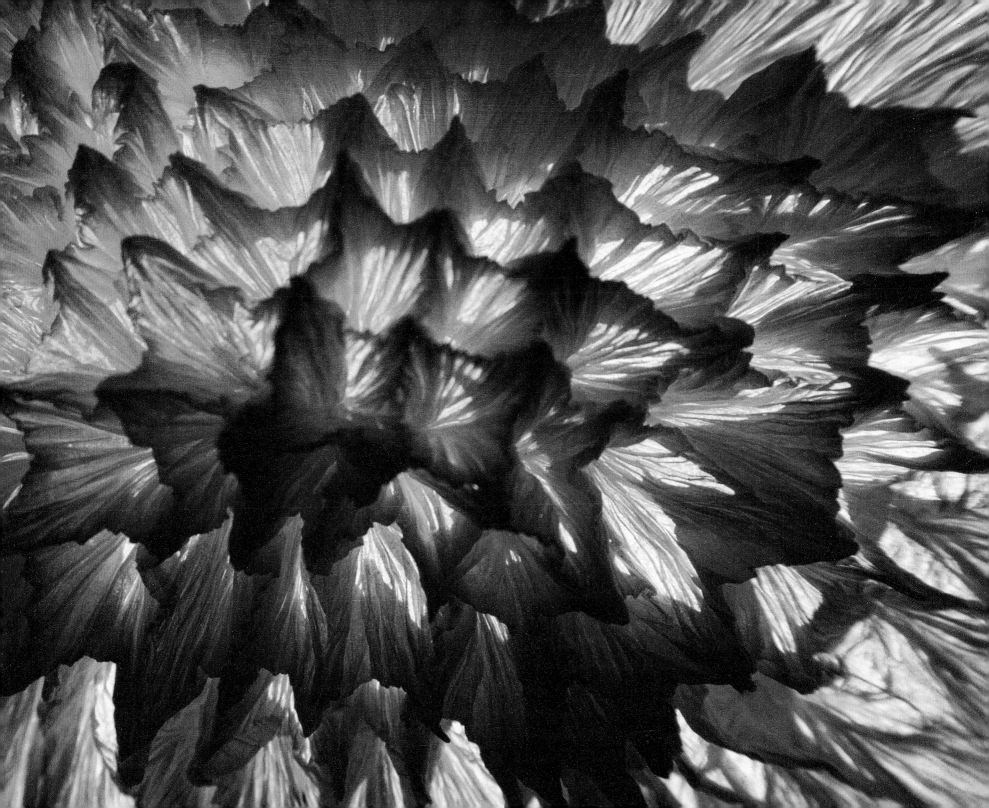

from mushrooms to magical worlds

THE CREATIVE CRUMPLING OF VINCENT FLODERER

It all began with a mushroom for Vincent Floderer (b.1961). In 1996, the French artist attended a workshop led by English folder Paul Jackson (see page 56) on paper crumpling techniques. Jackson's striking works of abstract paper sculpture were unlike anything else being created in the origami world. They profoundly inspired the French artist, who decided to use the techniques he had learned from Jackson to create representational sculptures of organic forms. At the time, Floderer was fascinated by mushrooms, toadstools and other fungi, so he experimented with these elegant organisms. By using thin paper, dampening and stretching it and adding surface coatings, he succeeded in modeling paper mushrooms that are barely distinguishable from the real thing. Since then, his exquisite and often spectacular crumpled sculptures and installations have been exhibited widely and have gained international acclaim. His work has also spawned the French organization Le Crimp, a growing group of artists and scientists who are exploring the possibilities of creasing, crumpling and crushing paper.

Part of Floderer's success as a "crumpler" can be credited to his solid foundation as a fine artist and his deep understanding of plasticity and form. He studied at one of the world's most prestigious art colleges, L'Ecole Nationale Supérieure des Beaux-Arts in Paris, where he took workshops in drawing, modeling, morphology, statuary molding, perspective and architectural elements. Having learned how to model realistic sculptures from stone, clay and other materials, he was able to apply his knowledge to the two-dimensional medium of paper. By studying paper folding more deeply and experimenting with different types of paper, he has gradually developed a whole new vocabulary of folding and crumpling techniques that allow him to achieve realism in his work. Because of the perceived irregularity of the crumpled fold, some origami purists have not accepted Floderer's crumpling as true origami. However, many of his

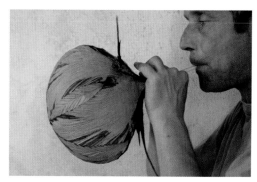

Photo by Vincent Briè

Opposite *Boom!* **(detail)**
Vincent Floderer, France
2000, Wenzhou calligraphy paper, watercolor
(Photo by Romain Chevrier)

Above *Big Blue*
Vincent Floderer, France
2005, Japanese Tengujoshi paper
(Photo by Romain Chevrier)

seemingly unteachable forms, including the mush-rooms, have very precise crease patterns and folding instructions. He has also taught crumpling workshops and classes, proving to the purists that his work is indeed a type of origami.

Over the years, many of his sculptures have been of fungi, plants and sea creatures. To create these highly textured natural forms, Floderer uses thin sheets of paper, such as tissue paper and even paper napkins, and at times applies beeswax and other substances to enhance their color and texture. The range of techniques, tones and textures he has developed have allowed him to create a whole repertoire of mushroom sculptures, from the delicate group *Clitocybe* (2007), folded very precisely out of tissue paper, to clusters of sulfur tufts and larger, thick-stemmed oysters. As well as mushrooms, Floderer has also succeeded in using crumpling to model a highly realistic tree, a form that has gained him considerable respect in the origami community, in part because it pays homage to the origins of paper in a manner that is not merely clever, but also spiritual: tree begets paper, then paper begets tree.

Some of Floderer's most exquisite sculptures are the multilayered sea creatures, such as corals, sponges, sea urchins and jellyfish. For these, Floderer uses single sheets of paper, crumpling them to build up a naturalistic volume and texture. His corals are striking examples of his skill in blending origami technique and pure artistry. He first crumples the model using a complex tessellation pattern that produces multiple points. He then colors it with watercolor or pigmented inks using a technique resembling tie-dyeing to produce works that possess the delicacy and translucence of the genuine organism. For his trees, branched corals and sea urchins, he uses a thin Japanese paper called Tengujo (5 gr/m2), but for many of his other natural forms he uses papers made of mulberry fibers or Korean, Indian and Thai papers that resemble Japanese handmade

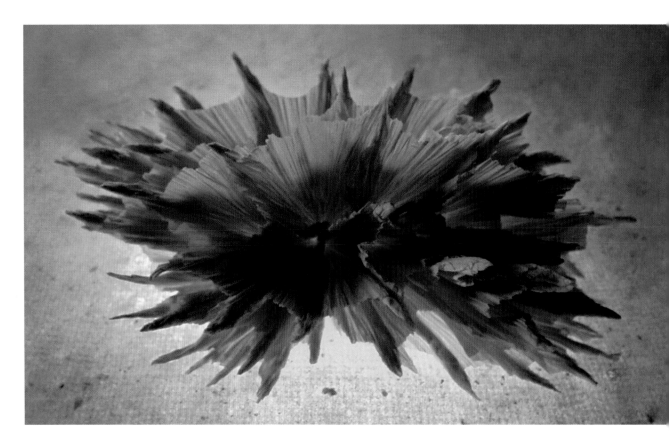

washi. Although his sculptures appear to have the delicacy of the actual creatures he is mimicking, they have proven resilient; only a few have been damaged after repeated manipulations or long-term exhibition.

Although realism is an important aspect of Floderer's work, mystery and fantasy also play a role in many of his larger sculptures and his installation work. Using similar folding patterns to those of the spiky coral, he turns the layers of paper inside out to produce spectacular abstract creations that evoke the stalactites of a limestone cave or rugged fantasy landscapes. One abstract work entitled *Boom!* (2000) is folded out of Wenzhou calligraphy paper, a thin but strong, rough and absorbent Chinese paper made from mulberry

bark, and colored with watercolor and Indian ink to evoke an organic explosion, perhaps even the Big Bang that created our universe.

Recently, in his installation work, Floderer has created life-size landscapes that are inhabited by mysterious looking creatures. In *Unidentified Flying Origami (UFO)* (2004), he has folded an eerie world inhabited by large, inflated crumpled paper models of micro-organisms that float and rotate via air flow. Although there are several forms in origami, such as the traditional frog that are inflated, Floderer is probably the first origami artist to explore the potential of inflatable origami in his art. As viewers walk through this mysterious space surrounded by unfamiliar floating creatures, they too are temporarily

Left **Coral**
Vincent Floderer, France
2005, Bolloré paper 12 gr/m2
(*Photo by the artist*)

Three Trees
Vincent Floderer, France
2001, Alios paper 25 gr/m2
(*Photo by Romain Chevrier*)

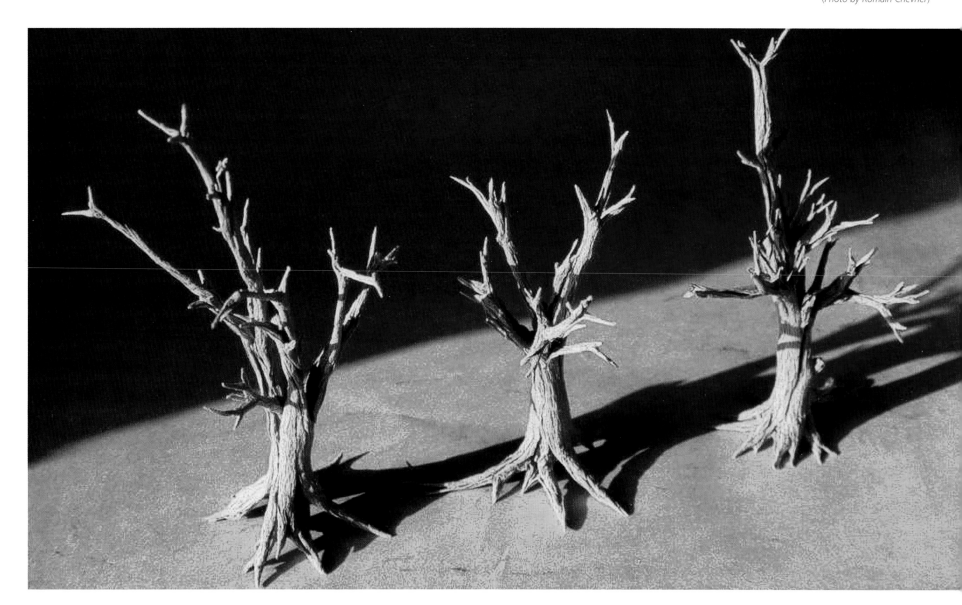

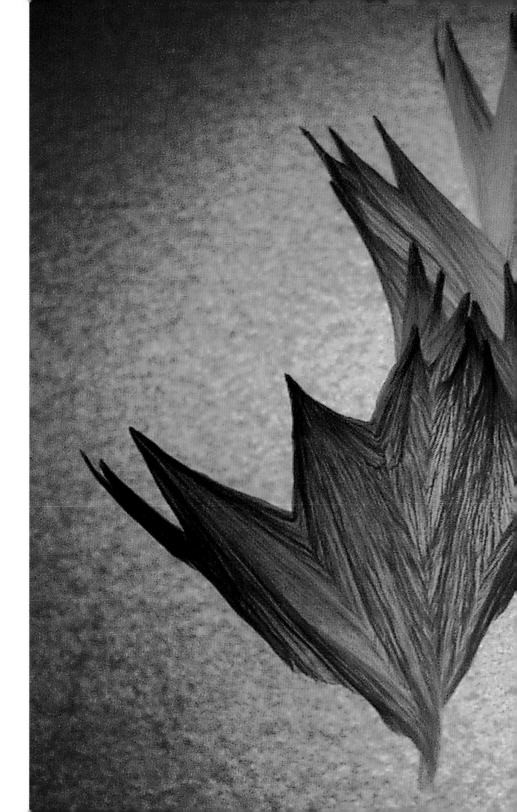

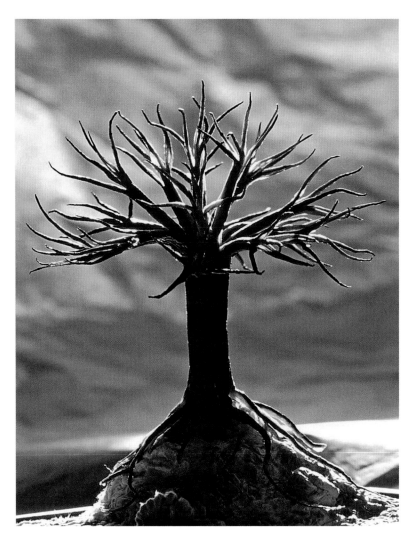

Blue Coral
Vincent Floderer, France
2005, Japanese Tengujo paper 6 gr/m2
(*Photo by Romain Chevrier*)

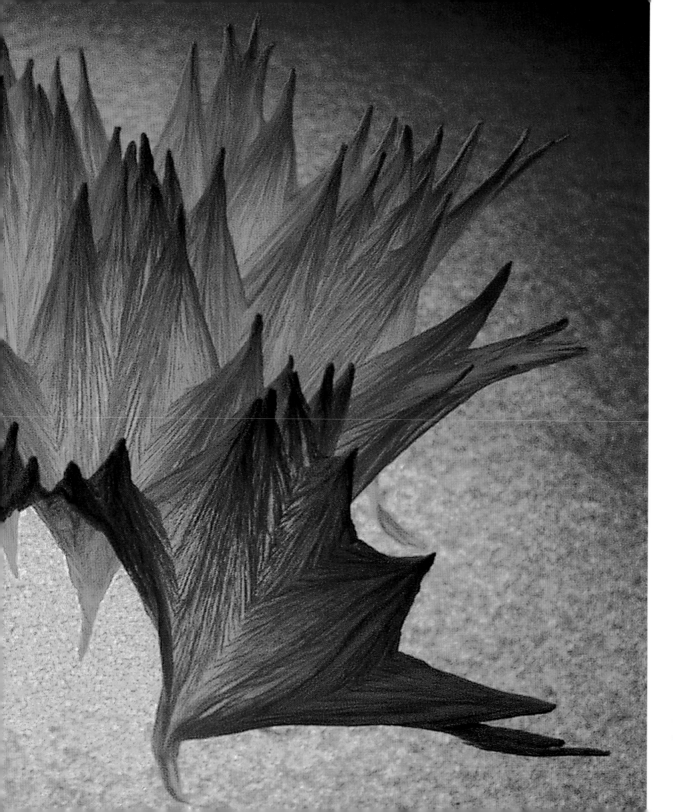

Branch 89b
Vincent Floderer, France
2007, Bolloré paper
(*Photo by the artist*)

part of this microscopic world, a perspective that invites them to consider their own place and relevance in a much larger universe.

In such installation works, in which his crumpled forms are suspended enticingly close to the viewer, the temptation to touch is strong. Floderer is aware that perhaps more so than in any other type of origami, his crumpled works invite movement and touch. So for many years he has been a rare creature in the origami world—an origami performance artist, giving performances that combine teaching, theater and comedy. In these, he teaches his students/participants (occasionally other origami artists) to crumple paper into various forms, a process that also involves dampening and stretching out the paper. These performances have also allowed him to inflate his own models, stretch them out and then recrumple them to their original form, not only to show audiences their ability to move and transform but also to demonstrate the concept that just like living creatures paper also has memory.

Vincent Floderer is considered by many other origami artists to be one of the great innovators in the realm of paper folding. With his background in fine art and his deep understanding of the relationship between materials and form, he has played a large role in elevating origami to a truly sculptural art form, in which a recognizable form is produced by the building up of folds rather than the cutting away with a chisel. With his unique aesthetic sensibility, boundless creativity and sense of whimsy, he has inspired many other artists both in the origami community and beyond to pick up some sheets of paper and explore creative crumpling.

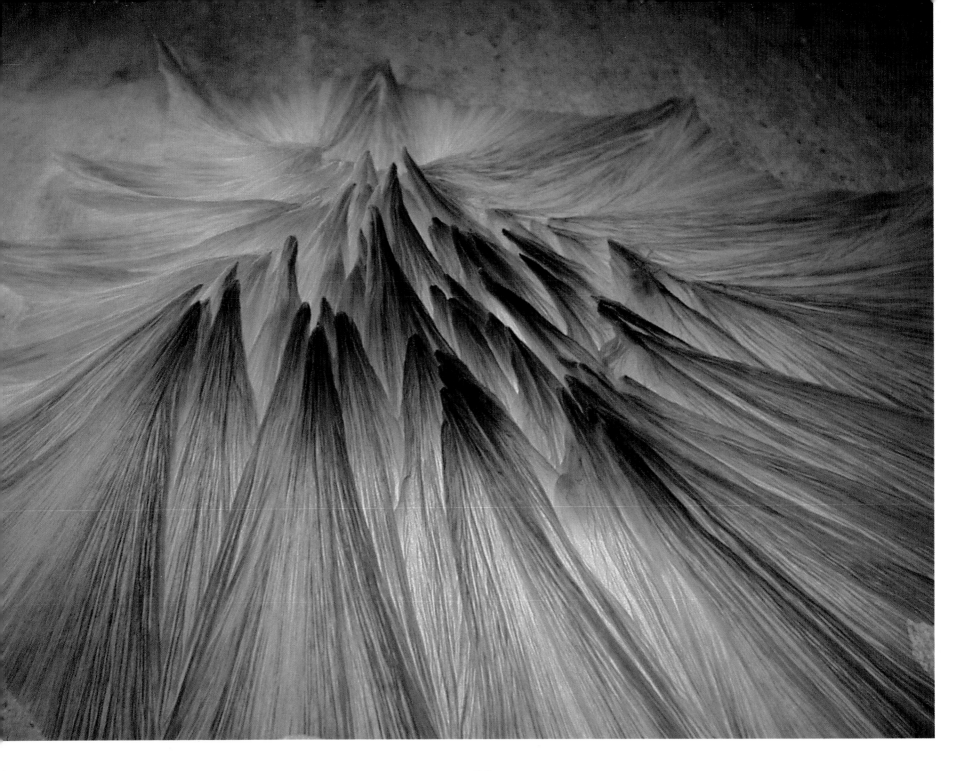

Above _Clitocibe_ (in glass)
Vincent Floderer, France
2007, tissue paper 17 gr/m2, colored ink, beeswax
(_Photo by the artist_)

**Left _Unidentified Flying Origami (UFO)_
Installation**
Vincent Floderer, France
2004, folded with the Le Crimp team, brown
wrapping papers 25–45 gr/m2, cassel extract,
shellac
(_Photo by Jean-Pierre Bonnebouche_)

Left _Volcano_
Vincent Floderer, France
2005, Bolloré paper 12 gr/m2
(_Photo by the artist_)

graceful geometry

IN THE ORIGAMI SCULPTURE OF TOMOKO FUSE

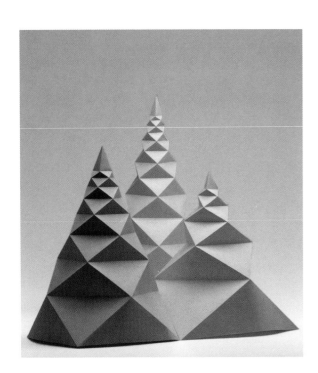

Tomoko Fuse (b.1951) occupies a unique position in Japan's origami community. Since the mid-twentieth century when origami started to become a worldwide phenomenon, the origami community in Japan (and elsewhere) has been dominated by male designers, folders and writers. Despite this gender imbalance, for over thirty years Fuse has quietly and modestly gained considerable respect in Japan and throughout the world as a designer of a multitude of modular creations, including boxes and containers, *kusudama*, paper toys, masks, and polyhedra and other geometric objects. She is also one of the most prolific origami authors in the world, having published some 100 instructional origami books, many of which have been translated into English, Chinese, French, German, Italian and Korean. As an origami artist, Fuse's designs have also evolved over the past couple of decades, from ornate boxes, toys and modular forms into sophisticated works of two- and three-dimensional sculptures that have been displayed in museum exhibitions and at art galleries around the world. Apparent in her recent sculptures, tessellations and installation work is not only her mastery of an array of complex folding techniques but also a uniquely gentle approach to geometry.

Fuse was born in Niigata in northern Japan and now lives with her husband Taro Toriumi, a respected woodblock print maker and etcher, in a hillside village in rural Nagano Prefecture, Japan. Fuse first learned origami while in hospital as a child, and her first model was a nurse's hat. When she was nineteen years old, she studied for two and a half years with Toyoaki Kawai, a modern origami master who published many origami design books from the 1960s through the 1980s. Several years later, in 1981, Fuse published the first of her own origami instruction books, many of which focus on modular origami, a type of origami in which multiple modules are folded separately and assembled to create more complex, often geometric, forms. In the 1990s,

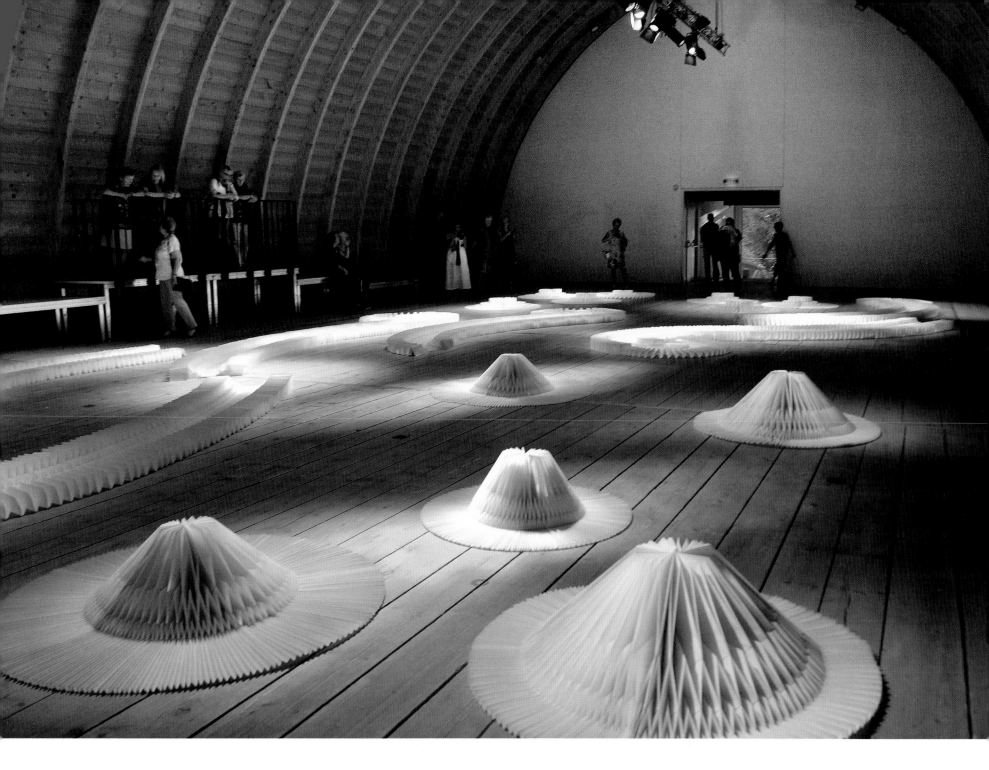

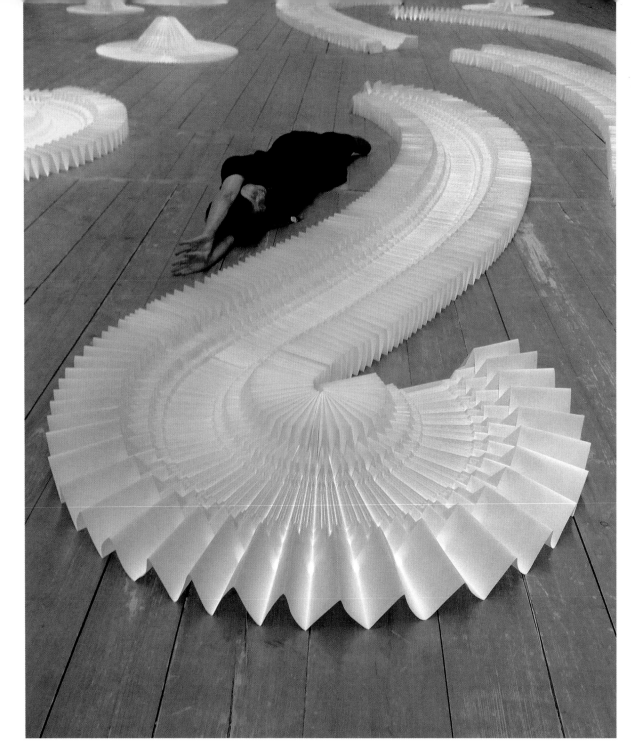

Infinity Folds **Installation (detail) with the artist**
Tomoko Fuse, Japan
2015, *shoji* paper, Schafhof Gallery, Friesing, Germany
(*Photo by Patsy Wang-Iveson*)

Fuse became particularly well known for her origami *kusudama*—decorative balls that are made by connecting separate, usually flower-shaped, units. She has also designed and published many books on origami boxes as well as origami wreaths, rings and quilts, all of which are made by assembling origami modules into elaborate geometric patterns.

In recent years, although she is still writing and publishing prolifically, Fuse has focused increasing attention on her artistic creations, and for over a decade now she has been showing her work in exhibitions in Europe and the United States. In 2004, on the invitation of fellow origami artists Paulo Mulatinho and Silke Shröder, Fuse was invited to Germany to present a solo exhibition of her work at the Bauhaus design school in Dessau. Here, she presented sculptural works, including shell forms, spirals and a number of her tessellation designs. Fuse's spirals have been admired all around the world since the 1990s, when she first published her spiral designs. One of her most famous designs is *Navel Shell*, a spiraling nautilus shell created from a long triangle of paper that is folded in a rotational pattern to create an elegant low-relief sculpture. A slight variation is her work *Ammonite*, which features a more complex spiral pattern at its center. Over the years, she has evolved her shell forms into more three-dimensional works, some crossing over into the realm of abstraction.

One of the most intriguing forms that Fuse included in the Dessau exhibition and has featured in a number of exhibitions since then is a faceted cone that tapers

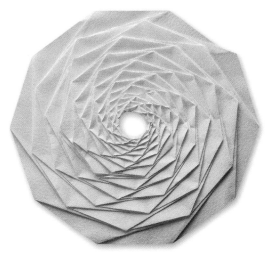

Top _Whirlpool Spiral_ Tomoko Fuse, Japan
Designed 2001, this model folded 2012, Takeo OK Golden River
paper (*Photo by Herbert Bungartz, Freising. Published in SPIRAL:
ORIGAMI | ART | DESIGN by Tomoko Fuse, Viereck Verlag*)

Above _Whirlpool Spiral_ Tomoko Fuse, Japan
Designed 2001, this model folded 2012, Takeo OK Golden River
paper (*Photo by Herbert Bungartz, Freising. Published in SPIRAL:
ORIGAMI | ART | DESIGN by Tomoko Fuse, Viereck Verlag*)

Right _Whirlpool Spiral_ (inside view) Tomoko Fuse, Japan,
Designed 2001, this model folded 2012, Takeo OK Golden River
paper (*Photo by Herbert Bungartz, Freising. Published in SPIRAL:
ORIGAMI | ART | DESIGN by Tomoko Fuse, Viereck Verlag*)

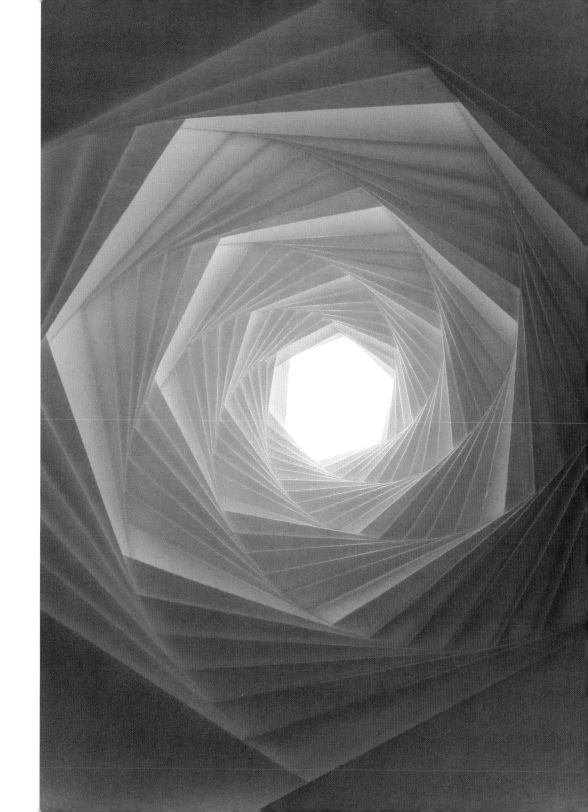

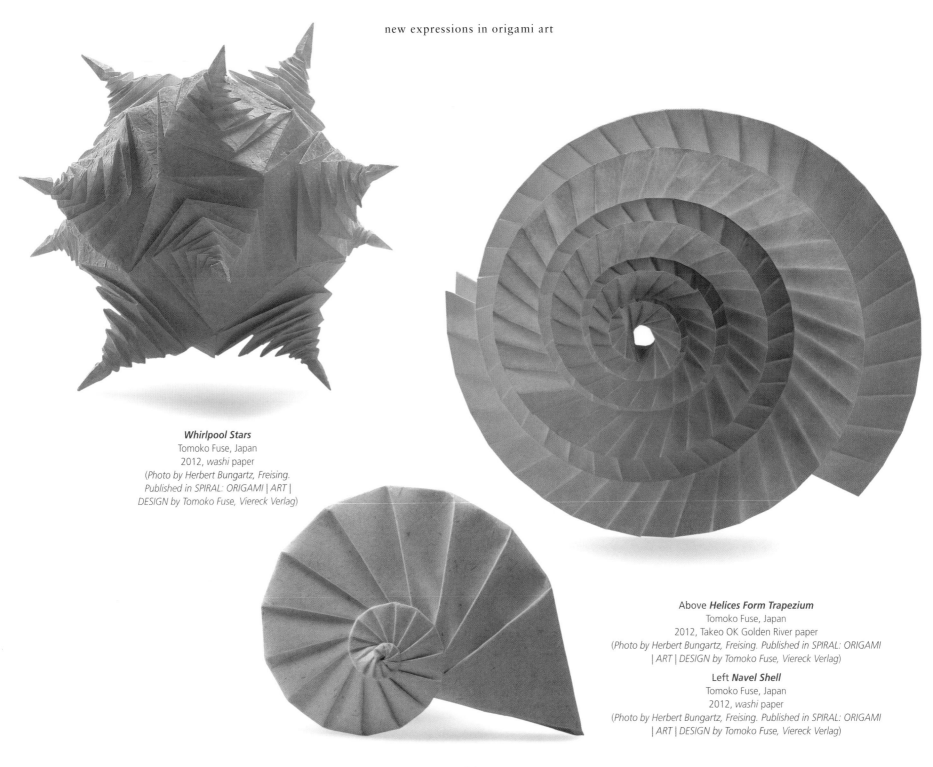

Whirlpool Stars
Tomoko Fuse, Japan
2012, *washi* paper
(*Photo by Herbert Bungartz, Freising.*
Published in SPIRAL: ORIGAMI | ART |
DESIGN by Tomoko Fuse, Viereck Verlag)

Above Helices Form Trapezium
Tomoko Fuse, Japan
2012, Takeo OK Golden River paper
(*Photo by Herbert Bungartz, Freising. Published in SPIRAL: ORIGAMI*
| ART | DESIGN by Tomoko Fuse, Viereck Verlag)

Left Navel Shell
Tomoko Fuse, Japan
2012, *washi* paper
(*Photo by Herbert Bungartz, Freising. Published in SPIRAL: ORIGAMI*
| ART | DESIGN by Tomoko Fuse, Viereck Verlag)

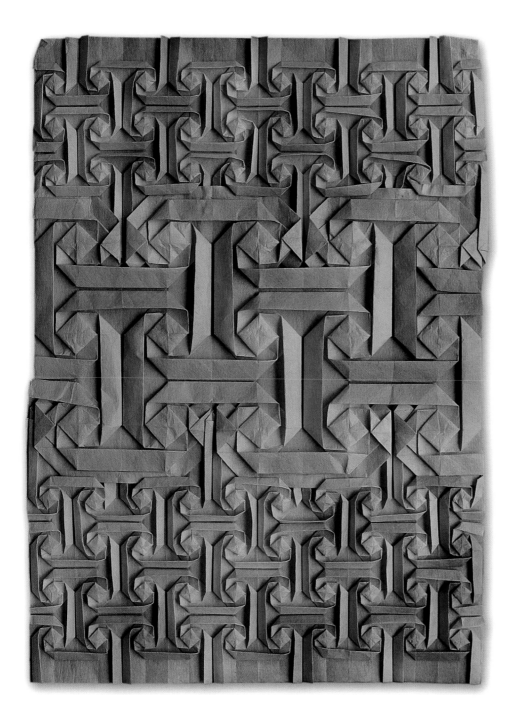

Whirlpool Tessellation
Tomoko Fuse, Japan
2007, *washi* paper
(*Photo by the artist*)

upward like a geometric stalagmite reaching to the ceiling of the gallery. Folded in a range of heights in white, gray and shades of brown paper, these elegant *Spiral Towers* (from 1992) are grouped together and evoke a fantasy mountain range or majestic structures hewn from ice. In a variation of these single cones, Fuse folded single sheets of paper into more complex structures comprising four cones rising up from a single base and reaching outward in four directions, in a dynamic flight of fancy that balances geometry and grace. She named the works *Biribiri* (2012), after the Japanese onomatopaic word for an electrical discharge. As with her shell forms, the spiraling motion of the geometric surface patterning of these conical works suggests a mysterious and powerful internal energy that is pushing the structures upward and outward. They appear both mathematical and magical.

Spiraling motion is also apparent in Fuse's tessellation work, which she has recently been exploring in a range of scales, from small low-relief works to larger three-dimensional installations. In a tessellation, a pattern fills a plane with no overlaps or gaps, like decorative wall tiles. Origami tessellations are often created using pleats to connect together elements such as twist folds in a repeating fashion, often giving the appearance of woven paper. Fuse had been folding tessellations since she was young, but only started incorporating them into her art work around 2000. Since then she has created many exquisitely colored and textured works, such as

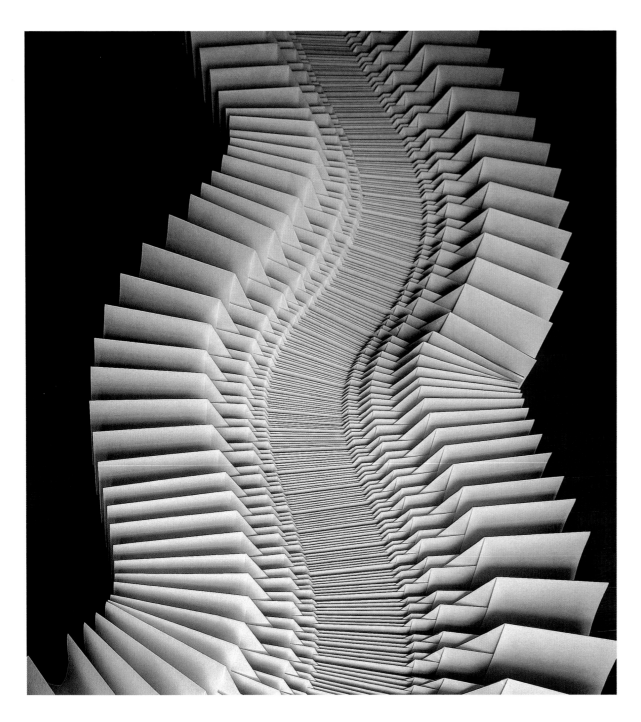

Infinity Folds Installation (detail)
Tomoko Fuse, Japan
2015, *shoji* paper, Schafhof
Gallery, Friesing, Germany
(*Photo by Taro Toriumi*)

Whirlpool Pattern 00810 (2003), which has the appearance of an intricately woven textile. Typically in tessellations, the modules that are repeated across the design are pointed and angular, but many of Fuse's tessellations include curved-creased elements that create a swirling motion in the patterning. At the same time, however, by interlocking each of the curls in the design, she anchors the motion to create an overall pattern that is energized but also stable and balanced. For many of these dynamic designs, she employs exquisitely hand-colored papers with tonal gradations that evoke a gentle sunset or the new greens of spring. These tones add a softness and depth to these elaborately patterned works.

In 2015, Tomoko Fuse created her largest work to date for a tandem exhibition entitled *Raumfalten* (*Space Folding*) with fellow origami artist Heinz Strobl in Freising in the Bavaria region of Germany. Required to fill a huge hangar-sized space at the Schafhof Gallery, Fuse used rolls 98 ft (30 m) long by 3 ft (1 m) high of Japanese *shoji* paper, the paper traditionally used to line Japanese wooden sliding doors. She rolled sections of the paper into an arrangement of cones interspersed with swirling pleated strands, evoking an origami landscape of mountains and rivers. Her characteristic spiral motion of the mountains and rivers invites visitors to meander through the landscape to enjoy the intricate details of each fold. About this installation, which she entitled *Infinity Folding*, Fuse reveals, "Origami is not about creating, but discovering. In

Right ***Spiral Towers***
Tomoko Fuse, Japan
2012, Takeo Mermaid Ripple paper,
various other papers
(*Photo by Herbert Bungartz, Freising.
Published in SPIRAL: ORIGAMI | ART |
DESIGN by Tomoko Fuse, Viereck Verlag*)

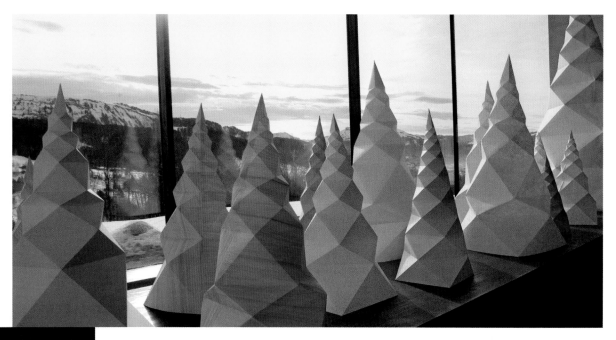

this exhibition, I discovered infinite origami in just one cell. Origami shows me a beautiful world." Using her detailed knowledge of geometry, her instinctive understanding of paper and her gentle artistry, Fuse has chosen to share her beautiful world not just as a teacher in her many valuable instructional books, but in her elegant geometric sculptures that are increasingly gracing the world's galleries and museums.

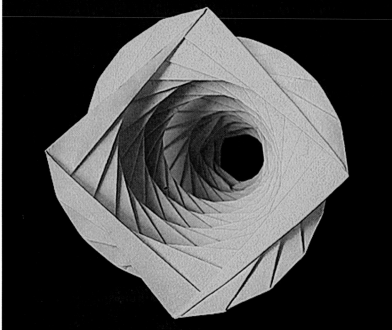

Left ***Whirlpool Spirals***
Tomoko Fuse, Japan
Designed 2001, this model folded 2012, Takeo OK Golden River paper
(*Photo by Herbert Bungartz, Freising. Published in SPIRAL: ORIGAMI | ART | DESIGN by Tomoko Fuse, Viereck Verlag*)

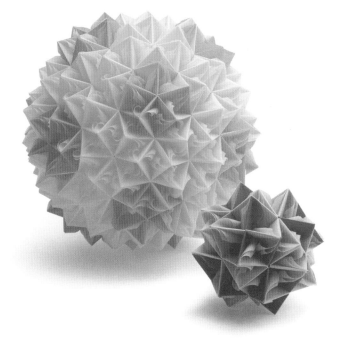

Right ***Two Kusudama***
Tomoko Fuse, Japan
2010, tracing paper
(*Photo by Shinichi Matsuoka in Unit Origami Fantasy by Tomoko Fuse*)

47

Holy Scroll
Miri Golan, Israel
2014, vellum, silicone paper, wood
(*Photo by Kobi Sharabi*)

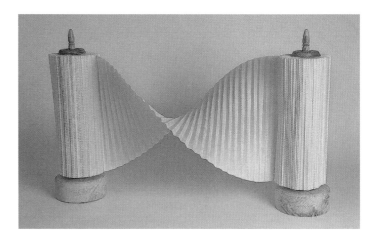

origami art meets activism

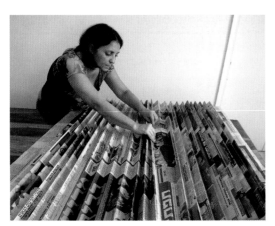

Photo by Paul Jackson

Opposite *Paper Wall* (detai)
Miri Golan, Israel
2013, Hebrew and Arabic
language newspapers
(*Photo by Leonid Padrul-
Kwitkowski, Eretz Israel Museum*)

In Israeli artist Miri Golan's (b.1964) work *Two Books*, small origami figures of people emerge from the pages of two hardcover books. The little white figures are structurally connected to their respective volumes but they appear to be moving out from between the covers, reaching out to each other and mingling peacefully. The two books here are the most sacred books of Judaism and Islam, the Torah and the Koran. Golan's conceptual origami work is inspired by the tendency of people in the Middle East to define themselves and others by their beliefs, the root of many of the region's problems. She created *Two Books* with the hope that people with different belief systems in this region can come together, "still tied to their own 'book', but free to move and mix."

With no end in sight to the enduring conflict in the Middle East, Miri Golan is one of a number of artist-activists in the Middle East who passionately believes that where politicians have failed, artists might be able to succeed in spreading mutual respect, tolerance and

ultimately peace. The medium for her activism is origami, an art form with little connection to her own culture but one to which she has felt drawn since childhood. As a young girl, Golan saw a Japanese woman on television folding an origami crane. She did not know this was origami, seeing it simply as "playing with paper." This sparked her interest in the art, and she began learning how to fold other forms out of paper. At school, to help her concentrate better in class, she obtained special permission to "make folding" during lessons. In her twenties, she traveled to Japan where she learned more about origami. After returning to Israel, she established the Israeli Origami Center, in 1993, and began teaching the art in schools.

For over twenty years now, Golan has trained and placed origami teachers in many of Israel's Jewish, Muslim and Christian schools. The Center now works closely with the Israeli education system to integrate origami into the teaching of geometry so that teachers

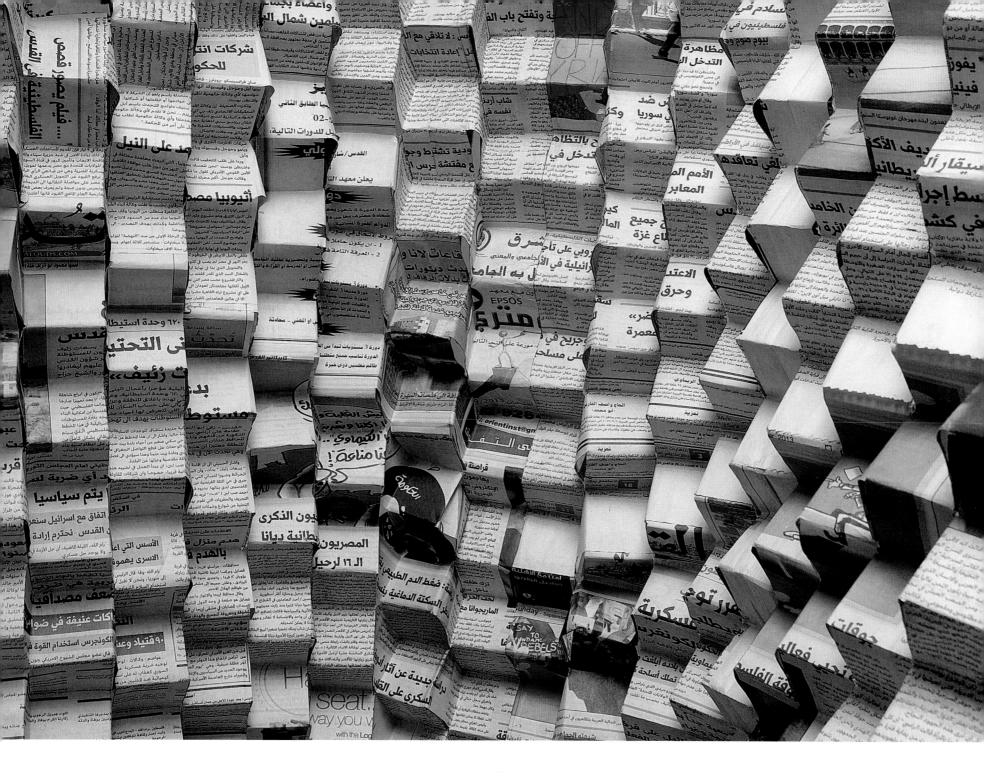

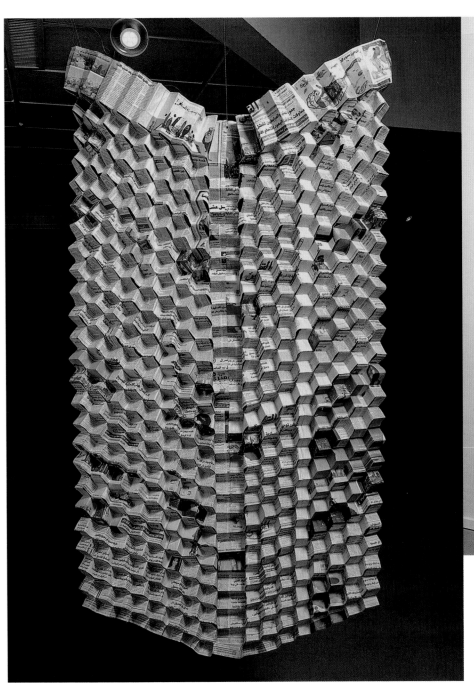

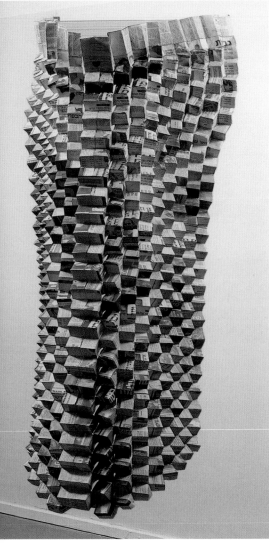

Paper Wall
Miri Golan, Israel
2013, Hebrew and Arabic
language newspapers
(*Photo by Leonid Padrul-
Kwitkowski, Eretz Israel Museum*)

Right **Fold, Don't Read!**
Miri Golan, Israel
2010, Arab and Hebrew
newspapers, thread, metal, wood
(*Photo by Simon Fong, courtesy of
International Arts & Artists*)

Far right **Fold, Don't Read!**
(detail)
Miri Golan, Israel
2010, Arab and Hebrew
newspapers, thread, metal, wood
(*Photo by Simon Fong, courtesy of
International Arts & Artists*)

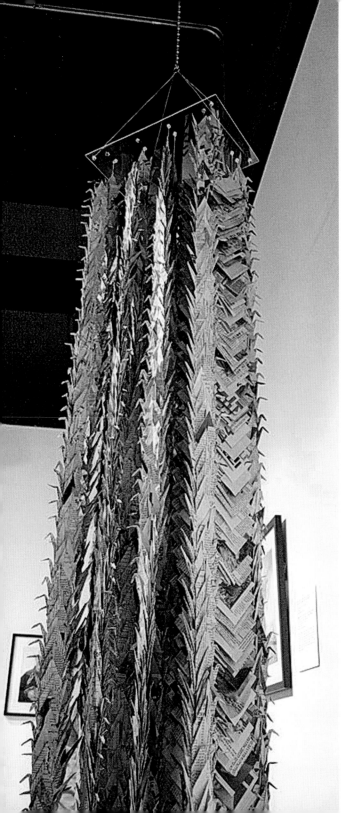

can help children to visualize abstract concepts by folding paper. However, Golan believes that origami can be used for more than illustrating mathematical and geometric concepts.

In the early 2000s, Golan also founded Folding Together (www.foldingtogether.org), an organization that uses origami to bring Israelis and Palestinians together in the Jerusalem area. Golan was inspired to establish this organization by memories of her own childhood in Jerusalem, where the Jewish and Palestinian communities at that time would mix freely and with equality. Now, the children of the two sides never meet, perpetuating the cycle of ignorance, mistrust and fear of the other side. "By bringing the children together in an atmosphere of fun and co-operative creativity," Golan believes, "we break this cycle and help to move the people of our region toward a more positive and mutually respectful future. Origami works as a powerful tool of reconciliation." Their students, both children and adults, learn to fold many

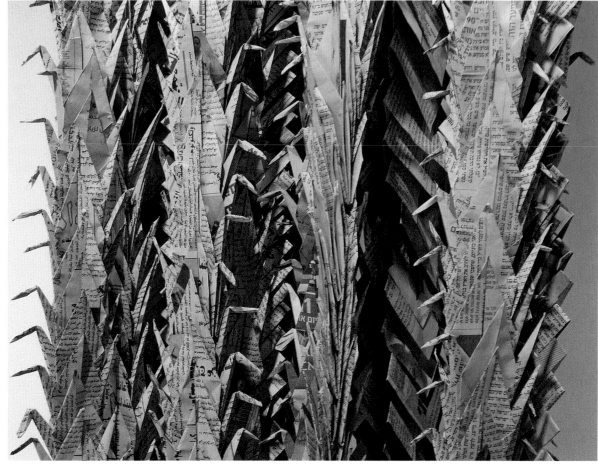

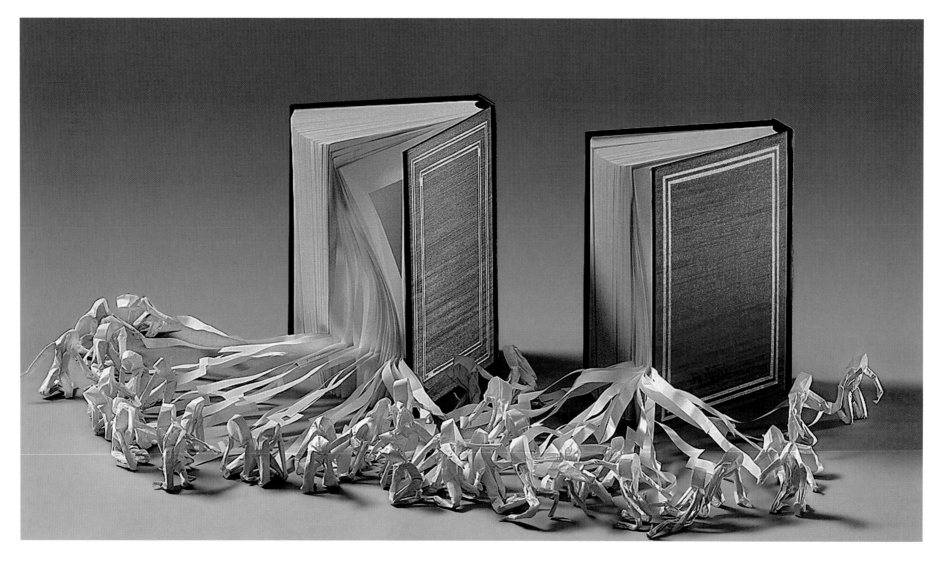

Above *Two Books*
Miri Golan, Israel
2008, paper, handmade books
(*Photo by Leonid Padrul-Kwitkowski,
Eretz Israel Museum*)

Right *Two Books* (detail)
Miri Golan, Israel
2008, paper, handmade books
(*Photo by Leonid Padrul-Kwitkowski,
Eretz Israel Museum*)

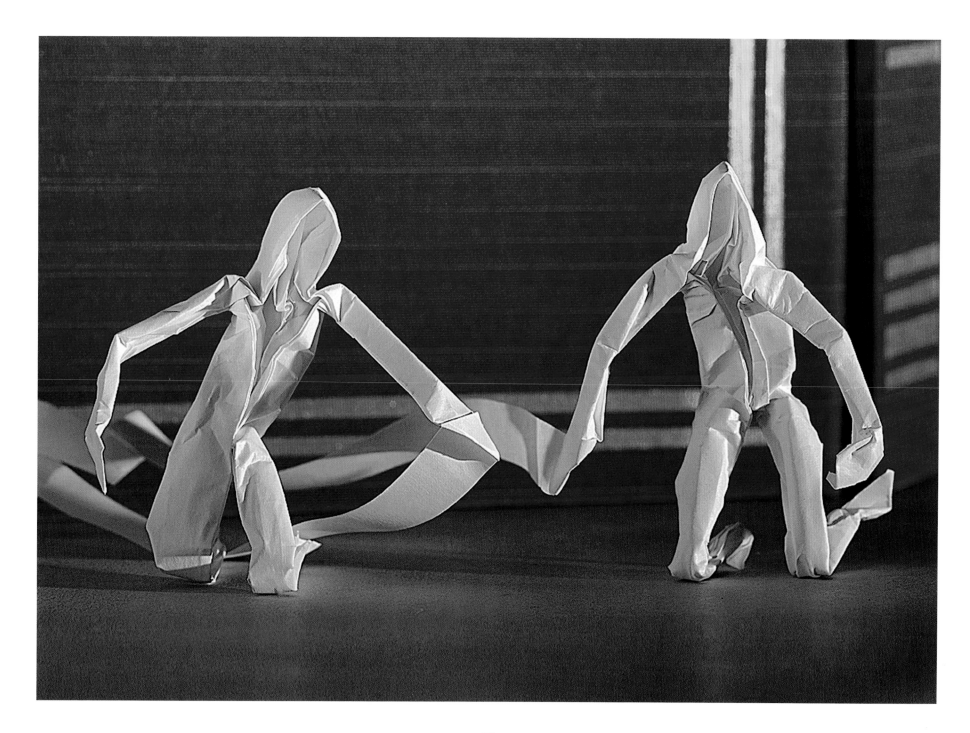

different origami forms together, but their garlands of origami cranes, worldwide symbols of peace, are among the most powerful and moving.

The lines blur somewhat between Golan's educational work with origami and her work as an artist. Her origami art works tackle the religious divides she experiences daily in her country and share the themes of hopes for peaceful co-existence, unity and reconciliation. Her 2011 garland installation *Fold, Don't Read!* is built up of hundreds of folded and half-folded origami cranes, once a Japanese symbol of long life and a happy marriage but now a worldwide symbol of peace and hope. In the decades since World War II, inspired by the 1,000 paper cranes folded by the young victim of

the Hiroshima atomic bomb, Sadako Sasaki, people all over the world have been folding garlands of colorful folded paper cranes as offerings to the victims of wars or natural disasters. Golan's garlands bear a similar message of peace and hope, but one that is geographically specific. Constructed out of squares cut from pages of Israeli and Palestinian newspapers and folded by Jewish, Christian and Muslim Children in Israel and the West Bank, the work sends a powerful message that artistic collaboration can transcend political conflicts. Suspended from the ceiling of a museum gallery, the piece, with its provocative title that encourages artistic action over reading daily news reports, suggests that perhaps the solution to war is not to be found in

propaganda-filled words, but in uniting to do something as simple as folding a paper bird.

Recently, Golan's conceptual origami sculptures have focused on the sacred books at the heart of the region's religious—and political—belief systems. And, as with *Fold, Don't Read!*, rather than emphasizing the words contained within the books, she has used the physical book itself as a symbol of education, wisdom and spirituality, a tool that can be used to help bring together people on opposing sides of conflicts. A metaphor for our distinct belief systems, her book sculptures suggest that despite religious differences, people are all fundamentally the same. In her 2014 work *The Sharing of Holy Books*, Golan reprises the

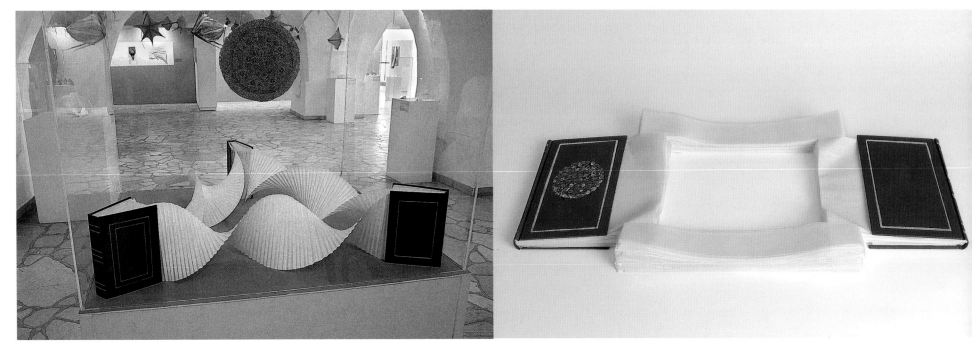

Three Holy Books Twisted Together
Miri Golan, Israel
2015, silicone paper, book board, book cloth, ink, installed at the
Jaffa Museum, Jaffa, Israel (*Photo by Meidad Suchovolski*)

The Sharing of Holy Books
Miri Golan, Israel
2014, silicone paper, book board, book cloth, ink
(*Photo by Kobi Sharabi*)

theme of her 2010 piece *Two Books*, in which figures emerge from the pages. Here, she interconnects the pages stretched out of the two sacred volumes, the Torah and the Koran, and cuts a square out of the center of the pages. According to Golan, "the cutting and folding of the pages separates the paper into two equal parts that create two holy books, separated yet connected." The perfect square cut out at the center of the layered sheets perhaps represents a removal of writings within the books that can be misconstrued to stir up conflict, a reminder that the core teachings of both books are essentially the same.

Regarding her recent works, Golan explains, "The holy text, the word of God, should neither be lengthened nor shortened. Even though the text is singular and definitive, it is open to many interpretations that roll and twist the meaning." To express this conceptually, she expresses this twisting of meaning quite literally. In *The Holy Scroll*, a length of pleated paper stretches from one dowel to the other and is twisted in the center, suggesting the ease with which the meaning of the scroll's content can be distorted. Similarly, in *The Holy Book*, the pages of the book, which here can represent the Jewish Torah, Muslim Koran or Christian Bible, are also pleated and twisted outward from the center of the book, as if to illustrate not only a distortion of the teachings in the region's most sacred texts but a drifting away from their true meaning.

In recent years, a handful of artists working with origami have been making social, cultural and political statements through their origami sculptures, installations and even murals. Only Miri Golan, however, has dedicated her career as an artist and educator to attaining a specific goal—tolerance and co-existence among the people of the Middle East. By folding sheets of pure white paper into forms that symbolize the most sacred of the region's texts, she not only challenges the distortion of religious ideas that have fueled the region's conflict but offers us a vision of the peace and beauty that can exist if the people of her region can empty their minds of religious and political indoctrination and biases and come together with honest, open hearts.

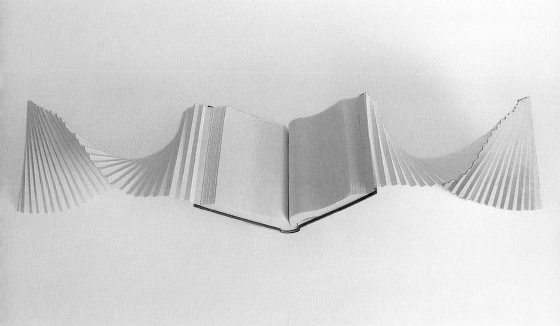

Twisted Holy Book (Quran) **(detail)**
Miri Golan, Israel
2014, paper, handmade book
(Photo by Kobi Sharabi)

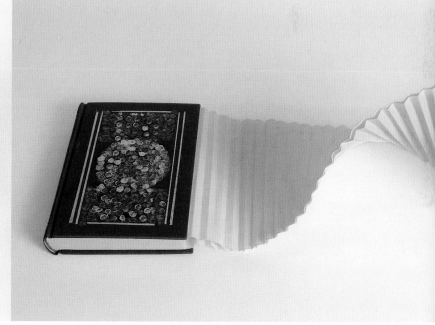

Twisted Holy Book (Quran) Closed Version **(detail)**
Miri Golan, Israel
2014, paper, handmade book
(Photo by Kobi Sharabi)

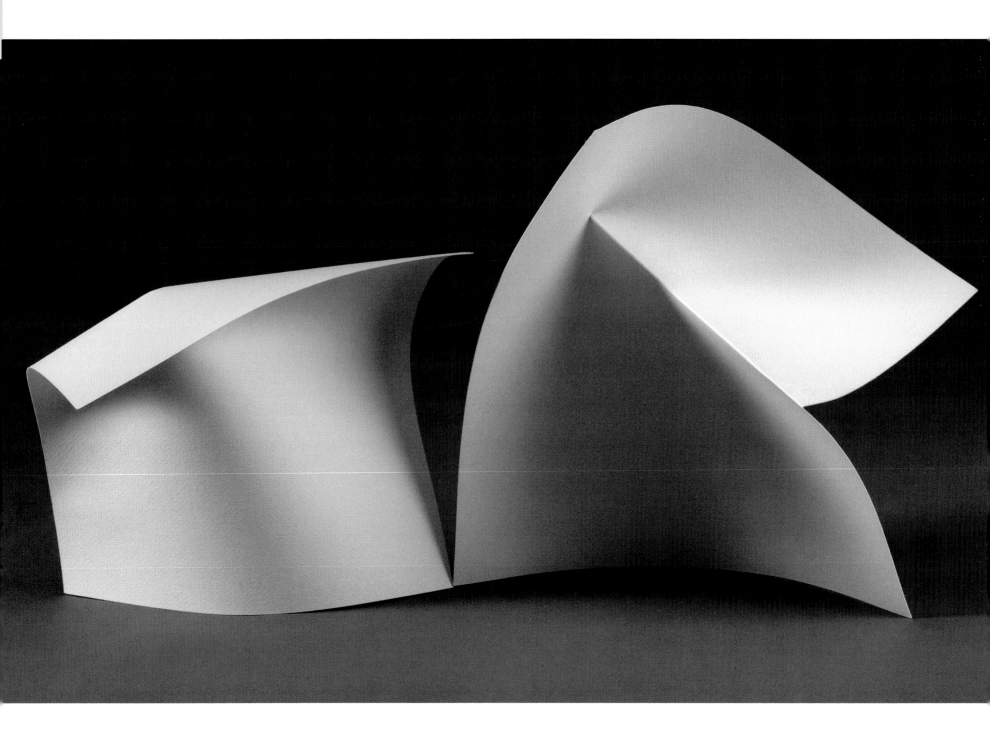

to fold or not to fold

Photo by Herbert Bungartz

For most of his life, British origami artist Paul Jackson (b.1956) has been fascinated by the many ways in which paper can be folded and the variety of forms that can be created by folding it. However, unlike many of his fellow folders, designers and artists, he has spent a considerable amount of time contemplating not only the "how" of folding a sheet of paper but also the "when" and the "why." Emerging more from right-brain than left-brain folding, Jackson's artistic process is more concerned with aesthetics than mathematics, to such an extent that perhaps his works should be referred to as "folded paper sculptures" rather than origami. Although Jackson is well versed in the mathematical aspects of origami, has written many instructional books about paper folding and sculpture, and has taught folding techniques to students of design, it is his philosophical approach to origami and his explorations of the quality rather than the quantity of the folds that sets his work apart from other paper

folding artists and has helped elevate origami into the realm of "fine art."

Paul Jackson's childhood hobby was origami. In college, he studied fine art and then went on to get an MA in Experimental Media Department at the Slade School of Fine Art at University College, London, where he specialized in creating sound sculptures, installations and performance art. While at the Slade, he joined the British Origami Society and achieved a reputation for designing simple models. Soon after graduating, he became one of the world's very few professional origami artists, making a living teaching folding techniques, writing books about paper art and eventually exhibiting his origami in the 1990s.

It was in this decade that Jackson began creating a series of richly colored and curvaceous folded sculptures evoking shells, seed heads, bacteria and other natural forms. For these "Organic Abstracts," he strayed from the path of other folders and designers, coloring

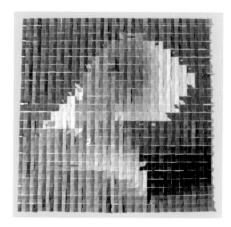

Above *Pixel (Rough)*
Paul Jackson, UK/Israel
2013, folded and cut digital print (*Original photo by Meidad Suchovolski. Photo of finished piece by the artist*)

Opposite *Duet*
Paul Jackson, UK/Israel
2010–11, watercolor paper (*Photo by Leonid Padrul-Kwitkowski, Eretz Israel Museum*)

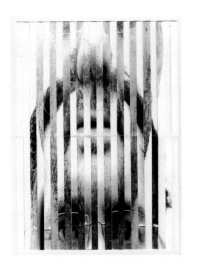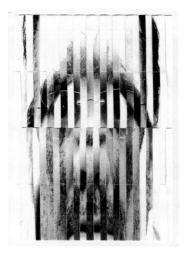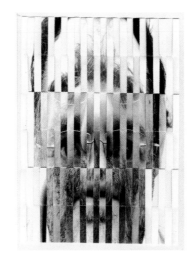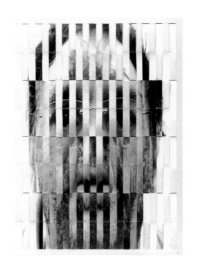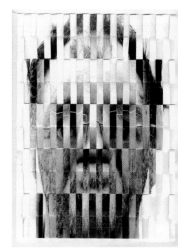

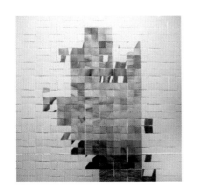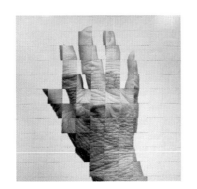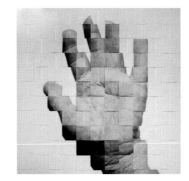

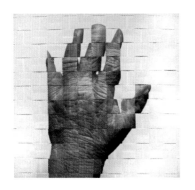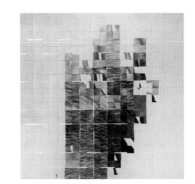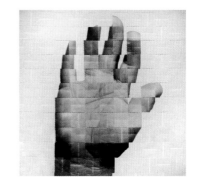

Two Hands
Paul Jackson, UK/Israel
2014, folded digital prints
(*Original photos by Meidad*
Suchovolski. Photos of
finished pieces by Christina
Johnston and Alyssa
Hockenberry)

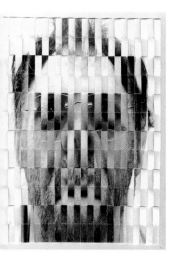
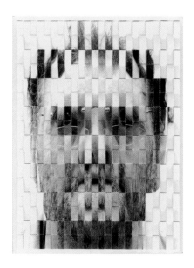

Left *Pixelated Self Portrait ("Scream")*
Paul Jackson, UK/Israel
2012, folded and cut digital prints
(*Original photos by Miri Golan. Photos of finished pieces by the artist*)

Below *Monoprint 4*
Paul Jackson, UK/Israel
2013, block ink on paper
(*Photo by the artist*)

his papers with charcoal and dry pastels before folding them. Using a pleating technique that forms "ribs" that allow the paper to curve and stretch sensuously and assume a variety of forms, he has created over 250 different abstract models in this signature series. With the early works in this series, Jackson was one of the few origami artists consciously pushing the boundaries of the art form, using paper folding as a medium to create sculptural forms that clearly transcend the designation of "craft" and belong comfortably in the realm of "fine art." It is worth noting that in the 1990s, Jackson also experimented with crumpling and realized that if paper is crumpled in controlled and precise ways, its elastic properties can produce spectacular results. He shared his crumpling techniques with French folder Vincent Floderer (see page 32), who has become renowned for his crumpled paper artworks and readily acknowledges Jackson's inspiration.

In stark contrast to his boldly colored and textured "Organic Abstracts," Jackson also experimented with a series of "One-Crease" sculptures, in which he explored the possibilities of manipulating paper with a single

fold. In the 1980s, this was a radical move for an origami artist, as the recent introduction of mathematics into origami had made possible the folding of super-complex models, and many origami artists and designers were competing to create realistic models of arthropods and reptiles made with hundreds of folds. Instead, Jackson was moving toward minimalism and abstraction. For many of his "One-Crease" works, he selected squares of watercolor paper, which he brushed with pigment and then wet folded at a single point, twisting and turning the square back and forth to unexpectedly reveal forms "hidden within the paper." Once dry, the sturdy watercolor paper retained the form, often at once dynamic and poetic. In his 2010–11 work *Duet*, folded out of two rectangles of pure white watercolor paper, he has taken his minimalism to the highest, most elegant level. With one gentle crease in each of the sheets, he shaped and positioned the papers so that the two rectangles appear to be dancing.

In recent years, although Jackson has continued with his "Organic Abstracts" and "One-Crease" sculptures, he has continued experimenting with conventional

approaches to origami, including the highly geometric "modular origami." In this style of origami, polyhedra of varying degrees of complexity are typically created by assembling separate modules that are held together using the tension created by tucking flaps of one module into the pockets of the next. For these structures, the paper must be sturdy enough to support the pressure. While Jackson has created many geometric models of note, he challenges these provocatively in his series of "Collapsed Platonics," a set of five models representing the Five Platonic Solids—the Tetrahedron (4 faces), Hexahedron or Cube (6), Octahedron (8), Dodecahedron (12) and Icosahedron (20). In Jackson's models, the modular strips lock in a conventional way at the corners of each solid but they have no strength, so each solid collapses into a cluster of limp, entangled strips. Jackson explains, "I made these 'Collapsed Platonics' as an aesthetic and philosophical alternative to the easily identifiable, strong, irrefutable symmetrical constructions typical of other origami modular designs, and of geometry in general."

For the last decade or so, Jackson has been turning his attention increasingly to two-dimensional treatments of origami. In one series of works, he creates folded paper collages with sheets of two-color paper rectangles, often black and white, laid over each other so that lines overlap and intersect to produce simple yet dramatic geometric forms that deliberately evoke the black-and-white imagery of Constructivist artists like Russian Alexander Rodchenko and Brazilian Lygia Pape. The collages possess the simplicity and abstraction of Jackson's "One-Crease" sculptures but they are somewhat enigmatic. They completely lack the three-dimensionality that is the promise of origami, yet by creating compositions that center on the folded lines, Jackson creates drama and dynamism in these minimalist works.

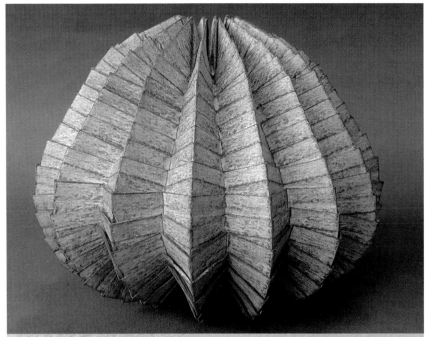

Organic Abstract (Untitled)
Paul Jackson, UK/Israel
2011, dry pastel on paper
(*Photo by the artist*)

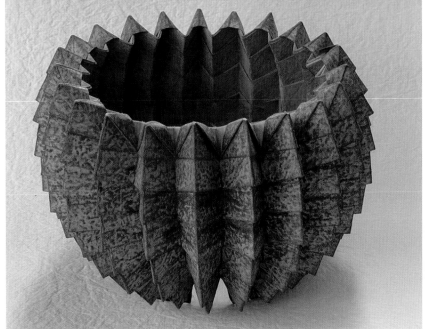

Organic Abstract (Untitled)
Paul Jackson, UK/Israel
2007, dry pastel on paper
(*Photo by the artist*)

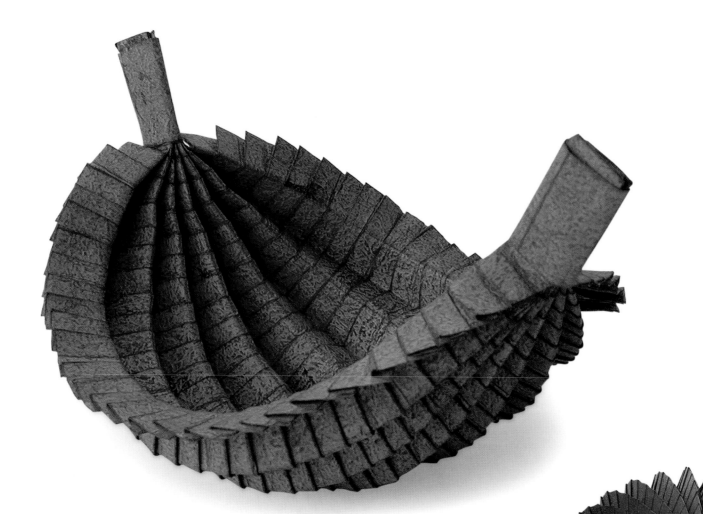

Organic Abstract (Untitled)
Paul Jackson, UK/Israel
2005, dry pastel on paper
(*Photo by the artist*)

Organic Abstract (Untitled)
Paul Jackson, UK/Israel
2010, dry pastel on paper
(*Photo by the artist*)

Coffee Shop
Paul Jackson, UK
2012, folded digital print
(*Photo by the artist*)

Cube (from the *Collapsed Platonics* series)
Paul Jackson, UK/Israel
2003, brown wrapping paper, charcoal, varnish
(*Photo by the artist*)

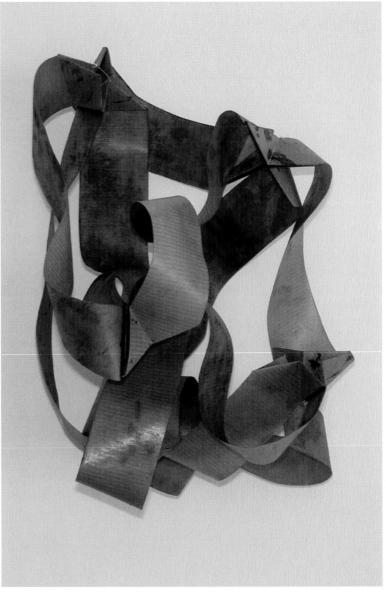

16 Grid (Set of Every Possible Crease Configuration Using Two Identical Cuts to Make Pop-ups)
Paul Jackson, UK/Israel
2014, watercolor paper
(*Photos by the artist*)

The concept of dimensionality figures cleverly in Jackson's recent large-scale installation works, in which he mixes media by combining origami with photography. In a two-piece work entitled *Two Hands* (2014), Jackson presents a series of blown-up folded photographs of his own hands. In this wry self-study, we see the ultimate expression of "digital art work," a portrait of the hands that usually fold the paper becoming the object of the folding and the subject of the piece. The process of folding breaks down the image, at once pixelating and distorting the hands so that in some of the images they are almost unrecognizable as hands. There is a touch of irony in these works. Typically, origami is used to construct a three-dimensional form from a flat sheet. Here, the three-dimensional objects in the image—the hands—are deconstructed through the process of folding.

In all of his varied origami creations, Jackson does not simply fold forms out of paper. Before his first—and sometimes only—fold, he questions the potential of the paper, challenging it to become something truly unexpected. By adding pigment to the paper, or allowing one single crease to dictate the entire form, or not allowing the paper to support its own form, he questions conventional approaches to origami and offers new ways to release the unexplored potentials of paper through folding. The result of his continuous questioning and boundary pushing are a masterful collection of sculptural works that are surprisingly organic in texture and tone, often witty and thought provoking in conception, and always elegant and richly poetic in form.

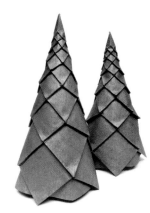

BETH JOHNSON'S

tessellated trees and spiraling squirrels

When most people think of origami, they imagine folded figures of birds or animals, usually pointed and angular, but nonetheless featuring the main characteristics of the creature represented. Since the mid-twentieth century, when master origami artist Akira Yoshizawa introduced wet folding, many paper folders worldwide have endeavored, and even competed, to fold increasingly realistic birds, bugs and beasts out of paper. However, there are some artists, most notably minimalist Giang Dinh (see page 24), who have foregone realism in favor of creating their own style of folded paper figures. Emerging origami artist Beth Johnson (b.1973), who has been folding for many years but only began designing her own models around 2010, has developed her own figural style that is inspired more by geometric patterning than by the physical characteristics of the creature itself. Her figures of sheep, jellyfish, squirrels, owls and bears are born out of tessellations,

corrugations and fractals, their faces, scales or tails detailed and textured with geometric patterns that add whimsy and an unexpected elegance to their forms.

Johnson, who lives in Ann Arbor, Michigan, began folding paper when she was about nine years old, enjoying the puzzle-like challenge and the endless creativity that the art form offers. After studying anthropology and natural resources, she worked for almost ten years in the environmental field helping communities in the Great Lakes region protect and manage natural resources. In 2009, she left the field for a variety of reasons, including the birth of her son, and around the same time she designed her first origami model. She joined a Maker Space in Ann Arbor called Maker Works that provides tools and training for working with wood, metal, electronics and other crafts. Once her son was in school and she was ready to start working full-time again, she decided to focus more on her art, and she now spends time folding paper, teaching origami and working part-time at Maker Works. In the last five years, she has shown her work in several exhibitions and been invited to origami events around the world to demonstrate her style of origami.

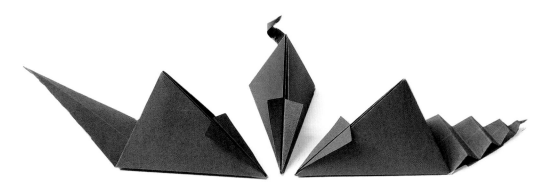

Mice
Beth Johnson, USA
2015, Tant paper
(*Photo by the artist*)

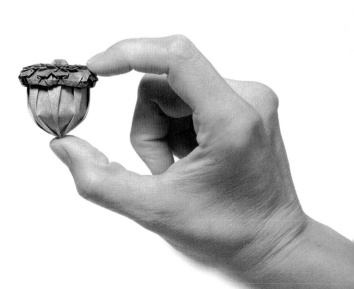

Squirrel with Acorn
Beth Johnson, USA
2014, Biotope paper
(*Photo by the artist*)

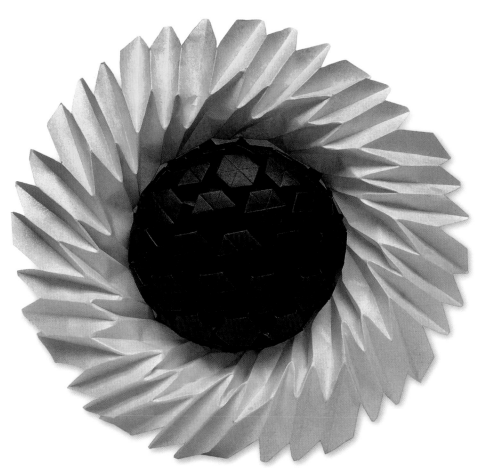

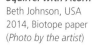

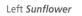

Left **Sunflower**
Beth Johnson, USA
2013, elephant hide paper
(*Photo by the artist*)

Right **Acorn**
Beth Johnson, USA
2012, elephant hide paper
(*Photo by Dave Brenner*)

Brown Bears
Beth Johnson, USA
2011, Canson Mi-Teintes paper
(*Photo by Dave Brenner*)

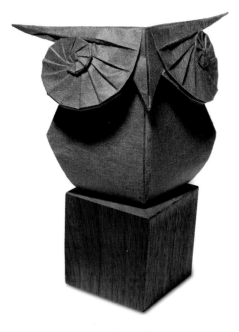

Left *Spirowl*
Beth Johnson, USA
2014, Moriki paper
(*Photo by Dave Brenner*)

Right *Hedgehog*
Beth Johnson, USA
2011, elephant hide paper
(*Photo by Dave Brenner*)

Her unique origami style and her designing process are well represented in her model *Sheep* (2011), a figure that is unmistakably a black-faced ewe with a full white fleece. The fleece, however, has been formed using a square twist tessellation pattern known in the origami world as the "Water Bomb" pattern because it consists of a cluster of water bomb bases. The "Water Bomb" pattern was originally developed in the 1960s by Ron Resch (1939–2009), but was popularized in the contemporary origami world by tessellation expert Eric Gjerde. Johnson began folding tessellations without knowing what they were. She simply folded repeated patterns and enjoyed the effects they created. While a number of artists have created stunning abstract designs using this pattern, it took Johnson to transform it into the thick, woolly body of a sheep. "I see a pattern that reminds me of something—the feathers on a bird, an owl's eyes—and the design often quickly follows," she explains. "There is not much more folding beyond the original pattern." After she has folded the pattern, there

Right *Tessellated Fish*
Beth Johnson, USA
2015, Agua Papel
(*Photo by Dave Brenner*)

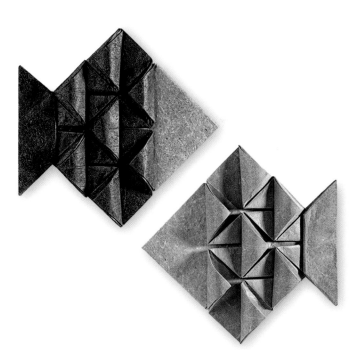

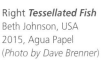

is minimal shaping to create the final form. In the case of this version of her sheep form, she added the black head, feet and tail.

Johnson's series *Bears* (2011) illustrates her skill in using a geometric folding pattern to create animals with tremendous personality. By folding a similar repetitive pattern of square pleats and then shaping the paper into the form of a seated bear, she carefully positions the folds of the face to create the bear's long nose, nostrils and heavy brow and allows the light to deepen the creature's expression. Her *Jellyfish in Water* (2014) was formed using a hexagon twist tessellation and shaped into the domed hoods of the jellyfish, with curled ribbons added to form their tentacles. Using wires to position them above swirling curved-crease paper waves or carved wooden waves, Johnson evokes their graceful swimming motion and highlights the delicate beauty and elegance of these gelatinous underwater creatures. Not confining herself to the realm of fauna, Johnson has also been inspired by these tessellation patterns to create plants that are similarly textured. Her *Pinecones* (2010) resemble the bear figures in conception, with each module of the tessellation representing the scales of the cone, while her highly

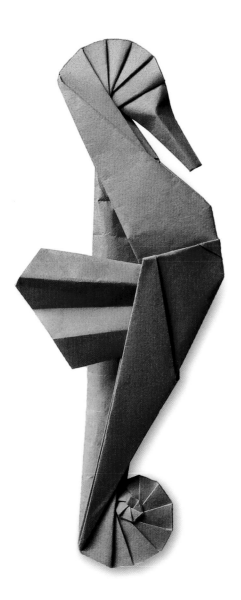

Seahorse
Beth Johnson, USA
2015, Biotope paper
(*Photo by the artist*)

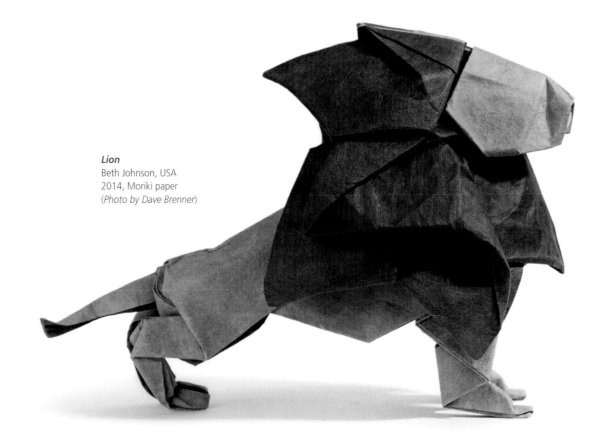

Lion
Beth Johnson, USA
2014, Moriki paper
(*Photo by Dave Brenner*)

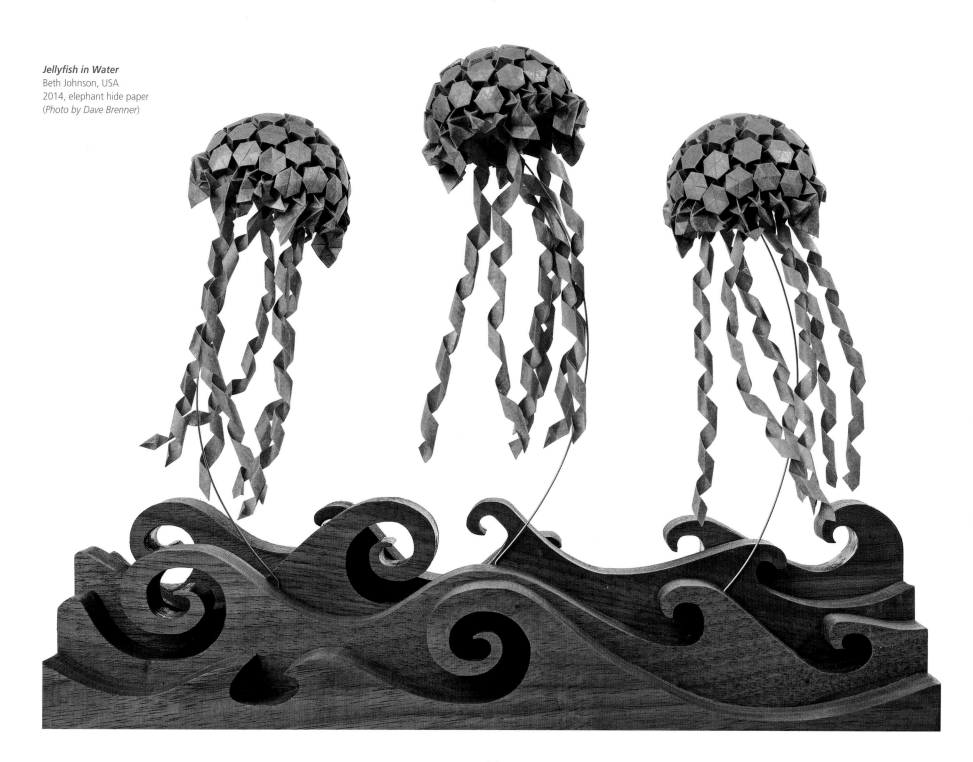

Jellyfish in Water
Beth Johnson, USA
2014, elephant hide paper
(*Photo by Dave Brenner*)

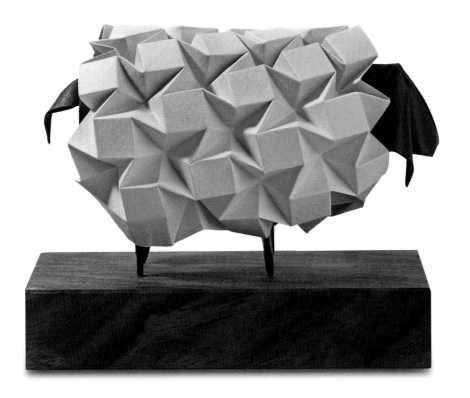

Left *Sheep*
Beth Johnson, USA
2011, Canson Mi-Teintes paper
(Photo by Dave Brenner)

Right *Elephant*
Beth Johnson, USA
2015, Arches paper
(Photo by Dave Brenner)

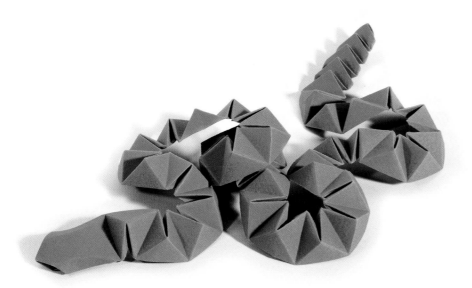

Snake
Beth Johnson, USA
2011, Canson Mi-Teintes paper
(Photo by Beth Baldwin)

stylized *Trees* (2013) are built up out of scale-like overlapping rhomboids that represent the bushy branches of a fir trees. Her *Sunflower* (2013) has a more complex structure, with hexagonal tessellations (like those of the jellyfish) forming the seed head and a rhythmically tessellated ring forming the surrounding petals.

Among the most elegant and evocative of Johnson's figures are those that begin with a spiral. She recently designed a figure of a squirrel with a spiral tail. When she originally designed the animal, she created it with a realistic body but realized that the aesthetics of the tail and the body did not match, so she reworked the design to match the lines of the body with those of the tail.

Pinecones
Beth Johnson, USA
2010, Nepalese lokta paper
(*Photo by Beth Baldwin*)

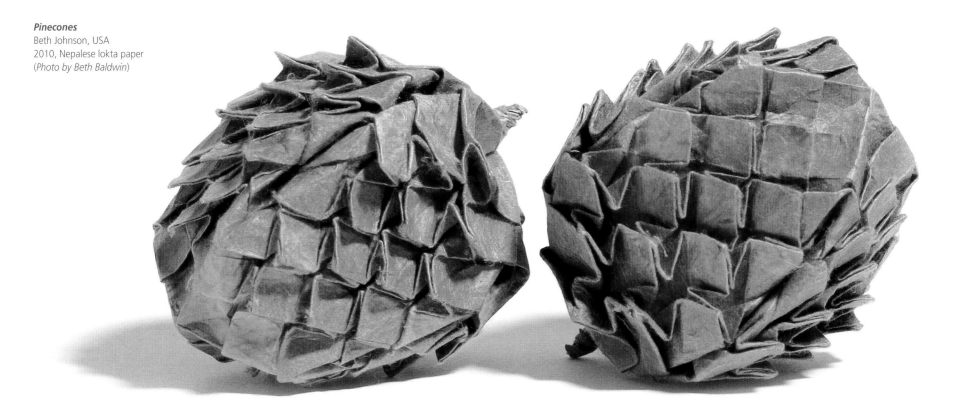

The resulting figures, *Squirrel* (2014) and *Squirrel with Acorn* (2014), may not be realistic depictions of these creatures but with their rhythmic, well-balanced lines and proportions, they are more intriguing works of paper sculpture.

Spirals have similarly inspired Johnson's seahorse figures. Although a number of origami artists have created designs for this tiny sea creature, Johnson's model *Seahorse* (2015), with spiral folds used only for the head and the tail and a very simple body seems particularly refined in its simplicity.

Perhaps the most powerful of Johnson's spiral-inspired works is her figure entitled *Spirowl* (2014), which features two mirrored spirals representing the owl's huge eyes. Johnson has created a number of owl designs using tessellations for the feathers, but in this sculpture the only detailing is in the eyes, each formed using a fold reminiscent of the nautilus-inspired spiral of Tomoko Fuse's *Navel Shell* (see page 44). While Fuse's shell design is a geometrically folded representation of the fractal, or repeating pattern that naturally occurs in this type of shell, Johnson's use of the spirals in her owl is more metaphoric and stylistic than naturalistic. By contrasting the stillness of the rest of the bird's body with these intricately spiraling eyes, Johnson creates a figure that is not only suggestive of the powerful vision of the nocturnal predator but is also aesthetically balanced and compelling.

Beth Johnson spent much of her folding history figuring out many of the puzzles of origami by herself, unaware that so many in the origami community were tackling similar complex artistic issues. Although she has now become part of the larger global origami community and is enjoying the inspiration that she gains from fellow designers, she often chooses to work in isolation so that she is not too heavily influenced by other artists' designs and can avoid worrying about how others would approach a particular design. Her models borrow from diverse areas of origami design, but they offer a fresh approach to figural origami, in which pattern and texture are not secondary to shape but actually dictate the final form of a figure.

where geometry meets genius

THE OTHERWORLDLY ORIGAMI OF ERIC JOISEL

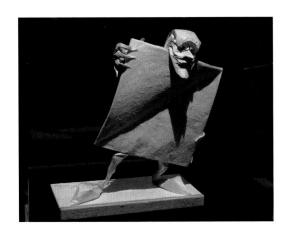

Above **Self-made Man**
Eric Joisel, France
2008, Nepalese *lokta* paper 250 gr
(*Photo by Lee Schang*)

Arguably one of the most thought-provoking origami sculptures is a figure comprising a human head, legs and arms holding a square of paper that is gently creased along one of the diagonals. The face wears a melancholy expression and the hands grip the edges of the paper tightly. At first glance, the figure appears to be a man holding a large square of paper, but the title of the work, *Self-made Man* (2006, 2008, 2009), and a more careful inspection of the form reveals that it is the man himself who is folded from the square of paper, and that he is still in the process of folding himself. In this work, we see the genius of French origami artist Eric Joisel (1956–2010), one of the brightest lights in the contemporary origami world until his tragic passing in October 2010.

Although many of Joisel's works of folded paper are considerably more complex than *Self-made Man*, this work perhaps best encapsulates his spirit as an artist. He was indeed self-made, a self-taught origami artist, and

he was constantly evolving, challenging his artistic self more and more even in his last year of life when cancer was brutally challenging his physical and psychological self. More importantly, the work epitomizes the unbounded imagination and whimsy that Joisel brought to his models as he folded animals, mythical figures and masks with an almost super-natural skill but a sensitivity that was deeply human.

A sculptor with a background in history and law, Joisel was inspired in the early 1980s by the works of Akira Yoshizawa, the Japanese "father of modern origami." Yoshizawa had created more than 50,000 models and invented the technique known as wet folding, dampening the paper to create more rounded, naturalistic sculptures. Joisel had studied sculpture in stone, clay and wood from the age of seventeen, but he was largely self-taught in origami techniques. He quickly mastered wet folding and began creating animals that appear sculpted or molded rather than folded.

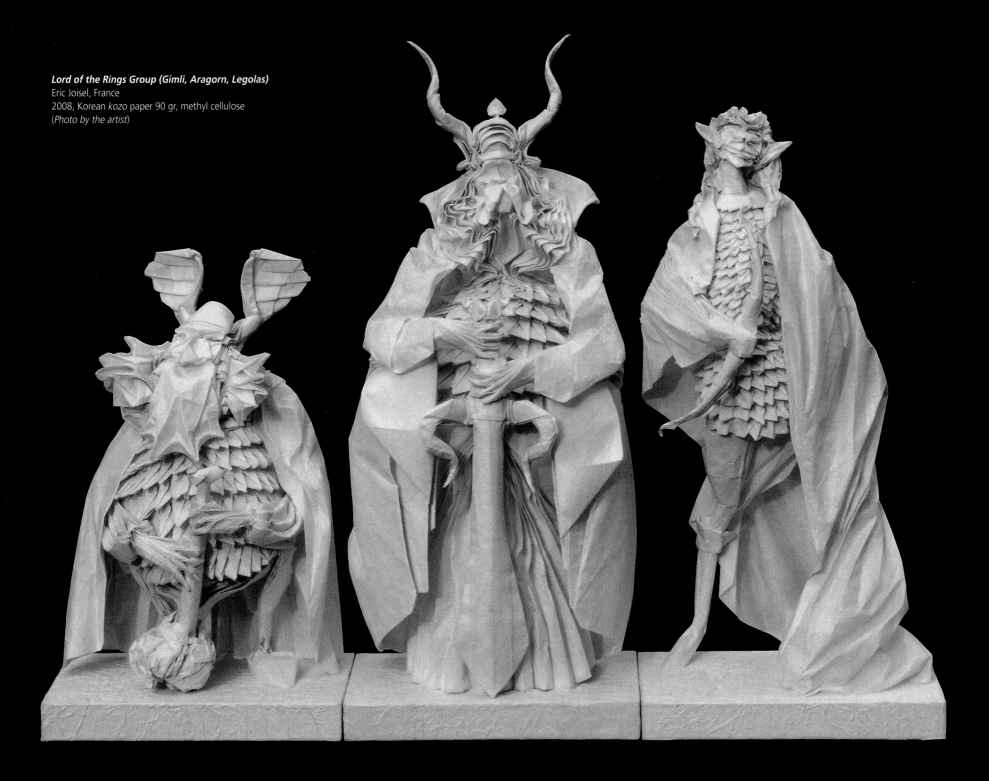

Lord of the Rings Group (Gimli, Aragorn, Legolas)
Eric Joisel, France
2008, Korean *kozo* paper 90 gr, methyl cellulose
(*Photo by the artist*)

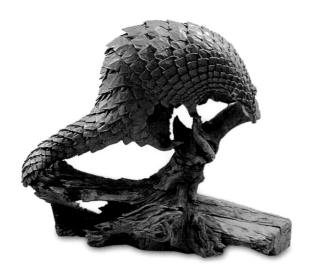

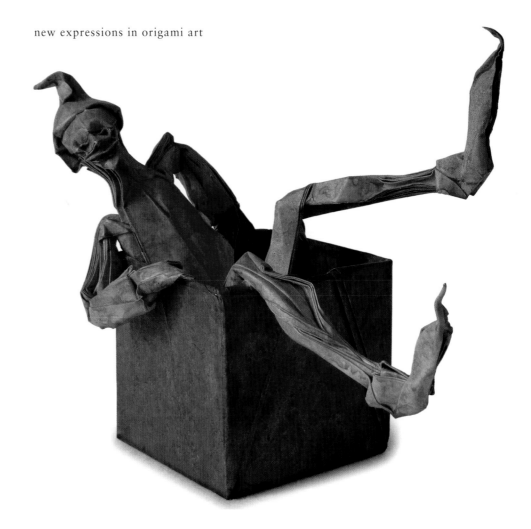

According to Alain Joisel, his brother, Eric Joisel's work as an origami artist can be categorized into three main periods. Animals were the primary focus of his first period of work, which extended from roughly 1987 to 1991 and included several distinct series—*La Ménagerie* (*The Menagerie*) (1987), *L'étang* (*The Lagoon*) (1989) and *La Mer* (*The Sea*) (1991). His *Hérissons* (*Hedgehogs*) (1990) and *Escargot* (*Snail*) (1989) ingeniously combine sculpted wet-folded areas with heavily box-pleated areas to create animals that are at once naturalistic and whimsically stylized. His *Hippocampe* (*Seahorse*) (1996, 2009), however, is a breathtaking work of realistic sculpture, with the modeled form, texture and color of the paper mimicking those of the actual creature so closely that the only thing distinguishing the paper model from the real creature is the size. Joisel explained in an article he wrote for French origami magazine *Le Pli* in 2005 that his seahorses and shell sculptures were folded in "true 3-D," that is to say, they possessed volume from the very first fold unlike many typical origami figures that are folded flat and then given volume in the final step. His later animals are no less naturalistic. Most spectacular of all is his *Pangolin*

(2000), a remarkable feat of box pleating that captures not only the form but also the essence of this rare and endangered scaly mammal.

In the early 1990s, Joisel embarked on his second phase, which lasted the entire decade and focused mainly on masks and bust sculptures. Joisel was not the first artist to create origami masks. In fact, his original inspiration for taking up origami was an intensely emotional self-portrait mask by Yoshizawa, folded around 1980. However, with his masks, Joisel made a significant departure from traditional—even modern—origami. These masks, many of which were portraits

Above left **Pangolin**
Eric Joisel, France
2000, sandwich foil/Kraft paper,
acrylic painting
(*Photo by Frédéric Wolf,
Art Management*)

Above **Out of Geometry**
Eric Joisel, France
2004, brown Kraft paper
(*Photo by Alain Joisel*)

Right **Birth**
Eric Joisel, France
2001, sandwich foil/
Kraft paper
(*Photo by the artist*)

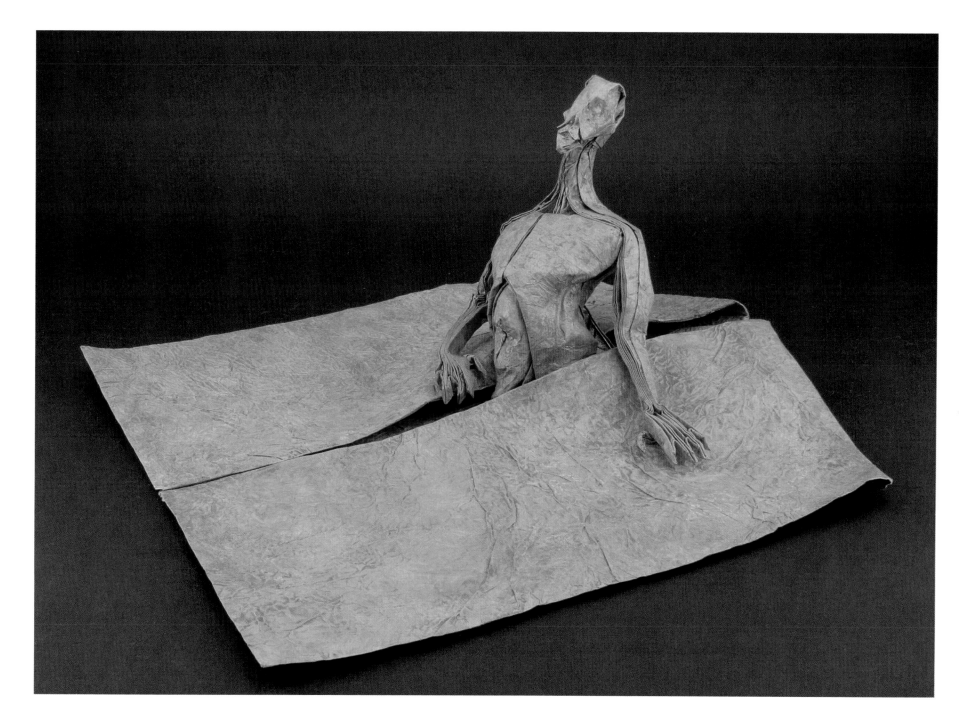

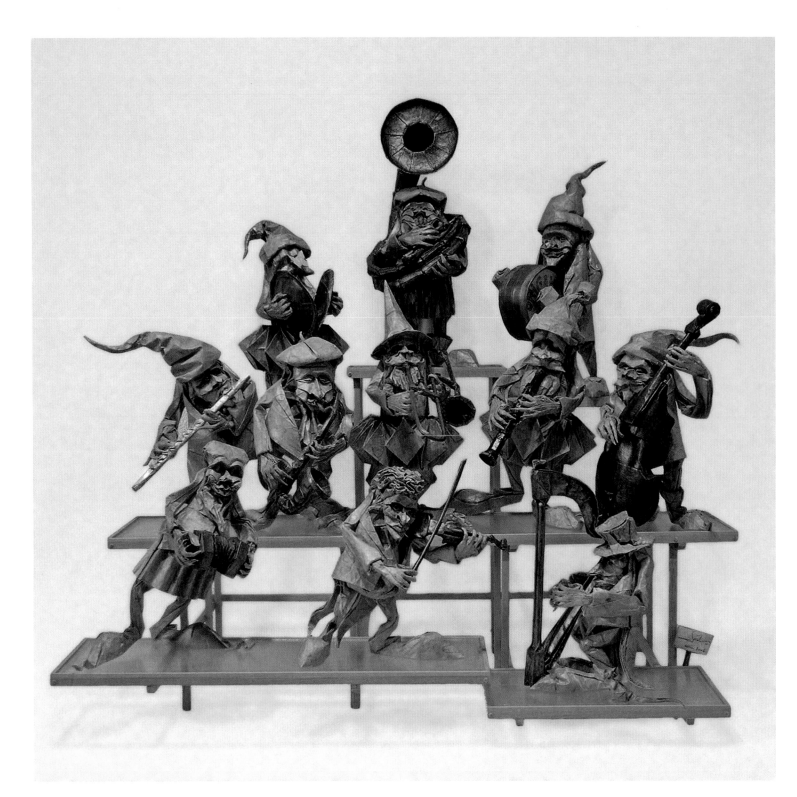

Left *Orchestra*
Eric Joisel, France
2006, sandwich foil/paper
(*Photo by the artist*)

Opposite left *Pagliaccio*
Eric Joisel, France
2010, Korean *kozo* paper
90 gm, methyl cellulose
(*Photo by the artist*)

Opposite right *Colombine*
Eric Joisel, France
2006 (first *Commedia dell'arte*
couple), paper
(*Photo by the artist*)

of fellow origami artists and friends or inspired by African masks, were only 50 percent folded. The other 50 percent of the process consisted of destroying the folded form, modeling it so that it would possess, as he explained, "volume, curves and life." The masks, and the bust models he made during this period, were therefore a blend of calculation and improvisation. It was in 1992, during this second period, that Joisel became a full-time origami artist, organizing origami exhibitions in France and becoming one of the most popular artists at international origami conventions. In 1998, his work was shown at the Carousel du Louvre in Paris. He often traveled to Japan and showed his work there, most notably in 1999, when he was one of only five other artists included in a commemorative exhibition in Tokyo to celebrate Yoshizawa's 88th birthday.

By the turn of the millennium, having mastered origami techniques, Joisel was now free to express his artistic sensibilities with paper. His final phase, from 2000 to 2010, was devoted primarily to an exploration of human and mythological characters, his *Personnages*. Inspired largely by characters from myth and legend, his fairies and goblins are among the most whimsical figures created by any sculptor, let alone an origami artist. Each folded and modeled from a single sheet of paper, these figures wear intricately detailed costumes, assume playful poses and have intense facial expressions. In particular, his series of goblins, with their long (or sometimes short) legs and pointed shoes and conical hats express a playfulness that seems to celebrate Joisel's sense of artistic freedom. His goblin playing the saxophone (*Sax*, 2006) is one of the most comical figures, wearing a blissful, almost meditative expression as he blows into his instrument. His *Orchestre* (*Orchestra*) (2006, 2008, 2010), comprising eleven goblin characters, each playing a separately folded miniature musical instrument, is a masterpiece of figurative sculpture in any medium.

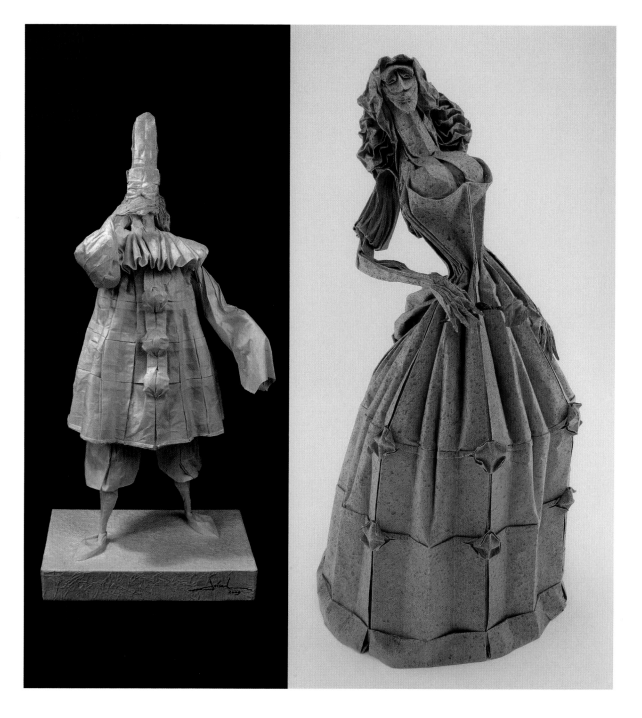

In his final years, Joisel was working on several series of origami portraits of characters from literature and theater. From around 2008, he began designing and folding some of the main characters from Tolkien's epic trilogy *The Lord of the Rings*. Since childhood, Joisel had been fascinated with the hobbits, dwarves and elves of Tolkien's world, so as an adult devoted to origami, he admitted on his website, "I continue to act out as a child living in my fantasy world." Figures like Legolas and Aragorn are particularly remarkable for their tightly box-pleated chainmail chest plates that contrast boldly with the loosely wrinkled cloaks draped over their shoulders. Gandalf the Grey, shown waving his wand high in the air with his pleated cloak billowing outward behind him, sensitively captures the immense spiritual power of this elderly wizard.

It was in another series, though, that Joisel's greatest passion lay in the final years and months of his life and career. Began after his diagnosis of lung cancer and folded during periods when he was debilitated by his treatment, Joisel's last series of figures were from the *Commedia dell'arte*, a form of comedic theater that had been popular since the sixteenth century. His *Capitan* (2009) and *Colombine* (2009) feature some of the most intricate pleating and modeling of all his characters, most notably in the ruffles of their collars and skirts but also in the delicacy of their hands. However, it is his character *Pagliaccio* (2009), the clown, who is perhaps the most sensitively rendered of his works in this series. Depicted with a long, loose tunic hanging over his pantaloons, a ruffled collar and a tall hat, Joisel's clown holds one hand to his mouth, to cover a yawn, and the other tucked inside his sleeve, an ingenious way of depicting laziness, the sin that the character represents in this theatrical form.

Eric Joisel folded six figures from the *Commedia dell'arte* series before he died on October 10, 2010. In an e-mail just weeks before he passed away, he wrote about this series, "there were difficult moments, with not so

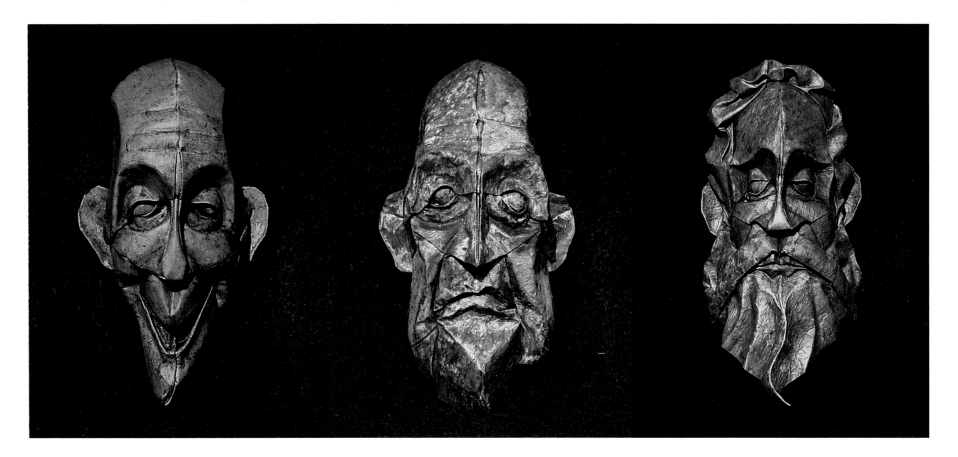

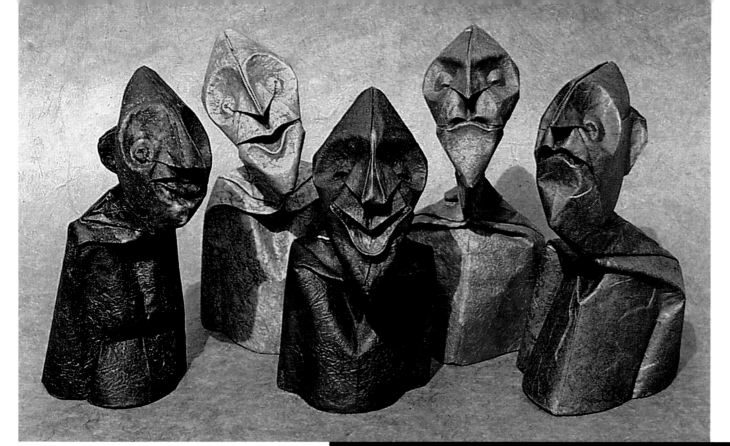

good production, but sometimes good surprises which
may be my very best models." Indeed, these figures are
some of the most extraordinary origami sculptures ever
produced, each created with a lightness of spirit that
masked whatever exhaustion and fear Joisel may
have been experiencing in the last months of his life.
Although it may seem surprising that an artist would
push his art so hard while struggling with a life-
threatening disease, his choice of subject matter is
understandable. In the *Commedia dell'arte*, Joisel found
an artistic form that was, like his own origami, a blend
of refined technique, improvisation and humor that
entertained and brought joy to a wide, very appreciative
audience.

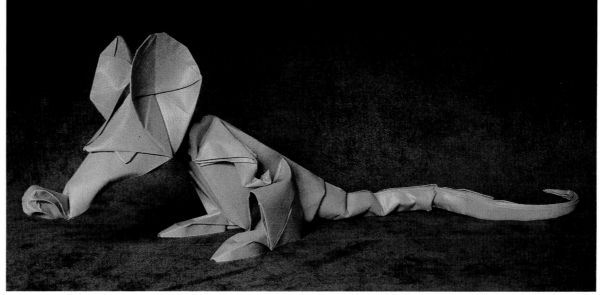

Photo by Ana Villafane

partnering with paper

THE ORGANIC ORIGAMI OF GORAN KONJEVOD

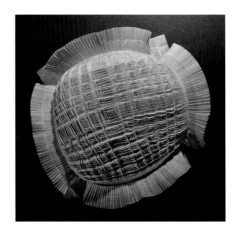

As more fine artists, philosophers, theoretical physicists, mathematicians and computer scientists explore the art and applications of origami, the number and range of ways to fold a two-dimensional sheet of paper into a three-dimensional form are growing rapidly. So too are the questions about what actually causes the formation of a particular origami shape. Is it the folding process, the sequence of the folds, the type of folds, the application of water in wet folding, or is it the type of paper used or the tension created by folding? The answer differs depending on the folding styles and techniques used, and typically more than one of these factors are at work in any single origami sculpture. Some artists, like Croatian-born origami artist Goran Konjevod (b.1973), take little personal credit for the remarkable sculptures they create by folding paper. Explaining that his dynamic abstract sculptures are naturally formed by the tension of the paper, Konjevod claims that he does not "invent" or "design" his forms;

he "discovers" them in the paper. The process is very organic—often a push-and-pull relationship between the artist and the paper—and the result is often unexpectedly poetic.

Goran Konjevod was a high school student when he first discovered origami at a Japanese festival in Zagreb, Croatia, and it remained a hobby for him for over a decade while he studied mathematics and computer science at the University of Zagreb and then moved to the United States to pursue graduate studies at Carnegie Mellon University. After receiving his PhD, he worked for ten years as professor of computer science at Arizona State University, but left Arizona in 2010 to work as a computer scientist at the Lawrence Livermore National Laboratory in Northern California. Origami had been a creative hobby for him as a student, but he had generally folded forms designed by other origami artists. For a few years while teaching in Arizona, he gave up his paper folding hobby, but in 2005 he was

inspired by a fold in a book by renowned origami artist Paul Jackson (see page 56) to pick up paper again. This time, he started folding with the passion of an artist, fired up by the realization that the paper itself can play an active role in creating the final form. For the last ten years, he has been creating wave-like forms that are at once geometric and highly organic. He freely admits that many of his designs were developed from a single form discovered by Jackson. "The experience of folding these pieces has helped me begin to understand how particular fold sequences interact and in a few cases I have been able to visualize the final shape before starting to fold." Jackson's philosophical approach to origami has also colored his folding.

Konjevod's works are predominantly origami tessellations, repeating patterns that fill a plane with no overlaps or gaps. Origami tessellations are often created using pleats to connect elements such as twist folds or box pleats in a repeating fashion. While many

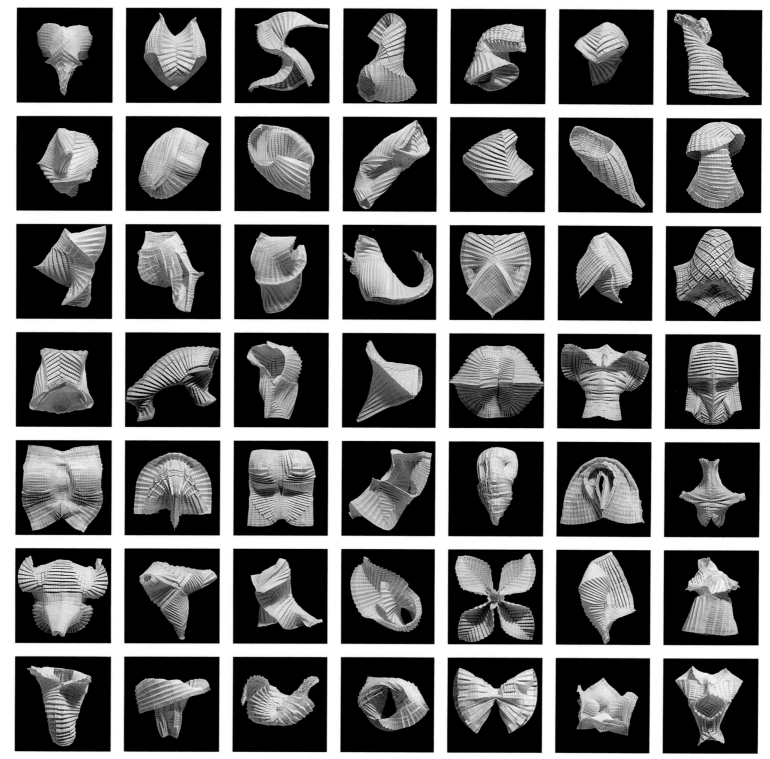

Left **Sunflower**
Goran Konjevod, Croatia/USA
2009, abaca paper handmade
by Cindy Iverson
(*Photo by the artist*)

Right **Grid (49 of the 50
pieces for 50-50/2015)**
Goran Konjevod, Croatia/USA
2015, Japanese *kozo* paper
(*Photo by the artist*)

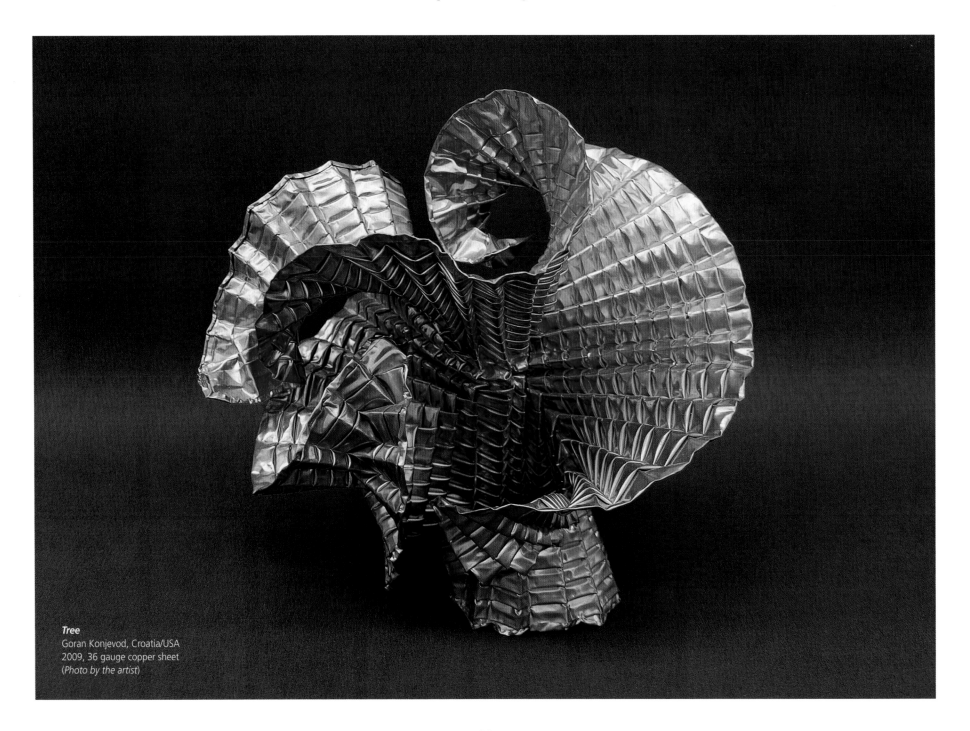

Tree
Goran Konjevod, Croatia/USA
2009, 36 gauge copper sheet
(*Photo by the artist*)

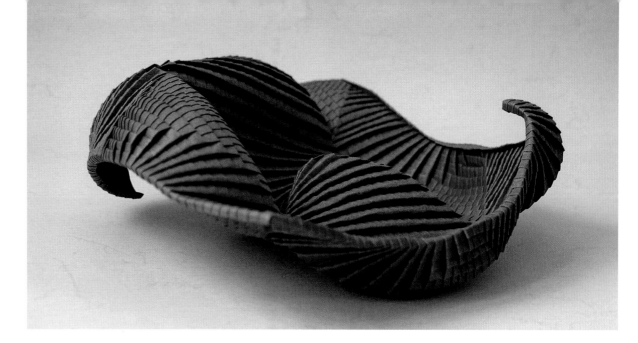

Double Wave
Goran Konjevod, Croatia/USA
2007, elephant hide paper
(*Photo by the artist*)

Untitled 1
Goran Konjevod, Croatia/USA
2013, elephant hide paper
(*Photo by the artist*)

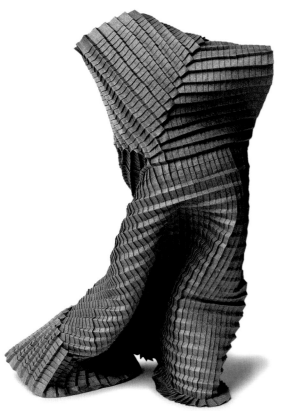

origami tessellation artists work with thin paper to create elaborately patterned shadows with the folds, Konjevod favors thicker paper, such as watercolor paper or elephant hide paper, sometimes using multiple layers to add volume to his sensuous forms. "A real sheet of paper is always three-dimensional—even when unfolded," he explains. "And its thickness brings about a much more obvious three-dimensionality when multiple layers are present." Although his folding of the paper begins the formation process, it is the tension at work in the paper—the physics within—that then takes the lead and creates the final form.

The work *Double Wave* (2007), folded out of rich blue elephant hide paper, exemplifies his approach. For the most part, Konjevod uses what are referred to as "pureland" folds, namely only the basic mountain (upward-pointed) and valley (downward-pointed) folds of origami, but by repeating the folds along a grid and then alternating between horizontal and vertical pleats he invites the paper to choose where it wants to move and the final shape it will assume. Typically, when he begins folding, he has no final form in his mind and

does not keep track of the number of folds he makes. He simply folds the paper until it has become something he considers beautiful, and then he stops. For some of his works, however, he seizes control again of the form by bringing the edges together or modeling them so that they assume the shape of a bowl, a heart, a tree trunk or even an abstracted dancer.

The rich colors Konjevod selects for his paper often enhance the sense of solidity in his works, giving them a weight that suggests they have been crafted from materials other than paper. However, the tightness of his folding and the thickness of his paper can lend a solidity to even his white sculptures. In 2015, invited by the Sanchez Art Center in Pacifica, California, to participate in their juried exhibition, *50/50 Show*, he folded a series of fifty sculptures (one every day for fifty days) from white Japanese *kozo* paper. Layering the thin sheets of paper allowed him to create sculptures as solid in appearance as any work in marble. Although each was folded from a sheet of paper measuring 12 by 12 inches (30.5 by 30.5 cm) using related tessallation patterning, each of the final abstract forms is unique,

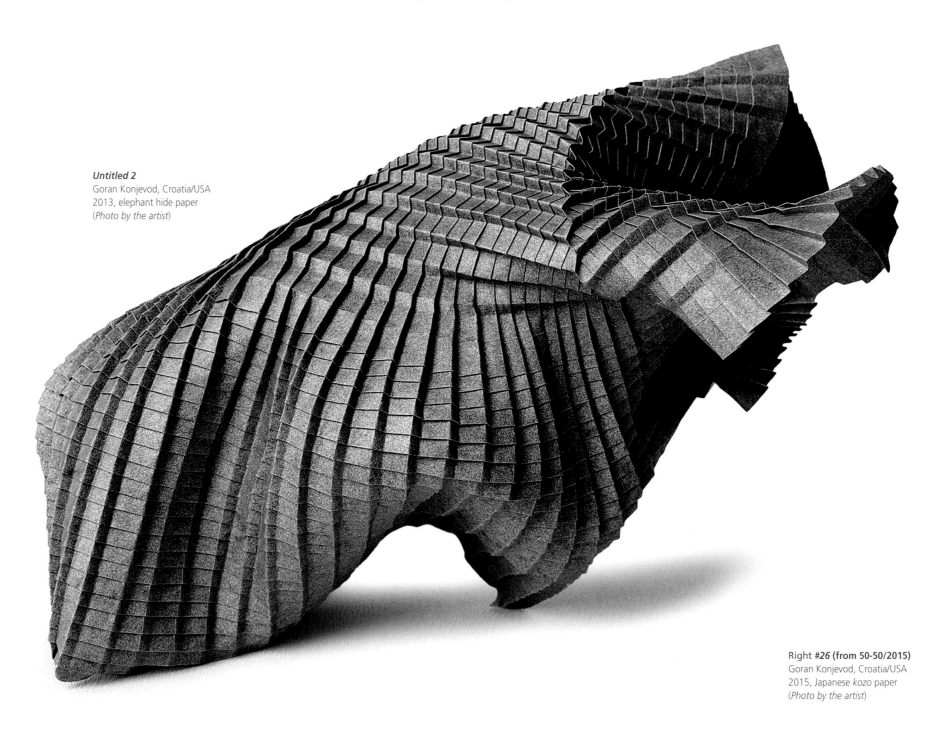

Untitled 2
Goran Konjevod, Croatia/USA
2013, elephant hide paper
(*Photo by the artist*)

Right **#26 (from 50-50/2015)**
Goran Konjevod, Croatia/USA
2015, Japanese *kozo* paper
(*Photo by the artist*)

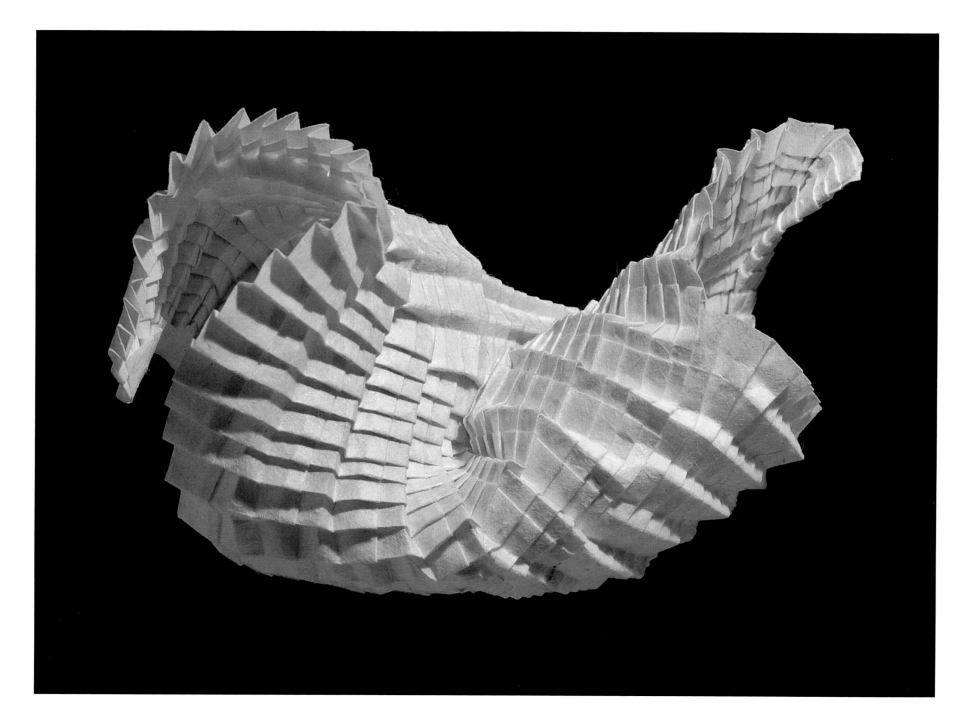

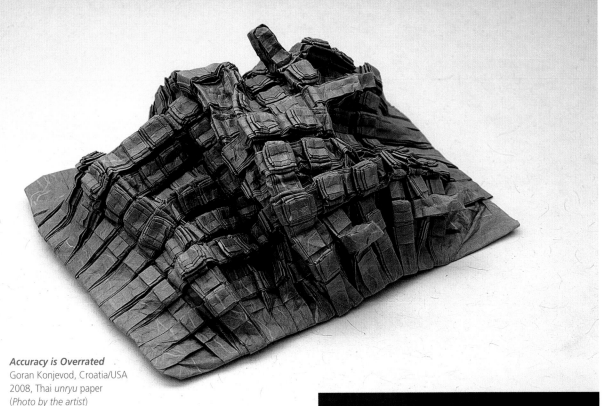

Accuracy is Overrated
Goran Konjevod, Croatia/USA
2008, Thai *unryu* paper
(Photo by the artist)

Waiting
Goran Konjevod, Croatia/USA
2009, elephant hide paper
(Photo by the artist)

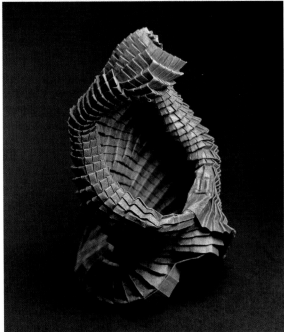

dimensional surface. Although there is drama in both series, the thicker white paper used in the 50/50 series quite clearly played a more active role in the ultimate design.

Konjevod's experimentations with materials have recently led him to work in other materials, including copper and bronze. His series of tessellated copper works are actually folded out of 36 gauge copper sheets measuring 0.005 inches thick, and some feature a patina created by applying heat. His *Tree* (2009), folded from a 36-inch (91.5-cm) square of copper, with its intricately pleated details, is a finely balanced work of abstract origami sculpture but with the added tone and sheen of polished metal. His bronze and iron works are created using a different process. Since 2012, Konjevod has been creating metal castings of his paper origami works. Using paper originals, he creates a mold, which is filled with poured molten metal. The resulting works, such as *Rearranged Pleats* (2012), retain the intricate detailing of the paper sculptures but with a richly textured patina. The solidity suggested by the tight folding of his thick paper works becomes real.

Goran Konjevod often describes the forms that he creates from paper as "naturally occurring," and credits the tension in the thick paper he uses for exquisite forms that result from his detailed folding. Physics and nature are indeed at work in the transformation of his sheets of paper into lyrical abstract sculptures. However, unlike zoologists and explorers who "discover" a new species or a new continent, Konjevod more than discovers his forms. They do not actually exist until he, the artist, begins to fold the paper. Instead, it may perhaps be fairer to say that he and the paper are partners in the artistic act, bringing together the creativity, skill and tension needed to create something uniquely magnificent out of folded paper.

some hinting at the shape of a shell, others at an animal head or a mushroom, while others are pure geometry. This series contrasts boldly with an earlier commission of a series of 25 folded works he designed in 2009 and folded in 2010 for the cover of the Amateur Press Association (APA) origami magazine *imagiro*. For this series, he folded simple linear formations in sheets of a gossamer-thin Japanese paper called Tengujoshi to create geometric Mondrianesque patterns on a two-

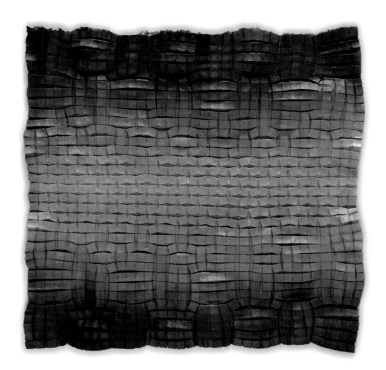

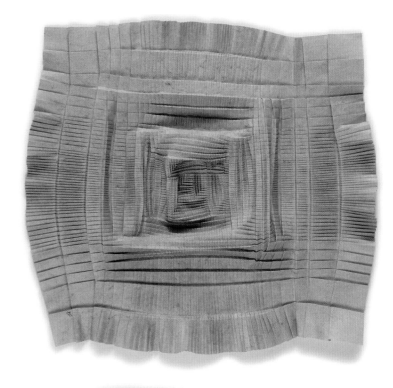

Right **Change Study 5**
Goran Konjevod, Croatia/USA
2012, Japanese *kozo* paper
(*Photo copyright 2012 Sibila Savage Photography. From the Collection of The County of Alameda commissioned by the Alameda County Arts Commission*)

Far right **Change Metaleaf Vario**
Goran Konjevod, Croatia/USA
2012, elephant hide paper
(*Photo copyright 2012 Sibila Savage Photography. From the Collection of The County of Alameda commissioned by the Alameda County Arts Commission*)

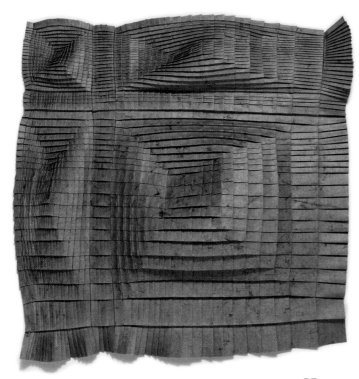

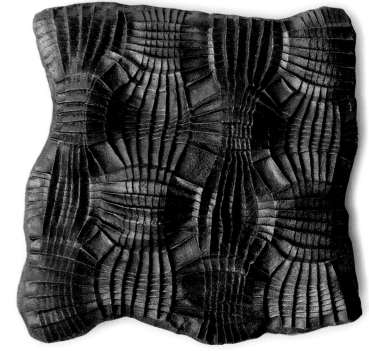

Right **Four Waves**
Goran Konjevod, Croatia/USA
2012, elephant hide paper
(*Photo copyright 2012 Sibila Savage Photography. From the Collection of The County of Alameda commissioned by the Alameda County Arts Commission*)

Far right **Rearranged Pleats**
Goran Konjevod, Croatia/USA
2012, iron
(*Photo by the artist*)

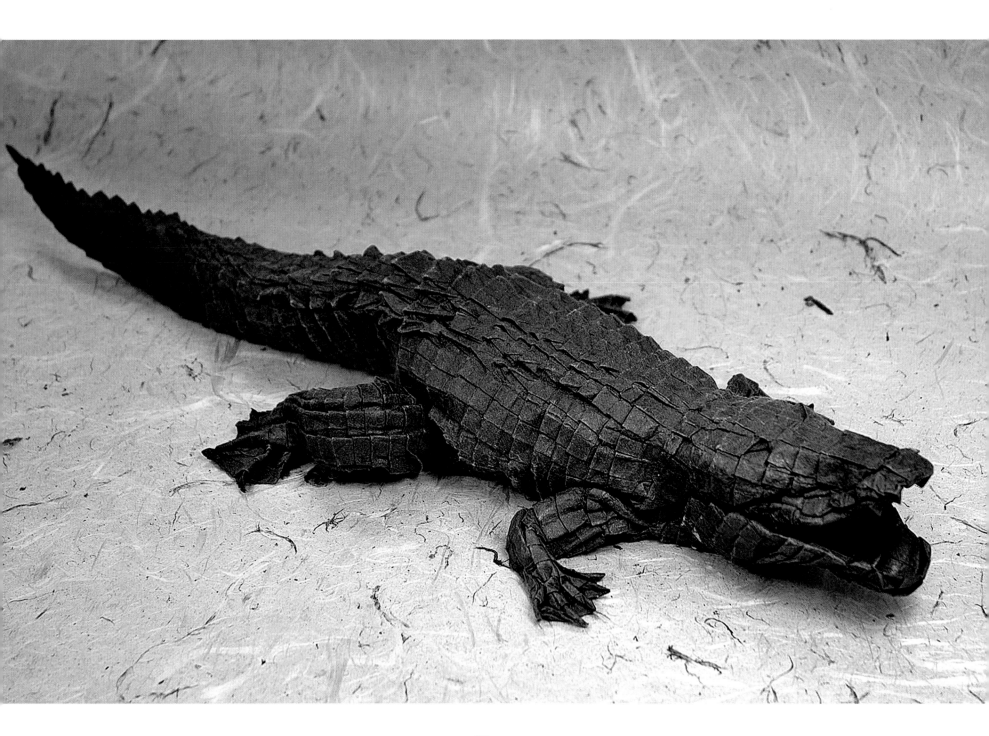

holism and realism

Photo by Richard L. Alexander

Photo by Michael G. LaFosse

Left *American Alligator*
Designed by Michael G. LaFosse 2005,
co-folded by Michael G. LaFosse and
Richard L. Alexander 2006, 6-ft (1.8-m)
square of Origamido abaca and hemp
paper handmade by Richard L. Alexander
(*Photo by Michael G. LaFosse*)

In the mid-twentieth century, Akira Yoshizawa, the "father of modern origami," developed the "wet folding" technique, dampening the paper during folding to allow the creation of more realistic models. The technique enables origami artists to work with larger, heavier, stronger papers. These papers are often custom-made for each subject from plant fibers carefully chosen, beaten and blended for their particular qualities. Not only does the paper furnish the surface tone, texture and sheen of the final model, it also allows complex folding maneuvers not possible with commercial papers. By wet folding custom-made papers, an increasing number of origami artists have succeeded in transforming flat squares of paper into the likeness of a bug, bird or beast. However, capturing the spirit or essence of the creature requires a deep understanding of how it moves, observes and interacts with the world around it. Origami artist Michael G. LaFosse, working with his partner Richard L. Alexander at their

Origamido Studio, has mastered this degree of realism in origami natural history sculpture more than perhaps any other artist. His lifelike creations have played a key role in elevating origami to a true sculptural form that is now recognized by many of the world's museums and collectors of art.

LaFosse became fascinated with origami at seven, and when he was twelve he discovered an article in an issue of *Reader's Digest* magazine about Yoshizawa and the new direction of expressive origami. From the article, LaFosse saw the hand of the artist, and learned that Yoshizawa had designed his own highly expressive models. At that moment he was compelled to design his own expressive origami. Yoshizawa's paper was like nothing he had seen, and as he started designing he realized that he too needed much stronger and larger sheets of paper. He lived in Fitchburg, Massachusetts, a paper making town, and at sixteen he began exploring hand paper making. At one point, when he was too anxious to wait for his paper to dry completely, he started folding it and discovered that not only could he sculpt the paper more easily when it was damp, the key to more artfully modeling realistic creatures, but unlike

Left **Michael G. LaFosse, putting the finishing touches to his origami Cormorant** Designed 1993, this model folded 2007 (*Photo by Richard L. Alexander*)

a dry folded model, the wet-folded model retained its shape after it dried. Later, he learned that Yoshizawa also wet folded his origami.

At college, LaFosse pursued his interest in wildlife as a scientist majoring in marine biology, and as a hobby he continued to design his own origami models. In the 1990s, he began to devote himself increasingly to origami and went full-time as an origami artist in 1994. In 1996, he and Richard Alexander founded Origamido Studio, a teaching and resource center, exhibits gallery, and production facility for handmade paper, fine art and paper folding. Alexander, also trained as a biologist, holds a BS from Cornell University where he studied

Below ***Three Koi*** Designed by Michael G. LaFosse 1974, set folded 1994, handmade watercolor paper (*Photo by Michael Lafferty*)

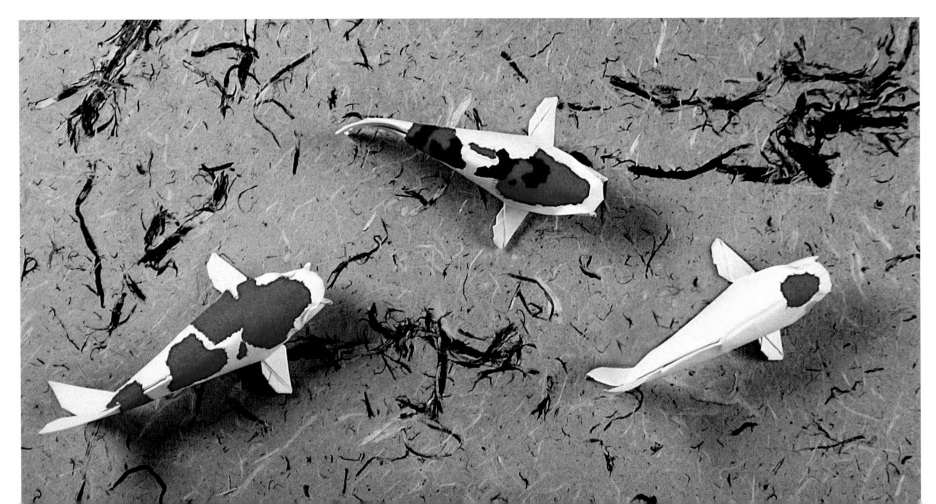

Right **Wilbur**
Designed and folded by
Michael G. LaFosse 1991,
Origamido abaca and cotton
paper handmade by Michael
G. LaFosse
(*Photo by Richard L. Alexander*)

Below **Leatherback Sea Turtle**
Michael G. LaFosse, USA
2012, handmade O-Gami paper
(*Photo by Richard L. Alexander*)

Above **Frog**
Designed by Michael G. LaFosse
1977, folded 1994, 8-inch
(20-cm) square of Origamido
abaca and cotton paper
handmade by Michael G. LaFosse
(*Photo by Richard L. Alexander*)

Below **"George L. Mountainlion"**
Designed and folded by Michael G.
LaFosse 1998, Origamido paper
from desert plant fibers handmade
by Michael G. LaFosse
(*Photo by Michael Lafferty*)

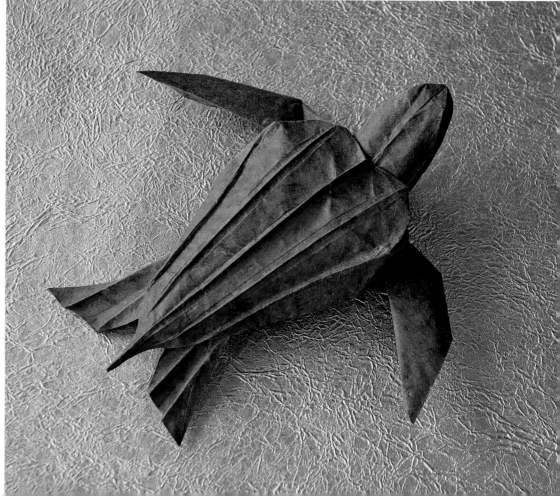

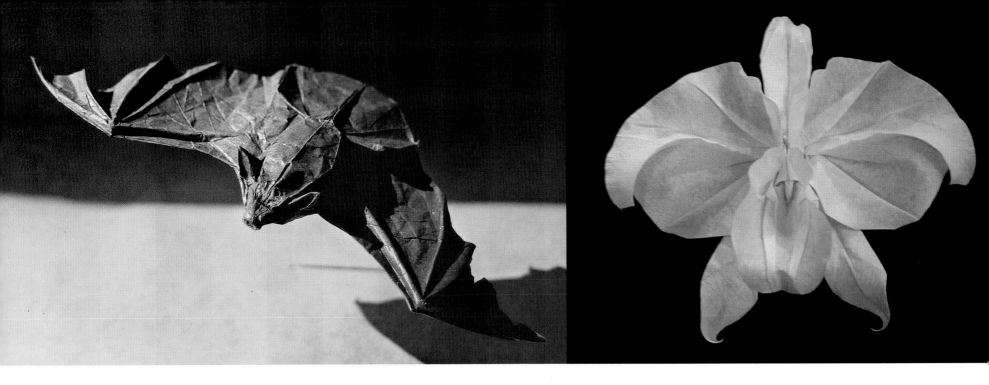

systems biology, landscape architecture and visual communications. He worked for many years designing, teaching and developing environmental management systems for government and industry. When he met LaFosse in 1988, he offered to help get his exquisite origami works shown to the public. Together, LaFosse and Alexander have dedicated themselves to the art of origami, teaching origami classes at all levels and authoring more than thirty books, origami kits and instructional DVDs. LaFosse designs, folds and prepares the technical diagrams for his complex models, while Alexander designs simpler models, photographs the work, makes their videos, writes the prose and assists with commercial and gallery installations. Since 2003, when Alexander devoted himself full-time to origami, he has also made all of the Origamido custom handmade papers. Their work has been shown in museums in the United States and Europe and many renowned origami artists either

commission them or come to Origamido Studio to make special papers with them.

For several decades now, LaFosse has been designing and folding a broad range of natural history subjects: birds, insects, mammals, reptiles, plants and flowers. Many of these works demonstrate how successfully he has combined his knowledge of biology, paper making, and origami to create sculptures that capture the essence of the subjects portrayed. One of his most remarkable works is *Frog* (2003). The figure not only has the taut,

muscular form of a frog poised to leap, created by skilful wet folding, but the natural dark green tone and sleek shine of the amphibian's skin has been achieved using handmade abaca fiber paper infused with powdered mica. If placed by a pond, the figure could be mistaken for a real frog. In a museum display case, however, the naturalistic sculpture might be taken for a bronze-cast sculpture. Likewise, his life-size *Praying Mantis* (designed 1974, folded 1982), folded from a 9-inch (22.8-cm) square of blended *kozo* (mulberry) and bamboo fibers, elegantly mimics the scale, texture and color of the real creature, and his *Toucan* (designed 1989, folded 1993) demonstrates LaFosse's ingenuity not only as an origami designer but also as a paper maker. Made of handmade abaca paper (Manila hemp) that is entirely black on one side and yellow on the other, the bird is designed and folded so that its bill and breast show the yellow side of the square against the black paper of the rest of its body.

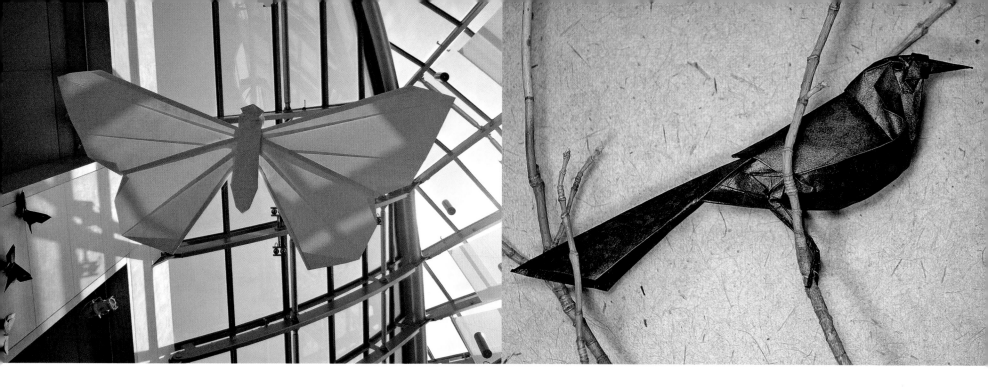

LaFosse's designs have been so lifelike that he and Alexander have been artists-in-residence in Florida, where they studied Everglades wildlife and folded an entire exhibition of animals using their handmade paper at the Arizona–Sonora Desert Museum, and in Hawai'i, where they made custom paper and folded a display of colorful and elegant flowering plants for the Honolulu Museum of Art. Their work has also been featured in fine art museums, including the Louvre in Paris and the Peabody Essex Museum in Salem, Massachusetts. In many of these exhibits, LaFosse and Alexander have expanded the scope of their work by creating larger sculptures and installations, including their 8-foot-(2.4-m)-tall *Winged Pegasus* for display in New York at the flagship Hermes of Paris store on Madison Avenue.

In 2006, LaFosse's *American Alligator (Alligator mississipiensis)* (2006) was displayed at the *Origami Now!* exhibition held at the Peabody Essex Museum.

Above left **Origamido Butterfly Mobile**
An 11-ft (3.3-m) wingspan, designed by Michael G. LaFosse 1996, folded 2007 by Michael G. LaFosse and Richard L. Alexander, five squares of commercial watercolor paper, displayed as part of an installation in the Grand Atrium of the Peabody Essex Museum, Salem, MA, during the exhibition *Origami Now!* (2007–8) (*Photo by Richard L. Alexander*)

Above right **Grackle**
Designed and folded 1990 by Michael G. LaFosse, 12-in (30.5-cm) square of Origamido abaca paper handmade by Richard L. Alexander (*Photo by Richard L. Alexander*)

Left **Michael G. LaFosse lifting a sheet of wet pulp from felts after pressing** (*Photo by Richard L. Alexander*)

Wet folded from a 6-foot (1.8-m) square sheet of baked-mud-colored Origamido paper, the 17-inch (43-cm)-long finished alligator not only captures the rough scaly physicality of an actual alligator, but with its muscular legs and open jaws possesses the menace and ferocity of the real beast. Far more delicate, but no less spectacular, are LaFosse's butterflies. Over the years, he has created

hundreds of original designs for butterflies and moths and shared them in his DVDs, books, and origami kits (four of their publications were devoted solely to LaFosse's original butterfly designs). For the same exhibition at the Peabody Essex Museum, they created a spectacular butterfly installation in the atrium made up of 30 large butterflies and one suspended creation measuring 11 feet (3.3 m) across. Not only do the forms of the origami butterflies evoke different, actual and fanciful butterfly species, but LaFosse and Alexander also prepared and selected papers that echo the exquisite colors or patterns of their wing spots.

Perhaps more than any other form LaFosse has designed over his long, prolific career, his butterflies exemplify his approach to origami. Grounded in a solid understanding of the biology, LaFosse carefully designs the proportions and forms, makes the perfect paper, and folds it to evoke a pleasing balance of the beauty, simplicity and realism of the butterfly. His painstaking and holistic approach to creating natural history origami models has secured his place as one of the great masters of origami in the early twenty-first century. The elegance and balance of his artfully folded designs will ensure his artistic legacy for centuries to come.

Below left *LaFosse Moth*
Designed 1993, folded 2004 by Michael G. LaFosse, 9-in (22.8-cm) square of duo Origamido abaca paper handmade by Richard L. Alexander
(*Photo by Richard L. Alexander*)

Below *Praying Mantis*
Designed 1974, folded 1992 by Michael G. LaFosse, 9-in (22.8-cm) square of Origamido *kozo* and bamboo paper handmade by Michael G. LaFosse
(*Photo by Michael G. LaFosse*)

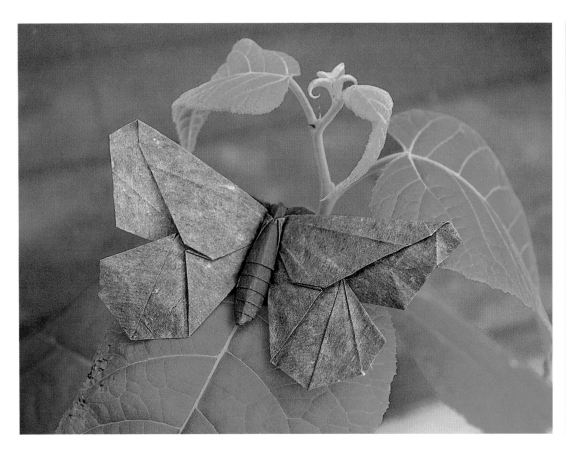

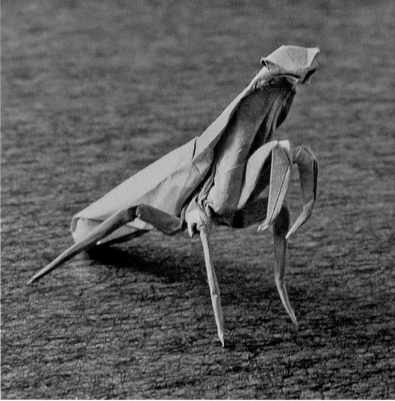

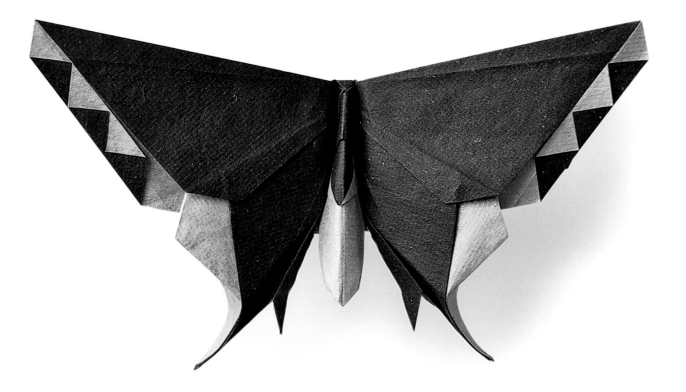

Left *Butterfly for Robert Lang*
Designed and folded 2012 by Michael
G. LaFosse, 8-in (20.3-cm) square
of duo Origamido abaca paper
handmade by Richard L. Alexander
(*Photo by Richard L. Alexander*)

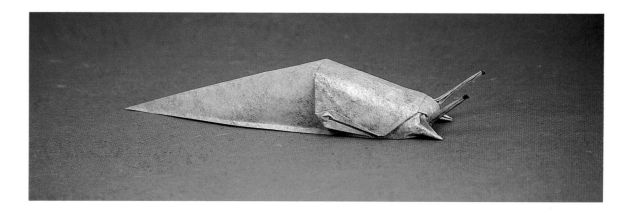

Right *Banana Slug*
Designed 1996, folded 2004 by
Michael G. LaFosse, 5-in (12.7-cm)
square of duo Origamido abaca paper
handmade by Richard L. Alexander
(*Photo by Richard L. Alexander*)

Photo by Diane Lang

Right *Acoma Pot 12, Opus 555*
Robert J. Lang, USA
2009, one uncut duodecagon (each) of Canson
Mi-Teintes watercolor paper
(*Photo by the artist*)

Below *C. P. Snow*
Robert J. Lang, USA
2009, one uncut square of Korean *hanji* paper
(*Photo by the artist*)

ROBERT J. LANG

where passion meets precision

In the world of origami, Robert J. Lang (b.1961) is one of the most respected of all the "Masters" currently creating origami art. His superstar status in the origami world is attributable in part to the precision that his highly scientific mind and training in mathematics, engineering and physics have enabled him to bring to the art form. More than this, however, it is his passion for the art form and the artistic process that enables him to fold a scorpion or other creature from a single square of paper so realistically and lovingly that we almost believe the creature is alive. As a scientist-artist, he is constantly experimenting with different styles, media, folding techniques and tools and increasingly collaborating with other artists to push the boundaries of his art form as well as his own artistic boundaries. For Lang, the possibilities of origami are endless.

These possibilities began when Lang started folding paper as a child in Atlanta. As a young adult, he trained in electrical engineering and applied physics at Stanford

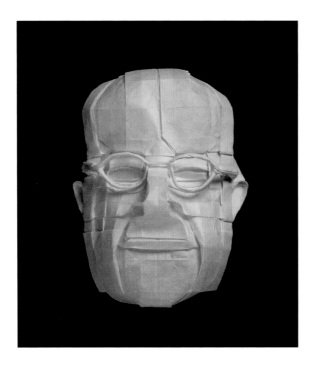

University and the California Institute of Technology (Caltech), and worked as a laser physicist at NASA's Jet Propulsion Laboratory in Pasadena and Spectra Diode Labs and JDS Uniphase in Silicon Valley. In 2001, after over thirty years of studying origami on the side as his passion, Lang gave up his day job to focus on both the art and science of origami. Now, as a professional origami artist, he lectures, writes books and articles about origami and consults with companies about folding applications in medicine, car airbag design and space exploration. His artwork, which has been shown internationally in exhibitions, featured in documentary films and displayed as a Google doodle, is broad in its range. For many years he has folded figural sculptures of birds, bugs and beasts and recently he has been recreating ancient ceramic pots out of folded paper. He is also known for his geometric modular works and has recently been exploring tessellations and crease patterns. Some of his most innovative recent work has

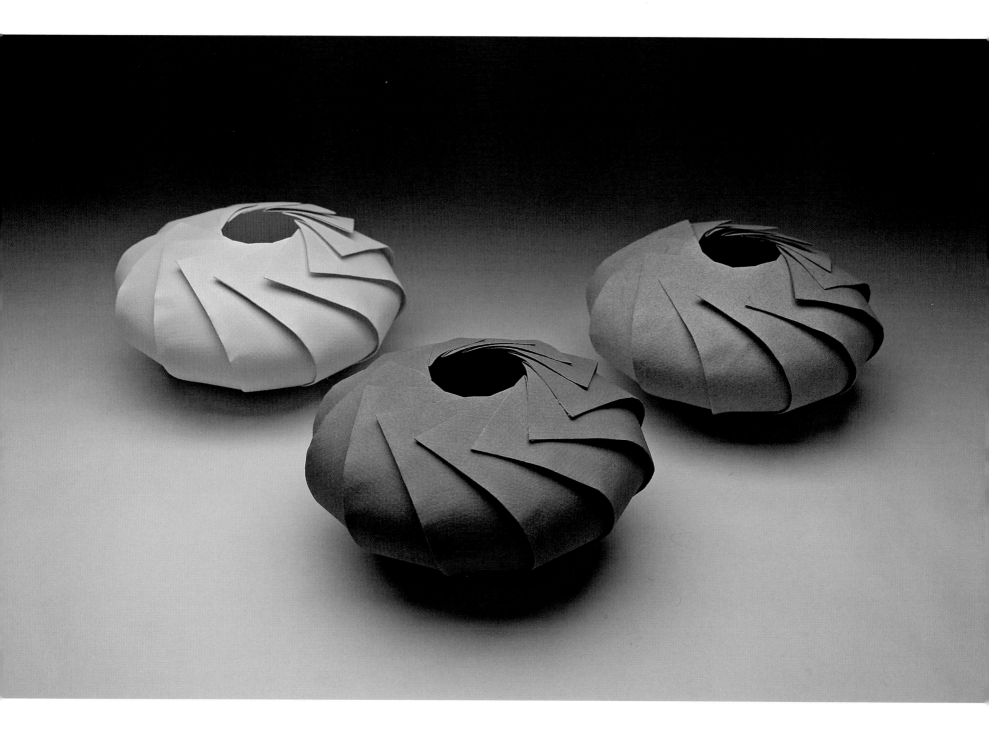

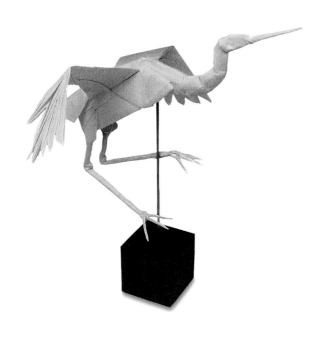

included installations, bronze sculptures, 3D-printed models and folded photographs, some of which he creates in collaboration with other non-origami artists.

His recent installation work *Vertical Pond II* (first created in 2011) is a prime example of his innovative and collaborative approach to the art of origami. Lang is probably best known for his highly precise, realistic origami models of animals. Here, we see as many as 60 folded *koi* fish mounted on a wall and arranged as though they are swimming in a pond. In this lyrical work, he has achieved a higher level of realism not only through his own skills but through technical innovation and artistic collaboration. The fish are folded from paper handmade by master paper maker and internationally recognized origami artist Michael G. LaFosse and Richard L. Alexander (see page 88). Lang commissioned LaFosse to develop a paper in which each sheet would be different and patterned in a way that would work for an origami *koi*, but in *Vertical Pond II* Lang envisioned a collaboration between paper maker and origami artist. To this end, Lang designed a

new *koi* folding pattern that revealed a large fraction of the surface of the paper in order to highlight the paper and make it a more equal partner in the artistic work. He joined LaFosse and Alexander to make the sheets of paper, adding colored pulp into the sheet molds as the sheets were being formed to create unique patterning for each fish. "Each sheet is different," Lang explains, "and there is some randomness as well in where and how the colored regions show up in the finished folded fish. In this way, despite all of the planning and design, there is still spontaneity, individuality and unexpected serendipity in each of the folded works."

Lang is also collaborating with artists working in media with little apparent connection to origami, most notably sculptor Kevin Box in Santa Fe, who has been casting sculptures from origami models for years. Coincidentally, Lang had worked with a foundry in 1999 to cast some of his own models in bronze. In 2008, the two artists decided to join artistic forces to produce origami sculptures, including most notably a Pegasus horse, bison and cranes. Box takes Lang's designs

Above ***Dancing Crane, Opus 460***
Robert J. Lang, USA
2005, one uncut square of Korean *hanji* paper
(*Photo by the artist*)

Right ***Raven, Opus 422***
Robert J. Lang, USA
2004, one uncut square of Korean *hanji* paper, one uncut square of foil paper
(*Photo by the artist*)

Far right ***Rattlesnake, Opus 539***
Robert J. Lang, USA
2008, one uncut square of Thai *unryu* paper
(*Photo by the artist*)

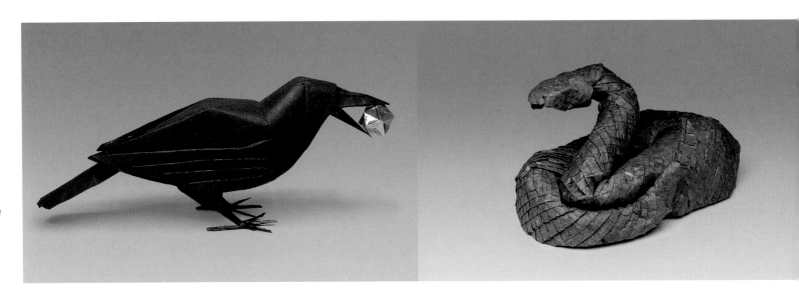

folded in paper, creates large-scale models and uses the lost-wax technique to cast them in bronze and/or stainless steel. Because Box then finishes the bronze sculpture with a treatment that resembles paper, the sculptures appear to be folded from giant sheets of paper. Yet, they have a durability that is unattainable in paper origami sculptures.

The intersection of different media is also apparent in a series Lang began around the year 2000 inspired by the ceramics of the native peoples of the American Southwest and Mexico. "There are fundamental differences between the forms possible with ceramic and those possible with folded paper," Lang admits, "so I have striven to capture the sense of Southwestern art rather than making literal copies." To evoke these ancient vessels, Lang uses several highly modern techniques. He uses mathematical descriptions to create rotationally symmetrical vessels from polyhedron-shaped sheets (for example, an octagonal sheet for an eight-sided pot) of paper and other materials. Since ceramics are rounded in form rather than angular

like typical origami, he folds the vessels along not just straight but also curved lines, which is particularly challenging when working with thicker paper or a wood laminate.

To facilitate the folding, Lang pioneered a laser scoring technique using an industrial laser cutter, in which lines of tiny perforations denote the folding lines in the sheet of paper or other material. In a fascinating cross-media and cross-cultural reference, Lang uses a type of paper called *amatl* or *amate* for some of these works. Mesoamerican cultures like the Aztecs and Mayans had a tradition of paper making and even paper folding going back many centuries. Some works, including *Amatl Pot, Opus 623*, are folded from the same *amate* paper used centuries ago in these cultures but using Lang's high-tech folding techniques.

Although much of Lang's work has always been figural, representing living creatures and inanimate objects such as pots and cuckoo clocks, he has also long been admired for his geometric creations, most notably his works of modular origami, in which

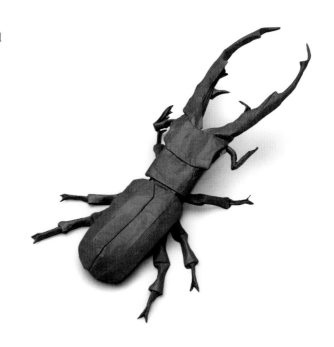

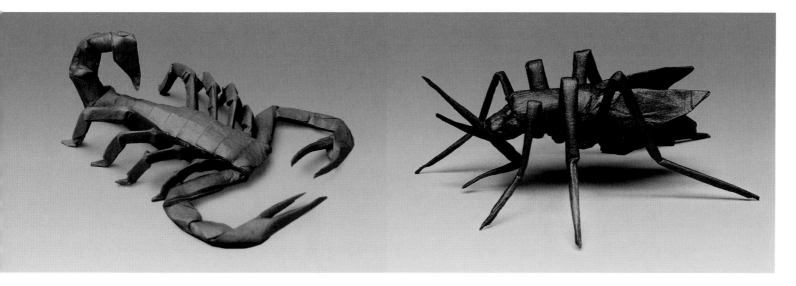

Above *Cyclomatus metallifer, Opus 562*
Robert J. Lang, USA
2010, one uncut square of Korean *hanji* paper
(*Photo by the artist*)

Left *Aedes aegypti, Opus 619*
Robert J. Lang, USA
2012, one uncut square of Origamido paper
(*Photo by the artist*)

Far left *Scorpion HP, Opus 541*
Robert J. Lang, USA
2008, one uncut square of Korean *hanji* paper
(*Photo by the artist*)

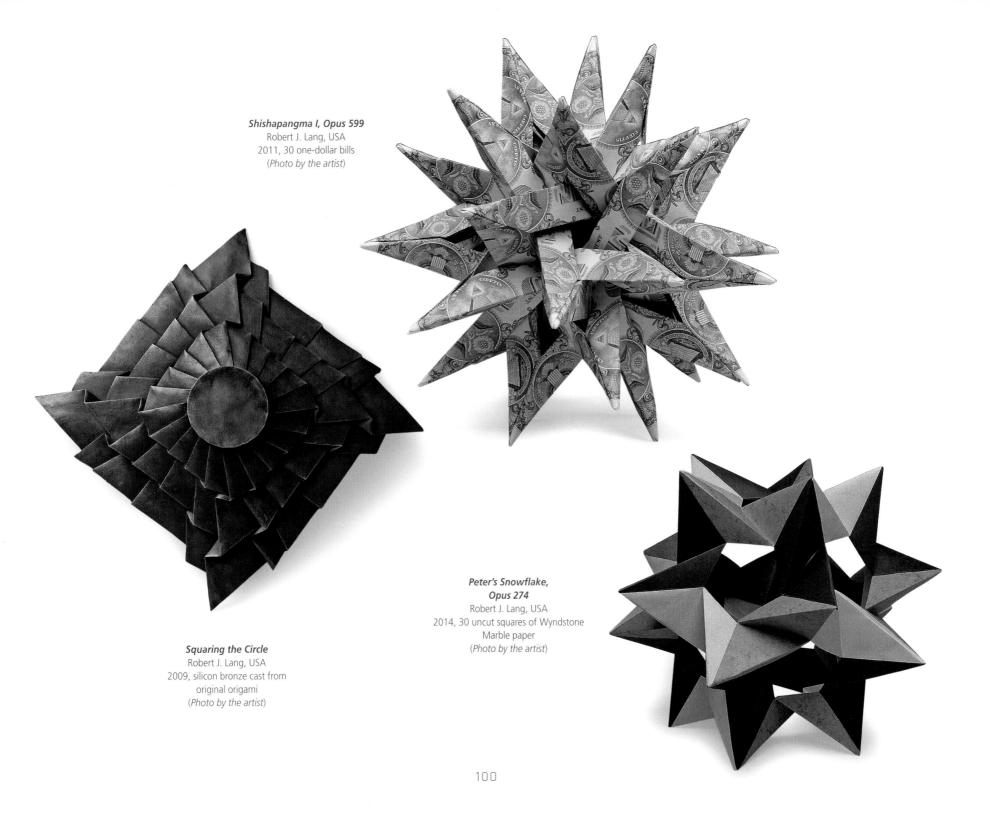

Shishapangma I, Opus 599
Robert J. Lang, USA
2011, 30 one-dollar bills
(*Photo by the artist*)

Squaring the Circle
Robert J. Lang, USA
2009, silicon bronze cast from
original origami
(*Photo by the artist*)

Peter's Snowflake,
Opus 274
Robert J. Lang, USA
2014, 30 uncut squares of Wyndstone
Marble paper
(*Photo by the artist*)

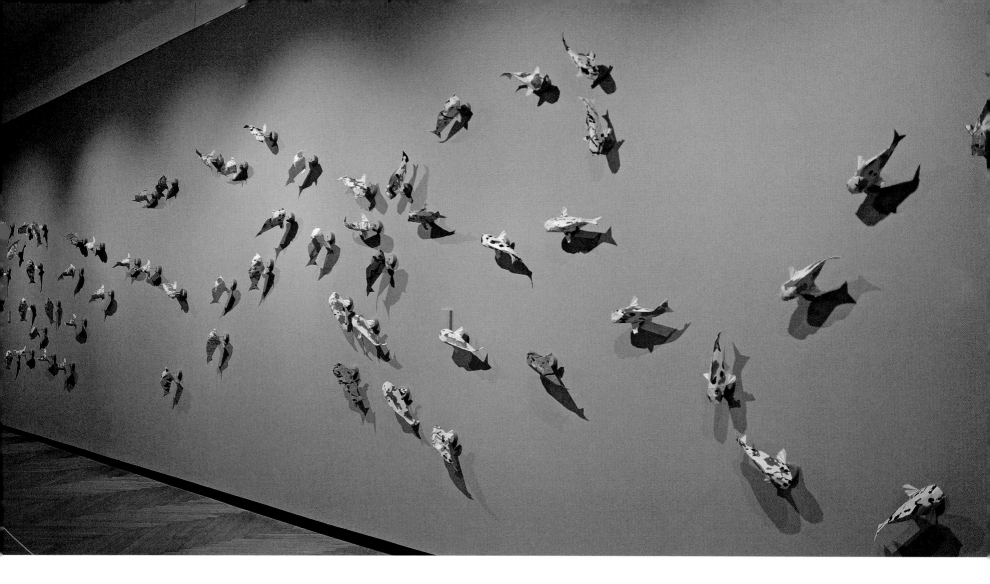

Vertical Pond II
Robert J. Lang, USA
2014, installation of *koi* folded
from 60 squares of custom-made
Origamido paper
(*Photo by Aaron Nelson at the
Clay Center for the Arts and
Sciences of West Virginia*)

multiple folded elements are assembled to create a complex geometric form. Recently, however, as well as these modular works, Lang has been experimenting with tessellations, a type of origami that has only become popular among artists in the last twenty years or so. Origami tessellations are often created using pleats to connect together elements such as twist folds in a repeating fashion and form an elaborately patterned surface. Most origami tessellations are abstract or purely geometric, but tessellation techniques can also be used in representational origami, producing scales and other repeating patterns as design elements. Among Lang's most impressive tessellation work is *Stars and Stripes, Opus 500*, a tessellated American flag designed and folded in 2007 from one uncut square of Wyndstone Marble paper for a commission by the *New York Times Magazine* for an article on the greening of America.

Apparently not satisfied with the challenge of paper tessellations, Lang folded the work entitled *Octet Truss, Opus 652* in 2010 out of a 12-inch (30.5-cm) square of Mylar, which he scored using a laser to help define the folds. The result is a highly elegant work created out of plastic. Even more recently, in 2012, he designed and folded a mathematically profound tessellation entitled *3^7 Hyperbolic Limit, Opus 600* from one uncut irregular polygon of glassine paper. The heptagonal pattern of this work could repeat infinitely if not for the limitations of the sheet of paper. For an exhibition at the Shumei Hall Gallery in Pasadena, California, in 2014, he mounted the folded piece on a light box to illuminate the exquisite pattern created by the folds. Although

Right *Black Forest Cuckoo Clock, Opus 182*
Robert J. Lang, USA
1987, one uncut 1 by 10 rectangle of Zanders elephant hide paper
(*Photo by the artist*)

Below *3^7 Hyperbolic Limit, Opus 600*
Robert J. Lang, USA
2011, one uncut irregular polygon of glassine paper
(*Photo by the artist*)

other artists, most notably American origami artist Chris Palmer, have backlit tessellations using natural light, Lang is one of the first artists to exhibit such self-illuminating origami tessellation sculptures in a gallery setting.

Although there are many other areas of origami in which Lang has proven highly innovative, it is worth including here his work with crease patterns. A crease pattern is a map of some or all of the folds within an origami artwork that provides an alternative view of the relationship between the unfolded paper and the folded subject. Several origami artists, including Lang, consider the crease pattern to be an art work in its own right and have chosen to exhibit their crease patterns, whether printed out and colored, or folded and then unfolded as final low-relief artworks. In Lang's crease patterns, typically giclée-printed wall pieces, the lines chosen for the pattern are those deemed most significant to the origami design; the colors of the lines and background are further chosen to represent structural information about the role, fold direction and/or orientation of each fold and facet in the pattern.

According to Lang, crease patterns "play multiple roles in the origami art world: to the origami artist, they can be a design aid; to a folder, they can provide a glimpse into the mind of the artist." To a viewer, they are often stunning works of patterning created incidentally when artists like Lang push the boundaries of paper folding well beyond what has been hitherto imagined in the realms of art or science. As Robert J. Lang continues to innovate and collaborate with his characteristic precision and passion, there will indeed be no end to what he will be able to create using origami.

Stars and Stripes, Opus 500
Robert J. Lang, USA
2007, one uncut square of
Wyndstone Marble paper
(*Photo by the artist*)

Flying Folds, Opus 553
Robert J. Lang, USA and Kevin Box
2013, cast stainless steel, powder coat finish
(*Photo by Kevin Box*)

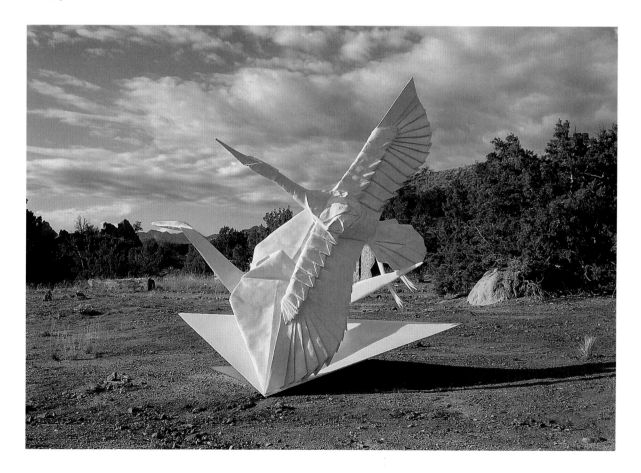

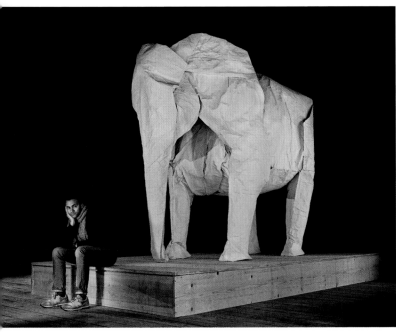

Photo by Philipp Schmidli

folding a statement

Like many folders of complex origami forms, artist Sipho Mabona (b.1980) starts with square sheets of paper and transforms them into bugs, birds and beasts that are so intricately folded that they often take hours to complete. Without using scissors or glue, he is able to create perfectly proportioned, anatomically correct and aesthetically exquisite representations of swallows, polar bears, insects and even people. What makes this South African-Swiss origami artist different is what he chooses to do and say with his folded paper bugs, birds and beasts. Now widely considered the foremost origami installation artist, Mabona magnifies or multiplies his folded paper subjects and presents them in provocative displays that convey potent social and political messages.

Mabona began his folding as a child. He started making paper planes when he was just five years old but by twenty had run out of ideas for plane designs so turned to origami as a way of creating new designs.

He became fascinated by the art form and soon evolved into such a talented folder that the German advertising company Nordpol Hamburg+ asked him to help them make a stop-motion animated origami commercial that tells the story of the Japanese sports brand ASICS. Working closely with computer animators, he designed around twenty origami models for the video, which has since won numerous international awards.

Around 2009, Mabona began creating installations, starting with rainbow-like groupings of colorful *koi* carp arranged so that they appear to be swimming elegantly upstream against a perfectly white wall, and then a similar arrangement with a flock of multi-colored swallows soaring and diving in unison. However, the tone of his installations soon began to become more serious, darker even, as he realized the symbolic and even satirical potential of such arrangements. In 2010, he folded a flock of swallows out of white paper for an installation in his first solo

exhibition, *Invisible Foes*, at the Gutenberg Museum in Fribourg, Switzerland. In this work by the same name, Mabona placed flat sheets of white paper and half-folded birds on the floor and then hung the fully formed birds from the ceiling with monofilament to show the evolution of the paper through folding into swallows. The swallows seem to take off and glide through the air, rejoicing in the power of flight until, that is, they hit a glass window and fall to the ground. In this dramatic and poignant work, Mabona addresses the themes of mindfulness and mortality. "I was trying to address the beauty and ephemerality of life. As we dwell in happiness amongst each other we often tend to take things for granted, but often we don't appreciate a lot of what we are blessed with until unexpectedly we get confronted with our mortality."

Featured in the same 2010 exhibition was the work *Bearly Surviving*, an origami sculpture that possesses similar potency. At first glance, the work appears to be

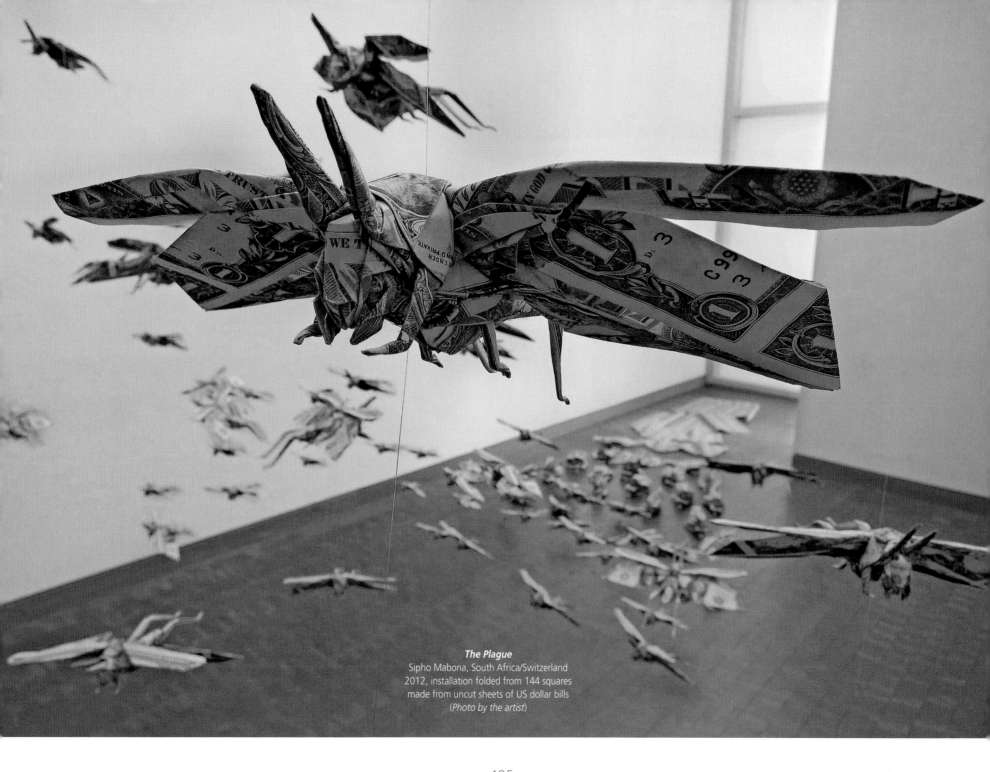

The Plague
Sipho Mabona, South Africa/Switzerland
2012, installation folded from 144 squares
made from uncut sheets of US dollar bills
(*Photo by the artist*)

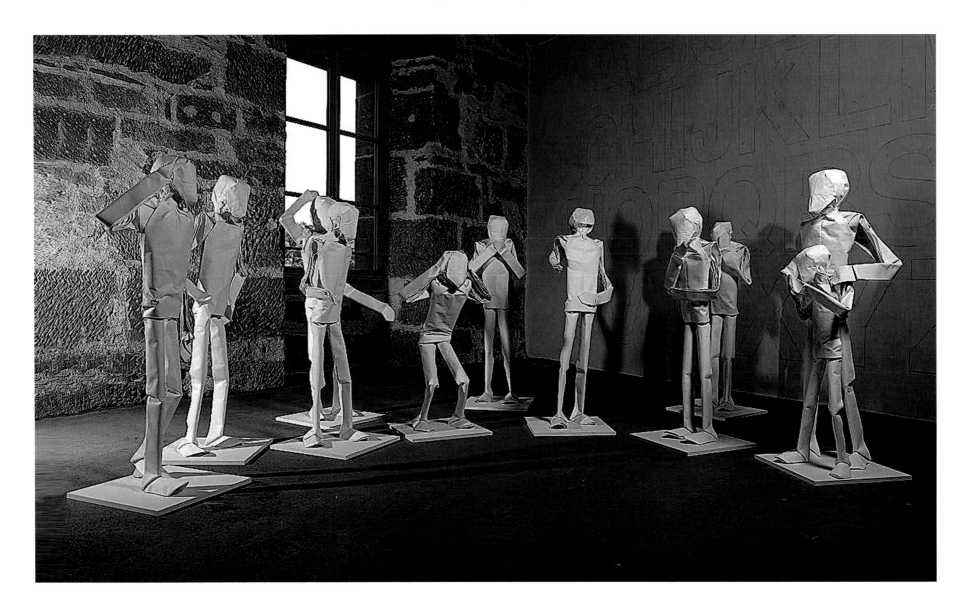

Much Ado About Nothing
Sipho Mabona, South Africa/Switzerland
2010, installation, Gutenberg Museum,
Fribourg, Switzerland
watercolor paper
(*Photo by Charly Rappo*)

a folded paper scene of a group of polar bears depicted in their natural habitat on the ice of the North Pole. But as we examine it more closely, we realize that the polar bears are actually crowding together on a shrinking iceberg; some have already fallen into the sea as the iceberg melts away. Although made up of folded paper animals, the sculptural installation serves visually as a heartbreaking reminder of the destructive effects of climate change on the natural world. A number of other origami artists have succeeded in creating such realistic portrayals of animals or birds, but Mabona is the first artist to fully explore origami as a medium for making such poignant social and political statements.

Although perhaps not as emotionally distressing as his works about endangered animals, an installation entitled *The Plague*, created for the opening of the traveling exhibition *Folding Paper: The Infinite Possibilities of Origami* at the Japanese American National Museum (JANM) in Los Angeles in 2012, is arguably his most powerful work. Again, he features multiple creatures flying through space, but in this work the creatures are not delicate swallows folded

Bearly Surviving
Sipho Mabona, South Africa/Switzerland
2010, installation, Gutenberg Museum,
Fribourg, Switzerland
watercolor paper
(Photo by Charly Rappo)

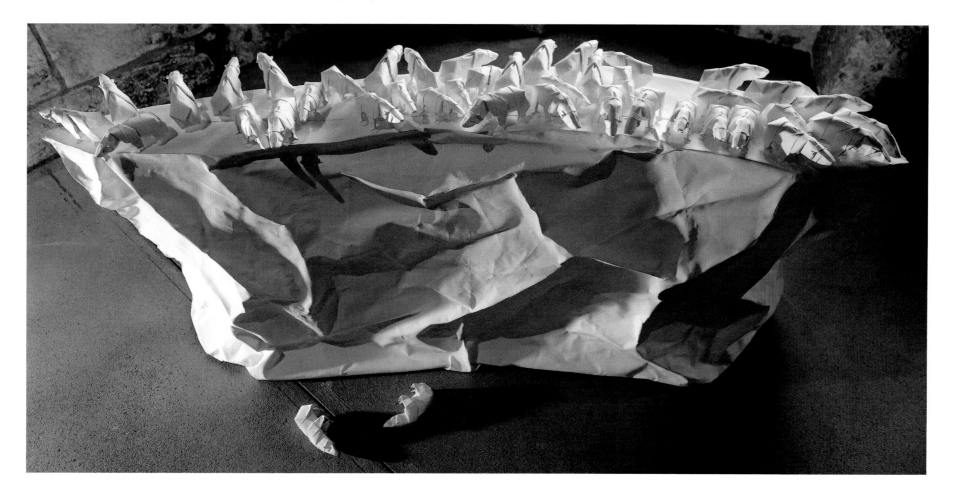

from colored or white paper. Instead, a total of 144 locusts take form out of sheets of dollar bills and swarm the gallery, evoking the biblical plague that was inflicted on humans who had behaved badly before God.

According to Mabona, the transformation of money into locusts is a reference to the large multinational investment corporations that take over smaller companies throughout the world and then discard them for a quick profit. In German-speaking Europe, such corporations, usually foreign, have recently been referred to as *Heuschrecken*, or locusts, spreading in swarms and greedily devouring local businesses. Since the US dollar bill has become the global symbol of capitalism, he contacted the US Bureau of Engraving and Printing and ordered sheets of uncut dollar bills for his project. Each locust was folded out of a square

measuring seven by three bills and was designed so that George Washington's head appears on the wings and upper back, and the phrase "In God We Trust" runs across their foreheads, enforcing the work's biblical message while also adding a touch of irony. Mabona was careful to study not only the anatomy of these voracious insects but also their swarming formation; they all fly in the same direction at once. The effect is quite menacing.

Mabona is fascinated by the transformational aspect of origami, the potential to fold a flat square of paper into any form. The concept of transformation plays a large part in *The Plague*, where dollar bills are morphed into a sinister plague of destructive insects. "Although a locust swarm is scary," says Mabona, "where there is the ability to transform, there is hope. In origami, paper is

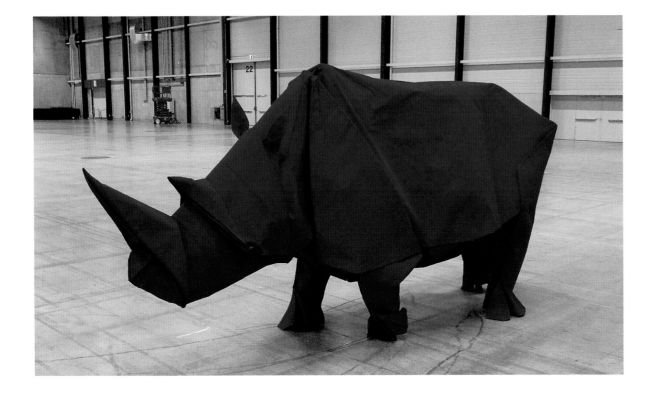

Above *Flying Locust*
Sipho Mabona, South Africa/Switzerland
2009, Japanese *gampi* paper
(*Photo by Christoffer Joergensen*)

Left *Life-size Blue Rhino*
Sipho Mabona, South Africa/Switzerland
2015, one uncut sheet of watercolor paper
(*Photo by the artist*)

Right *Untitled*
Sipho Mabona, South Africa/Switzerland
2009, watercolor paper
(*Photo by Christoffer Joergensen*)

Right ***Swallow (White Gold)***
Sipho Mabona, South Africa/Switzerland
2015, watercolor paper, gold leaf, acrylic
(*Photo by the artist*)

Far right ***Femmeausfall***
Sipho Mabona, South Africa/Switzerland
2015, paper, gold leaf, acrylic
(*Photo by the artist*)

Below ***Currency Bull Black on Green***
Sipho Mabona, South Africa/Switzerland
2014, US currency sheets, acrylic
(*Photo by the artist*)

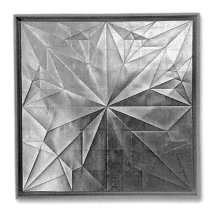

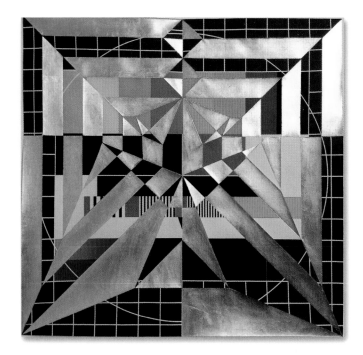

folded into forms like these locusts, but the forms can be unfolded again. The creases will remain, but the paper can be folded again into something else—perhaps butterflies."

Mabona has continued to use US dollar bills in his work since *The Plague*, not only folding them into animals but also incorporating them into his non-figural crease pattern series. In the last seven years or so, Mabona has been experimenting with the artistic potential of the geometric patterning in crease patterns, the folding lines left when an origami model is unfolded. In many of his recent crease pattern works, he has mixed his media by replicating crease patterns on ceramic tiles and applying gold leaf to elements of the patterns on paper. In 2015, he folded a small series of dollar bills and added color using acrylic, gold leaf or palladium leaf to sections of the pattern to create exquisite miniature works of art.

While Mabona's experimentation in non-figural

works is ongoing, he has by no means moved away from representations of animals in his work, and a number of his most provocative recent works have featured endangered animals, such as the rhino depicted with a broken horn and the bears splattered with red paint in his mixed-media work to signify blood. In 2014, he embarked on his most monumental tribute to date to the animal world. Rather that folding a multitude of creatures to fill a space, he chose to create one monumental figure—a life-size elephant. Funded by an Indiegogo campaign, Mabona folded a model of an adult elephant measuring 10 feet (3 meters) tall out of a single sheet of paper measuring 50 by 50 feet (15 by 15 meters) at the Art Museum in Beromünster, Switzerland. The work *White Elephant* (see page 104) was completed with the help of three assistants and supported by a wooden structure that bore the weight of the enormous model.

Mabona's origami elephant sculpture is a marvel of paper engineering. Like his other folded creatures, it is also a life-size reminder of the plight of one of the world's most majestic animals as it is poached to the brink of extinction. The title of the work *White Elephant*—a term we use for things that are of no use to us—hints at the cruelty and tragic waste of killing these peaceful creatures just to remove their precious ivory tusks. By creating a life-size elephant out of a single sheet of paper, Mabona proved to himself and others that origami artists are by no means limited by their medium. In fact, he contends that the opposite can be true. "In the art form of origami a simple piece of paper can be transformed into anything imaginable," he explains. "It's exactly this transformation, which in my opinion stands for many struggles we have to overcome in life." In his origami installations, Sipho Mabona shows us that this medium can be used as successfully as any other artistic media to motivate us toward transforming our world into a better place.

Left *Big White Praying Mantis*
Sipho Mabona, South Africa/Switzerland
2013, one uncut sheet of Japanese *kozo* paper
(*Photo by Christopher Joergensen*)

Below *Untitled*
Sipho Mabona, South Africa/Switzerland
2010, watercolor paper and ink
(*Photo by the artist*)

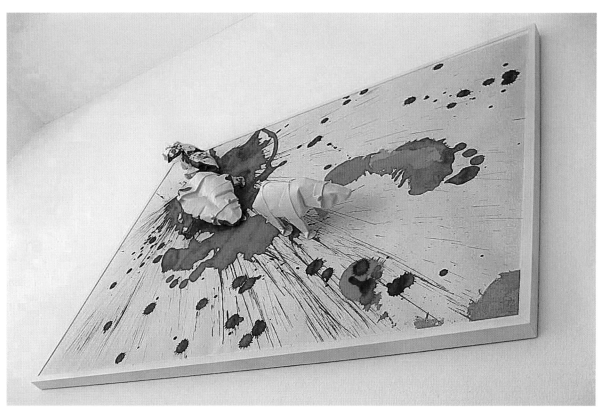

taking origami to the streets

THE MOMENTARY MURALS OF MADEMOISELLE MAURICE

In the last few decades, origami has been evolving so rapidly as an art form that just in the first years of this millennium artists have begun creating conceptual origami art works, large-scale origami installations, illuminated and kinetic origami sculptures, mixed-media origami—all an artistic leap from even the most complex of folded paper animals. In the last five years, French artist Mademoiselle Maurice (b.1984) has taken a further leap with her folded paper art—she has taken it outside onto the streets, beaches and riverbanks of cities all over the world by creating colorful murals on walls, stairs and rocks, each built up of hundreds upon hundreds of folded paper forms. Outside, the paper is vulnerable to the elements, so her dazzling designs only retain their initial color and form until the next rainfall or strong wind. Nevertheless, her ephemeral works of origami street art have captured worldwide attention, not only because of the beauty of the patterns she creates and the originality of her concept but also

undoubtedly because of the transitory nature of her work. The fading of the colors and the disintegration of the paper itself is a reminder of the transience of life, an idea that is embraced and celebrated in Japan, origami's land of origin, and one that seems to be striking a cord today throughout the world as more people consider the fragility of our environment and societies.

Mademoiselle Maurice (she prefers to be known by her artist name) was born in the Savoy region of France, and after studying architecture in Lyon worked in Geneva and Marseille. In 2011, she was spending a year living in Japan when the devastating earthquake, tsunami and nuclear meltdown struck northern Japan. Inspired by the tragedy that affected so many Japanese people, she decided to create artworks in urban settings to help lift the spirits of the people. Taking her cue from the 1,000 folded origami cranes of Sadako Sasaki, who died as a result of the atomic bomb in Hiroshima, she began folding paper for all the victims of conflict and

war and as a wish for peace around the world. Soon after her return to France, she began creating urban installations using origami, folding hundreds of small butterflies, windmills, flowers and other forms. Her first installation in Paris was a protest against nuclear power and weapons. Originally, she made it with white origami forms and the letters "NO." However, she explains that this work was "too sad and negative, so I put the colors and abstraction after that." The paper creatures she folds represent nature, and their vivid colors symbolize brightness and optimism. She deliberately selects particularly gray, dilapidated and abandoned parts of Paris and the other cities where she has taken her work, hoping that, in contrast, the vividly colored mural will bring lightness, the beauty of nature and hope to the surroundings.

In just a few years, Mademoiselle Maurice has created origami murals out of brightly colored papers in many countries, including France, Vietnam, Canada, the

Origami mural in Hue, Vietnam
Mademoiselle Maurice, France
2012, colored origami papers, adhesive
(*Photo by the artist*)

Above and right **Origami street art on the steps
of the St. Maurice Cathedral of Angers, France**
Mademoiselle Maurice, France
2013, colored origami papers, clips
(*Photo by the artist*)

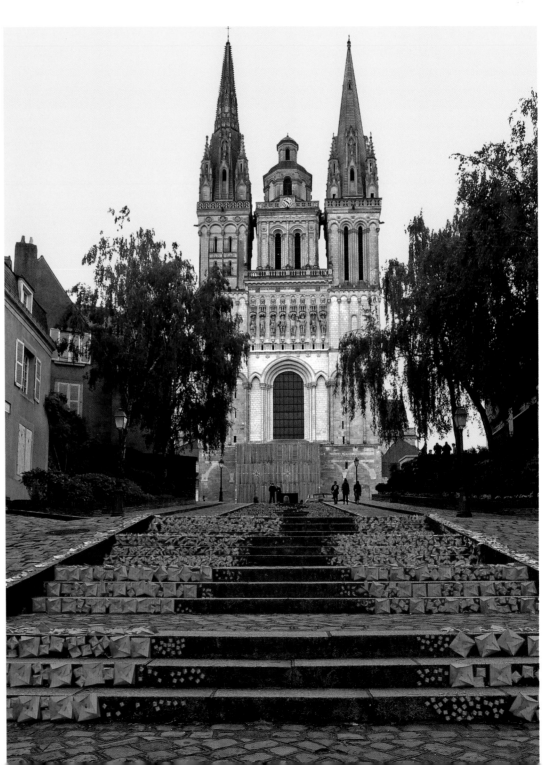

United States and Japan. She refers to her work as "urban art," but it could also be described as "street art" since there is much in her approach to her work that conforms to the evolving definition of this genre. Since street art was first recognized as an art form in the 1980s, it has been defined using certain criteria, which have become flexible over the decades. Typically, street art is unsanctioned and often provocative or subversive. In many cases, street artists are protesting against social or economic oppression or highlighting a particular cause. By anonymously spray painting, stenciling or posting their artwork on city walls, bridges and subways under cover of darkness, their aim is to communicate directly with the public by bringing their messages to the streets. As more galleries and museum curators have embraced the art form, more mainstram artists have moved outdoors, creating video projections and yarn bombings that often have very little to do with

Right and below *Origami mural along the bank wall of the Maine River in Angers, France*
Mademoiselle Maurice, France
2013, colored origami papers, adhesive
(*Photo by the artist*)

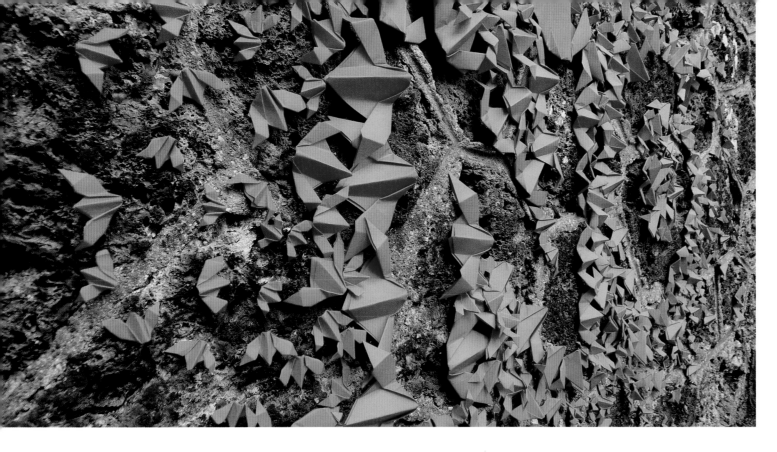

social or economic oppression. In Mademoiselle Maurice's "origami bombing," much of her work is authorized, created in public in daylight and relatively impermanent. However, with her upbeat folded murals, the world's first "origami street artist" bears a message. Using bright colors and natural forms, she hopes to subvert the pessimism and hopelessness found in many of our cities and offer light and hope to their residents.

Maurice's smaller murals are geometric and abstract, built up around a central empty triangle or circle that represents a "huge idea" like harmony, spirituality or peace. Around this symbolic negative space, she arranges the folded elements by color to build a rainbow stretching across the surface to express the artist's hope for a more diverse, accepting, environmentally conscious and peaceful world. While realizing

Origami mural on the rocks of Baker Beach, San Francisco, USA
Mademoiselle Maurice, France
2014, colored origami papers, adhesive
(*Photo by the artist*)

that the rainbow can be a somewhat "naïve" symbol, Maurice admits to finding inspiration in the words of Harald Zindler: "The optimism of the action is better than the pessimism of the mind." Zindler, a German environmental activist, was one of the founders of Greenpeace, and she notes that this organization often uses the rainbow as a symbol of hope.

The rainbow motif also features in her larger works, but often as the color scheme for a specific motif that she builds up out of origami forms. One such motif was a bundle of wheat grains she selected for a work on the stepped seating of an Athens stadium to mark the fifteenth anniversary of Action Aid's charity work there. The wheat represented food and its many stalks, formed in rainbow colors, the diversity of people helping to bring food to the poor. Although the origami forms she

uses to create the murals are not usually complex, she needs so many for each mural that they take many hours to fold. "Sometimes, I like to imagine when I am folding that all the origamis are like people, and I imagine some imaginary positive connection between these humans." On certain projects, she has also had to recruit volunteers to help her fold. For her contribution in 2013 to a cultural festival in Angers, a city southwest of Paris, she created two large-scale works—a large mural featuring a portrait on a wall along the river, and the decoration of the grand staircase leading from the river up to the city's St. Maurice Cathedral. Because of the scale of the mural, it required months of planning and folding—a total of about 30,000 folded pieces. Maurice recruited help folding from volunteers in local schools, colleges, leisure centers and even prisons.

Origami mural on the beach, Sicily
Mademoiselle Maurice, France
2013, colored origami papers, adhesive
(*Photo by the artist*)

Whether she is folding alone or with collaborators, she believes that the folding of all these papers creates a network of human solidarity, and this feeds the optimism of her work.

Later in 2013, Maurice collaborated with some more conventional street artists in Marseilles. As the Graffiti Crew PST spray painted their names, characters and slogans in chunky lettering along a length of wall in a run-down part of the city, Mademoiselle Maurice applied her folded windmills and flowers to the central section of the wall to create an exploding rainbow. In the center, which she typically leaves empty as a circle or triangle, one of the graffiti artists painted in a roll of unraveling toilet paper. The playfulness of the motif and the fact that the graffiti crew followed Maurice's lead in the rainbow palette used for the entire mural shows an acceptance of her urban origami art into their world. For decades now, many origami enthusiasts have known that origami is "cool." One hot July afternoon in Marseille in 2013 may have been the moment when origami as an art form officially gained some serious street credibility.

Top *Origami street art portrait of
Annaick Le Mignon in Angers, France*
Mademoiselle Maurice, France
2013, craft paper, adhesive on white paint
(*Photo by the artist*)

Above *Origami street art in Paris, France*
Mademoiselle Maurice, France
2013, colored origami papers, adhesive
(*Photo by the artist*)

Left *Origami mural in Malmö, Sweden*
Mademoiselle Maurice, France
2014, colored origami papers, adhesive
(*Photo by the artist*)

modern interpreter of ancient forms

Photo courtesy of the artist

The Japanese have been folding paper cranes for several centuries now. In Japan, the crane symbolizes long life and good fortune, and folding 1,000 cranes is believed to guarantee the granting of a wish. Hence, garlands made of 1,000 cranes have traditionally been made as wedding gifts as a wish for a long, happy marriage. By the Edo period (1615–1868), an entire book was devoted to different folding methods for origami cranes. The 1797 volume, entitled *Hiden Senbazuru Orikata* (*Secret Folding Methods for One Thousand Cranes*), explained how to fold not just a simple crane form but also multiple crane forms out of a single sheet of paper. These *renzuru*, or connected cranes, are made by strategically cutting the paper and folding each square without tearing the corners, a technique that inspired Japanese American origami artist Linda Tomoko

Mihara (b.1959) to create some of her most well-known works of contemporary origami art.

Linda Tomoko Mihara is a third-generation Japanese American who learned the art of origami around the age of five from her parents and grandparents. Her grandfather Tokinobu Mihara wrote the book *Origami: Japanese Art of Paper Folding* (Volumes 1 and 2) in 1958, the first books about origami to be published in English in the United States. Not surprisingly, therefore, Mihara's origami sculptural works are grounded in Japanese tradition. However, as an artist and designer, she has pioneered several different origami styles, most famously her three-dimensional connected crane sculptures, which are based on the traditional *renzuru* style, also known as *Rokoan* after Gido Rokoan (1759–1831), the Buddhist priest who authored the origami crane book. Following the tradition, she folds multiple connected cranes out of a single sheet of paper cut into small squares connected at only the corners, a technique that is challenging enough because of the fragility of the paper typically used for origami. After many years of practice and experimentation, Mihara literally pushed this technique into another dimension. The result was the first ever 3-D connected crane

sculpture, *Peace Sphere*, designed in 1994. Comprising eighteen connected cranes, the sculpture references the more recent symbolism of the origami crane form that grew after the atomic bombing of Hiroshima. Since young Hiroshima girl Sadako Sasaki folded origami cranes in the hope that she would be cured of the leukemia the bomb inflicted upon her, the paper bird has come to represent a wish for world peace. Because of the novelty of its form and the power of its message, Mihara's *Peace Sphere* has been exhibited in many countries since its creation.

Her 3-D connected cranes, which she describes as a "traditional technique with a modern spin," is demanding for both the artist and the paper because the tension caused during folding of such a detailed form can cause the paper to tear at the joins. It took Mihara five years to find the right type of paper to realize the *Sphere*. It had to be thin enough to fold intricately but sturdy enough to support the folded form. The paper she chose is *unryu* paper, a Japanese paper made from mulberry bark, which contains long fibers that give the sheets strength and durability. She also uses a type of *unryu* that is coated with metallic powders, which gives her crane sculptures a bronze-like finish that

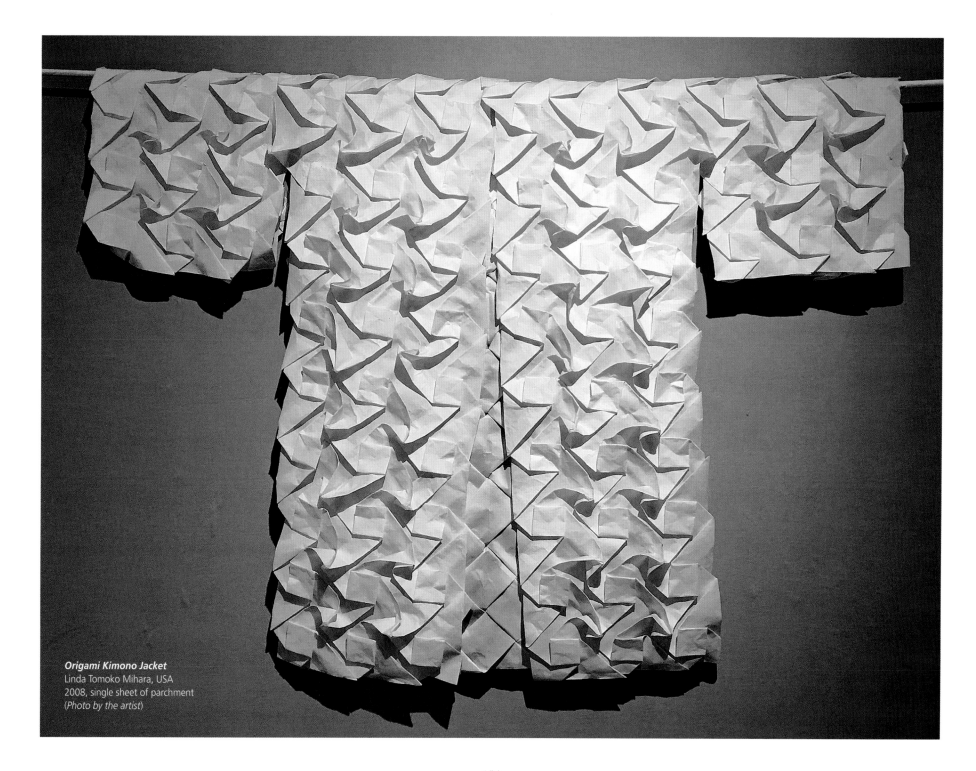

Origami Kimono Jacket
Linda Tomoko Mihara, USA
2008, single sheet of parchment
(*Photo by the artist*)

aesthetically evokes many classical sculptural traditions. *Crane Cube*, which Mihara designed in 2003, is even more technically complex. It is made with 54 cranes all connected at the corners and modeled into a perfect cube.

The crane also features in Mihara's two-dimensional series, the "Art of One Thousand Cranes," in which she forms bold two-dimensional designs and patterns using 1,001 cranes, usually folded out of metallic papers and assembled often overlapping each other to form richly textured gold and silver patterns. For over twenty years now, she had been creating custom designs, including traditional family crests, modern kimonos, fans and waves, often as commissions for wedding gifts among the Japanese American community but also for exhibitions. Many of the designs echo traditional Japanese treatments of motifs on textiles, the gold and silver papers reminiscent of the luxurious gold couch threads stitched onto traditional Japanese ceremonial gift covering cloths called *fukusa*. These were often used to cover wedding gifts, so the connection to traditional

Right ***Blue Wave Dress***
Linda Tomoko Mihara, USA
2012, single sheet of Thai *kozo* paper
(*Photo by the artist*)

Far right ***Star Tessellated Dress and High Heel Shoes***
Linda Tomoko Mihara, USA
2010, single sheets of parchment
(*Photo by the artist*)

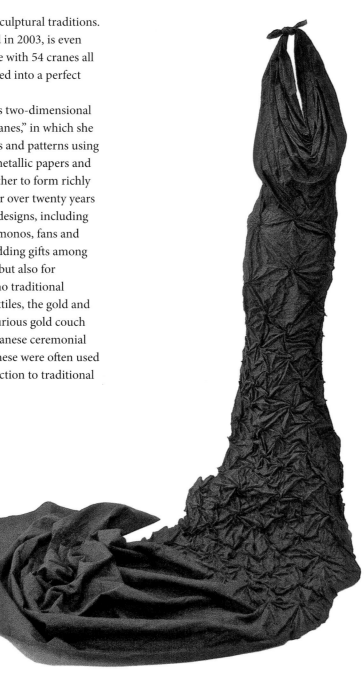

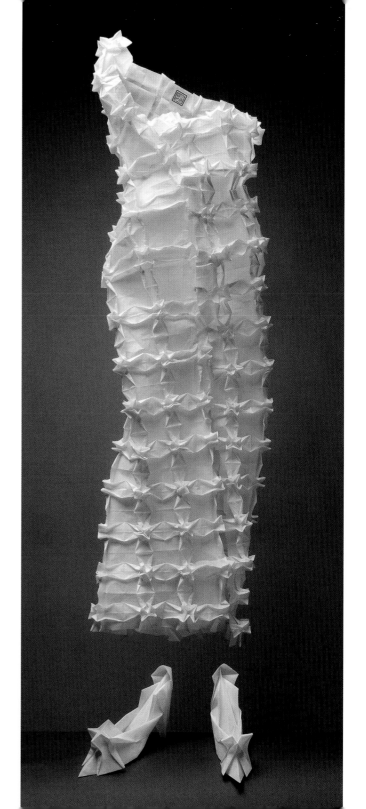

Japanese culture in these works is more than simply visual. However, some works in this series contain multicultural motifs, among them roses and skulls, drawn from sources that include tattoo art.

Textile design is also evoked in her recent larger-scale two-dimensional works created using the connected crane technique. Recently, she folded a single rectangular sheet of paper into a piece entitled *9 Diamond Crane Quilt* (2007), a long vertical wall hanging composed of twenty rows of eight (totaling 160) folded cranes, all connected to resemble an exquisitely woven or braided textile. Mihara carefully calculated the gaps between the cranes so that when viewed from a distance, a diamond pattern appears throughout the surface of the piece. In a similar large piece, *Copper Crane Quilt* (2004), in which connected cranes are folded from a large square of copper-leafed paper, larger gaps were created by removing sections from the original square, forming a carefully balanced geometric pattern in the final quilt design.

Given Mihara's fascination with textile designs over the decades, it is perhaps not surprising that her current area of interest is designing and creating wearable origami art. The works are remarkable both technically and aesthetically. For these creations, she employs a more modern origami technique known as tessellation. In its most common form, a tessellation is created when a single sheet is folded to form a pattern of folded lines that fills a plane with no overlaps or gaps, much like decorative wall tiles. Tessellations are often created using pleats to connect together elements such as twist folds in a repeating fashion and have become popular in the last couple of decades among origami enthusiasts and artists. Since 2008, Mihara has created several notable folded fashion pieces, including *Star Tessellated Dress and High Heel Shoes* (designed 2009, folded 2010), a wearable dress folded out of a single sheet of paper, with matching but not wearable shoes, and *Kimono*

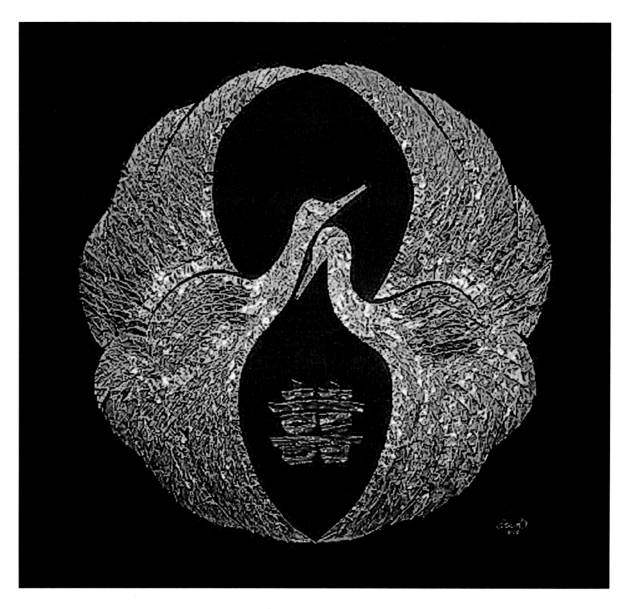

Infinity Cranes with Double Happiness
Linda Tomoko Mihara, USA
2008, gold and red Japanese foil paper
(*Photo by the artist*)

123

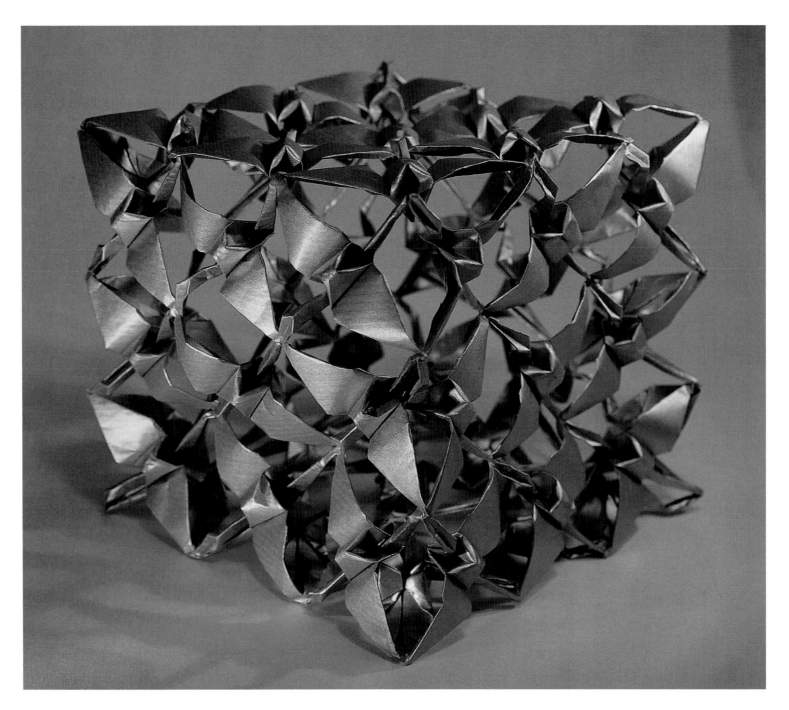

Crane Cube
Linda Tomoko Mihara, USA
2005, 54 connected cranes
folded from a single sheet
of silver foil *washi* paper
(*Photo by the artist*)

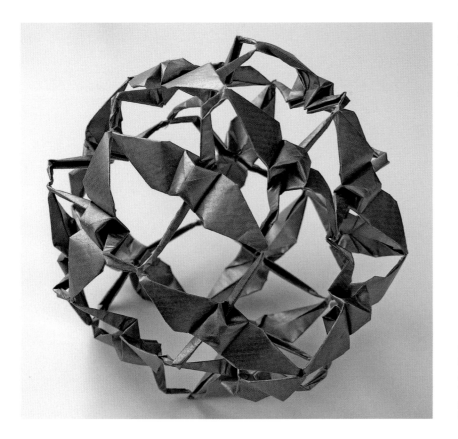

Left ***Peace Sphere***
Linda Tomoko Mihara, USA
1994, 18 connected cranes folded
from a single sheet of gold foil
washi paper.
(*Photo by the artist*)

Right ***9 Diamond Crane Quilt***
Linda Tomoko Mihara, USA
2007, 160 connected cranes folded
from a single sheet of Japanese *unryu*
paper
(*Photo by the artist*)

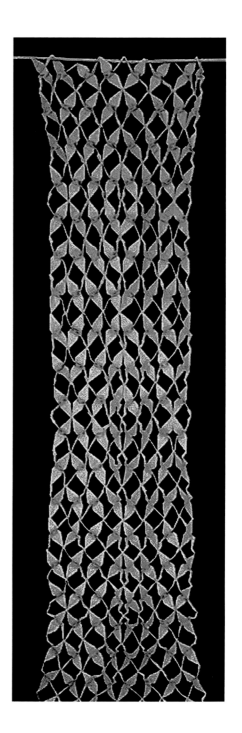

Jacket (2008), created with a complex swirling pattern, also using the tessellation technique from a single sheet of parchment that originally measured 9 feet (3 meters) by 15 feet (4.6 meters). In 2010, she used a more durable material, Tyvek, for a wearable vest, which was also folded using tessellation techniques, without cuts or glue.

Linda Tomoko Mihara has been a professional origami artist since 2001. Along with a handful of other colleagues who share this rare job title, she has created a considerable amount of commercial work, including models that have been featured in television commercials. In 2005, she worked with Robert J. Lang to create the origami models for an animated commercial for the Mitsubishi Endeavor, a car that was depicted driving through a mythical landscape built of origami models. She collaborated again with Lang in 2006 for a Febreze commercial, in which a young girl enjoys the scent of her bathroom so much that she sits there for hours folding models of animals out of toilet paper. From her work inspired by connected cranes designed by an eighteenth-century Japanese Buddhist monk to her wearable origami garments and work in animation and television commercials, Mihara's creative range is expansive. There are few origami artists today whose work blends Japanese tradition with global and contemporary aesthetics more than this American artist with a deep connection to her Japanese cultural roots.

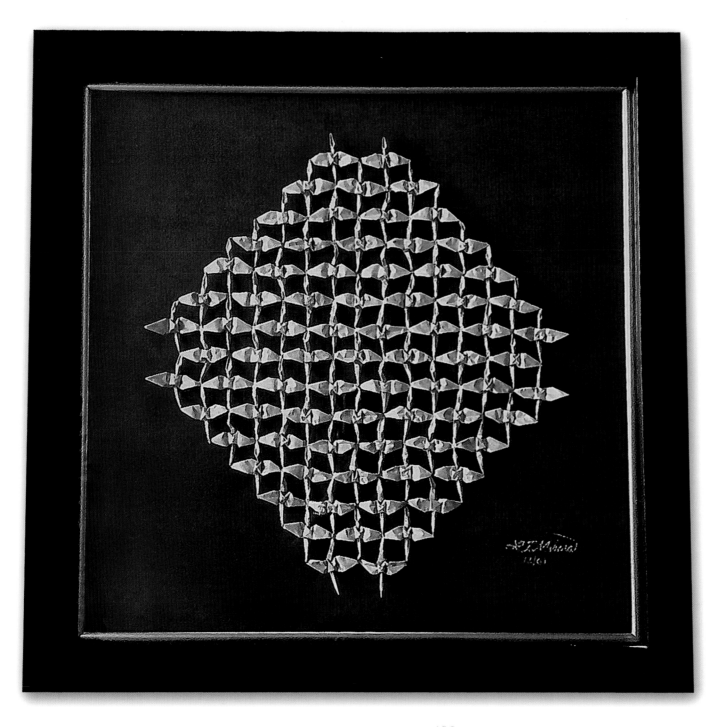

Top right **Dollar Bill Fox**
Linda Tomoko Mihara, USA
2010, US ten-dollar bill
(*Photo by the artist*)

Center right **1,001 Cranes
Art** (detail)
Linda Tomoko Mihara, USA
2005, gold and silver Japanese
foil paper, mounted on
Ultrasuede
(*Photo by the artist*)

Bottom right **Deby Star
Necklace**
Linda Tomoko Mihara, USA
2013, silver Japanese foil paper,
designed for Emmy nominee
Deborah Ivers, who wore it
to the 2013 Emmy Awards
(*Photo by the artist*)

Left **77 Cranes**
Linda Tomoko Mihara, USA
2001, folded for the 77th birthday
of Reverend Seiji Kobara, single sheet
of Mylar paper brushed with *unryu*
threads, mounted on Ultrasuede
(*Photo by the artist, courtesy of the
Kobara family, San Francisco*)

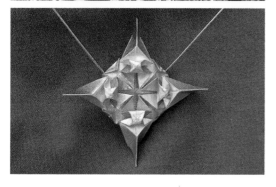

Red Kimono with Gold and Silver Dragon
Linda Tomoko Mihara, USA
2005, 1,001 cranes folded from gold, silver and red Japanese foil paper
(*Photo by the artist*)

where computers meet creasing

THE DIGITAL ORIGAMI OF JUN MITANI

In 2010, one of Japan's most renowned fashion designers, Issey Miyake, best known internationally for his *Pleats Please* line, sought to create a new line of clothing that would have a three-dimensional form but would fold flat. He turned to origami for inspiration. For the designs, he approached Jun Mitani, a computer scientist specializing in geometric modeling in the field of computer graphics, who had been studying algorithms and user interfaces for generating 3-D shapes on a computer. Mitani, who was then an associate professor at the University of Tsukuba in Ibaraki Prefecture, 30 miles (48 km) north of Tokyo, led a team of researchers at Miyake's Reality Lab to create an algorithm that allowed 3-D clothing and accessories to be folded into flat 2-D forms, like origami. The *132 5* line was named, in part, for its origami characteristics. Each garment was made out of one piece of recycled PET polyester, took a three-dimensional form but could be folded into two dimensions. The line received significant acclaim in the fashion world, spotlighted origami as a rich design source and demonstrated to Mitani the myriad potential applications for his origami technology.

Mitani learned origami as a young child growing up in Japan. Although he enjoyed making models of airplanes, ships and buildings, he found paper folding restricting since he preferred having the freedom to cut and glue paper. At a very young age he also had a passion for computers, and his father bought him his first computer when he was in first grade. Later, as a university student, his interests in paper craft and computing came together. His 2004 doctoral thesis from the University of Tokyo was based on designing paper models using computers. A few years later, in 2009, Mitani designed a computer software program called ORI-REVO, which can be used to design 3-D origami forms that have rotational symmetry. The program can generate a variety of shapes from a 2-D sheet and uses animation to show the folding and unfolding of the origami form. This program was not created to help people design traditional origami figures of animals or birds, but instead to assist in the creation

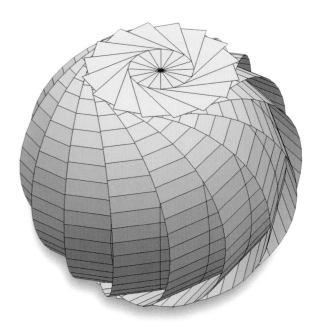

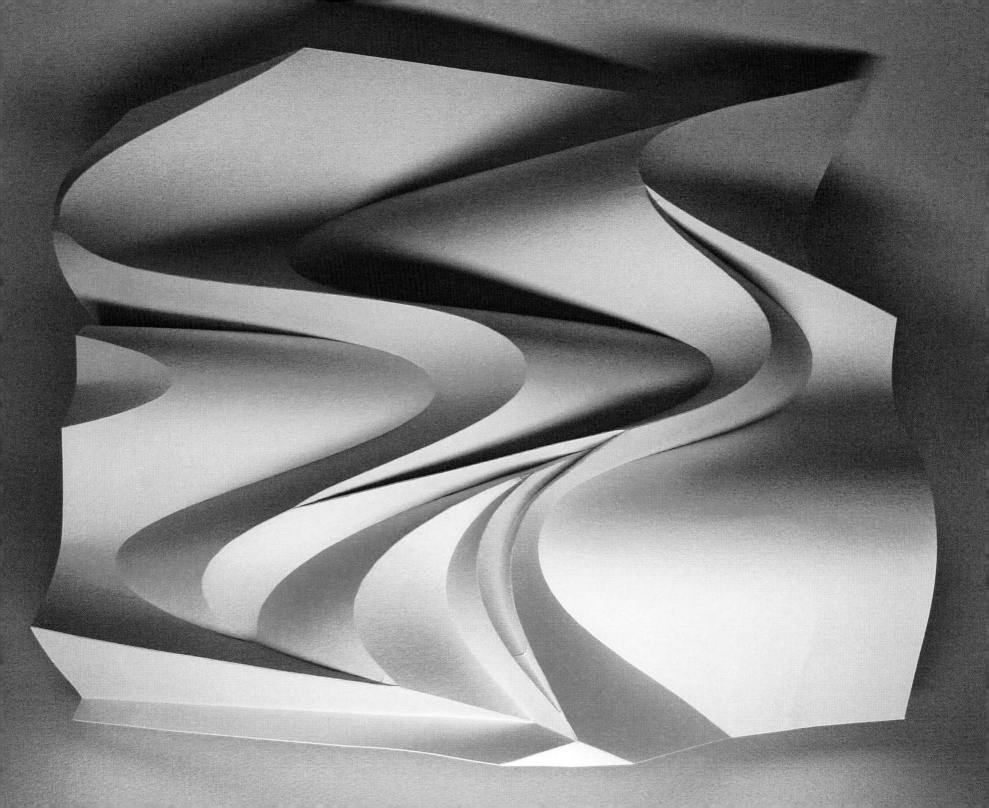

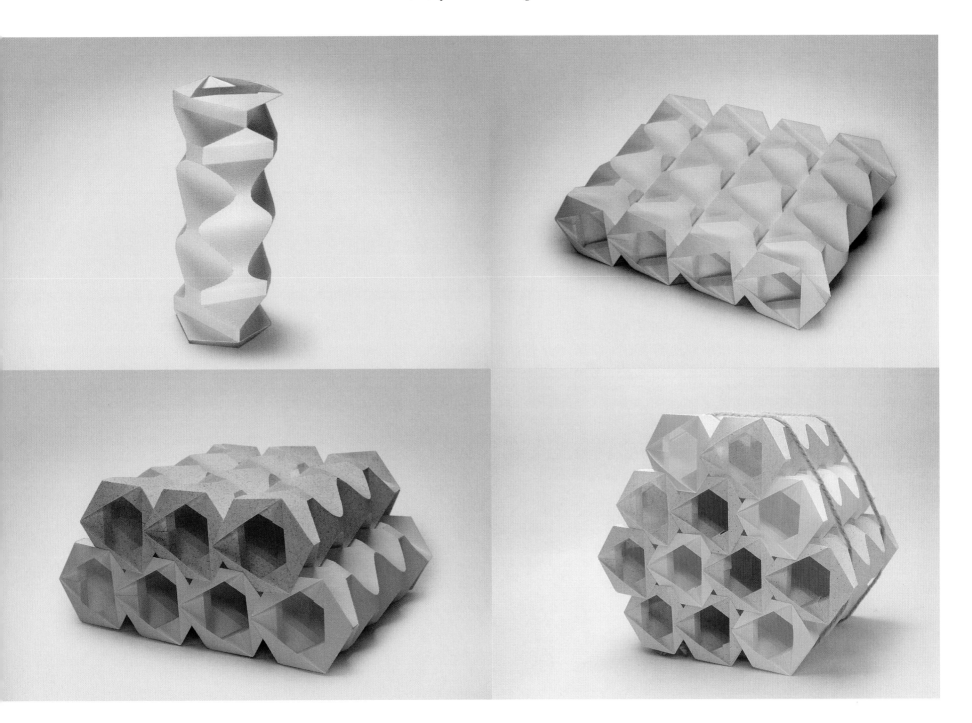

Left *Corrugated Hexagonal Column
(1, 4, 7 and 12 modules)*
Jun Mitani, Japan
2014, Tanto paper
(Photo by the artist)

Below *Pear*
Jun Mitani, Japan
2011, Tanto paper
(Photo by the artist)

Below right *Combination of Cubic
Units with Curved Folds*
Jun Mitani, Japan
2011, Tanto paper
(Photo by the artist)

complex symmetrical objects based on basic forms. "I don't really understand much about traditional origami. I am more interested in geometric forms," he admits.

Although Mitani respects traditional origami masters who can create an animal or other form from memory, his approach uses technology to challenge classical origami and allow him to create forms he would otherwise be unable to build by folding paper. He has used ORI-REVO himself to design folded paper sculptures, and to help with the folding he generally uses a cutting plotter to score lines in the paper. He then folds the paper by hand to create a wide range of forms. Although most of the hundreds of models he has created are non-representational, one of his most elegant works is *Pear* (2011), a sculpture that appears simple in silhouette, yet is challenging to fold successfully from paper. However, because a perfectly formed pear has rotational symmetry, his software can

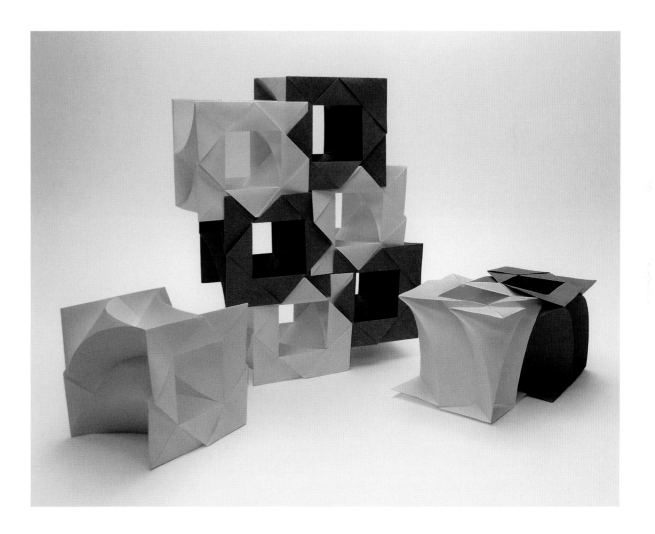

map out a folding pattern that allows him to fold its gentle curves and capture the unique form of the fruit.

The work *Connected Spheres* (2013) is representative of the complex forms Mitani has been folding over the years. The sculpture, folded from a single rectangular sheet of Japanese Tanto paper, comprises two spheres that are formed by folding along curved lines and then twisting the entire form and securing it at each end with a neat spiral fold. Unlike a number of origami artists who work with thick paper, Mitani does not use wet folding, but he sometimes uses glue to secure and stabilize the form. Similarly curvilinear is his work *Half of a Torus* (2013), a folded paper representation of a mathematical surface known as a torus, which resembles a perfectly circular donut. Mitani also folded this form from a rectangular sheet of paper and added small cuts at certain points to help form the curve. One of his most recent works, *Folding a Gear* (2015), is both a well-balanced geometric paper sculpture and an artistic exploration of one of the most important

Two Variations of the *Six Windmills*
Jun Mitani, Japan
2013, Tanto paper
(*Photo by the artist*)

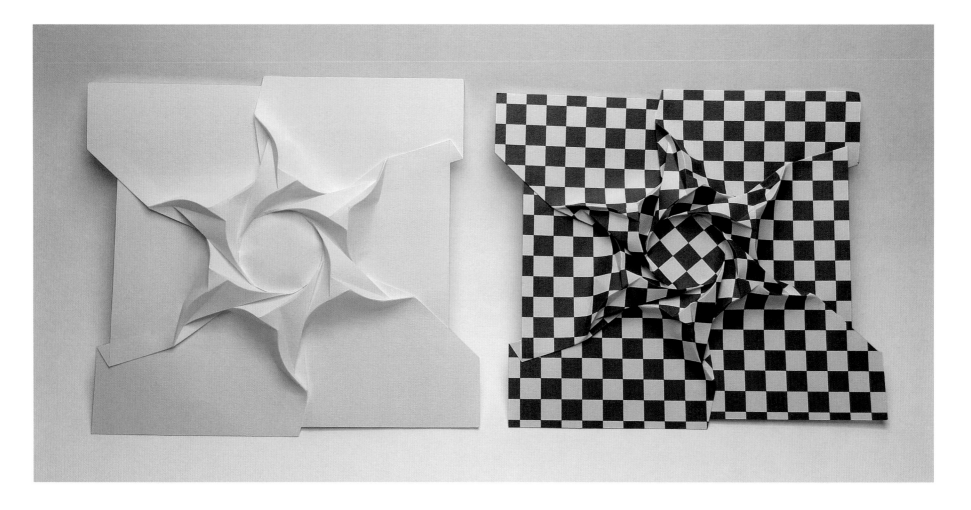

Connected Spheres
Jun Mitani, Japan
2013, Tanto paper
(*Photo by the artist*)

components in any mechanical device—perhaps a wry reference to his own mechanization of origami.

Mitani's fascination with geometry has also led him to explore modular works and tessellations. He has created a series of works entitled *Stackable Origami*, in which a number of modules, each somewhat complex in their geometric composition, can be assembled to create a larger form. In *Combination of Cubic Units with Curved Folds* (2014), the contrasting brown and white blocks are attached to each other with flaps and pockets, typical of modular origami, to create additional geometric surface patterning. In *Corrugated Hexagonal Column* (2014), each module is twisted and elongated with a hexagonal opening at each end. When stacked, the entire form takes on the intricately complex appearance of a honeycomb. Another work that can perhaps also be considered modular is *Whipped Cream* (2015), in which a series of bud-like forms are assembled on a flat surface, not connected but with their bases overlapping. Their pure white color and the bud form evoke a pond full of lotuses preparing to bloom in a Buddhist temple garden.

As well as modular creations, Mitani has created some spectacular low-relief tessellation work, the most intriguing of which are those that are the least symmetrical. His *Voronoi Based Tessellation* (2013) is based on a mathematical diagram, a Voronoi Diagram,

Crystal Boundary
Jun Mitani, Japan
2012, Tanto paper
(*Photo by the artist*)

Right **Kabuki Face**
Jun Mitani, Japan
2011, Tanto paper
(*Photo by the artist*)

Opposite **Whipped Cream**
Jun Mitani, Japan
2015, Tanto paper
(*Photo by the artist*)

in which a plane, which has a set of points on it, is divided by straight lines drawn at an equal distance between pairs of points throughout the plane. Mitani's tessellation appears to grow from one corner of the paper, spreading outward like cracks in ice or lightning. In another work, *Relief of a Wave* (2010), which was exhibited at the *Surface to Structure* origami exhibition at Cooper Union in New York City in 2014, is an elegant work of relief tessellation, at once geometric and highly organic in its rhythmic undulation.

Because Jun Mitani's folded paper sculptures are created using computer software and his folding lines are scored with a cutting plotter, some in the origami community would not consider him to be a true origami artist. However, it is exactly this high-tech approach to folding three-dimensional forms out of paper that makes him one of the most daring innovators in the world of origami, one who is not afraid to cross over into other worlds like fashion and industrial design. Like Robert J. Lang, who has designed software that makes crease patterns for figures of animals, birds and insects, Mitani is adapting the advanced technology available to scientists to enable artists to create elaborate works of sculpture they might not otherwise be able to make. Although much of the creative process involves a keyboard and a mouse, it is ultimately his imagination and creativity that gives birth to these exquisitely curved and complex works of folded paper—digitally created sculptures in multiple senses of the word.

134

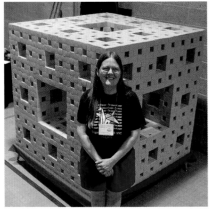

Photo by Ravi Apte

folding fractals

THE EXPANSIVE ORIGAMI OF JEANNINE MOSELY

Origami artist Jeannine Mosely (b.1953) loves numbers and breathing life into them. With a PhD in electrical engineering and computer science from the Massachusetts Institute of Technology (MIT) and following a career in three-dimensional modeling, she brings to origami a unique approach involving thousands of business cards, hundreds of folding helpers and a mathematical phenomenon called a fractal, which provides the foundation for her large-scale structures. There are many other origami artists who explore mathematical algorithms, patterns and structures in their modular origami or tessellation work, but there are few who are as elegantly expansive as Mosely, folding a basic form and using it to create a larger version of itself and sharing this experience with as many other people as possible, both participants and viewers.

Mosely approaches origami believing that "You can see a mathematical theorem or formula made real when you create a new model." Many of her models begin with a fractal, a naturally occurring phenomenon or a mathematical set that has a pattern that repeats and displays as it is enlarged or shrunk. If the replication is exactly the same at every scale, the pattern is referred

Opposite **Snowflake-shaped hole in the level-3** *Business Card Mosely Snowflake Sponge*
Jeannine Mosely, USA
2015, 2010, business cards
(*Photo by Margaret Wertheim, Institute For Figuring, Los Angeles*)

Level 2 Snowflake
Jeannine Mosely, USA
2010, business cards, colored card stock
(*Photo by the artist*)

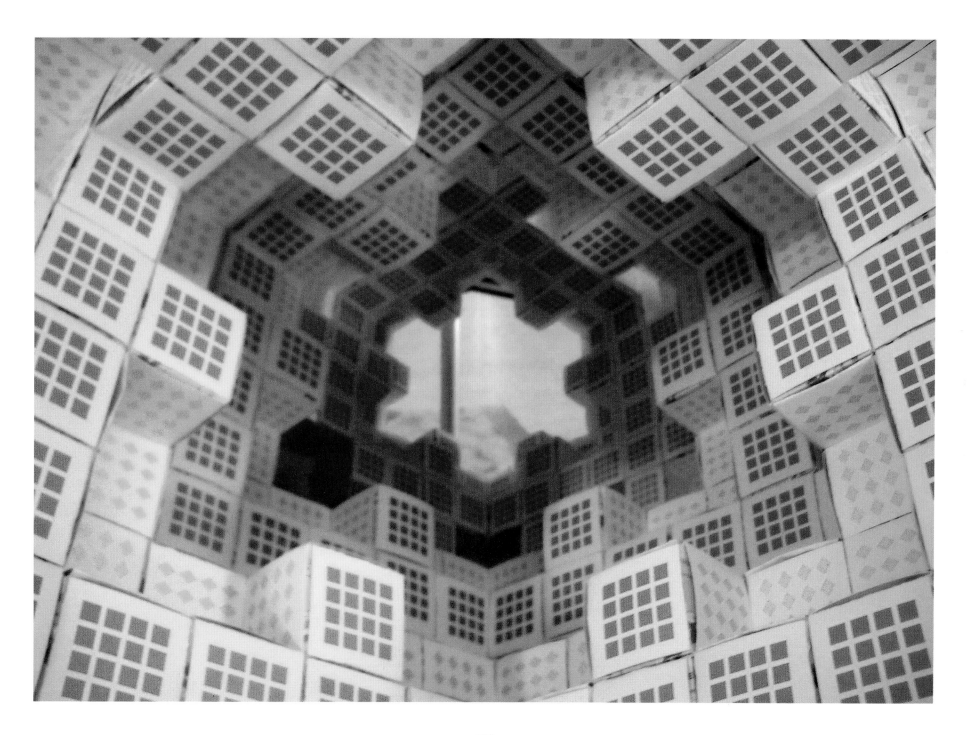

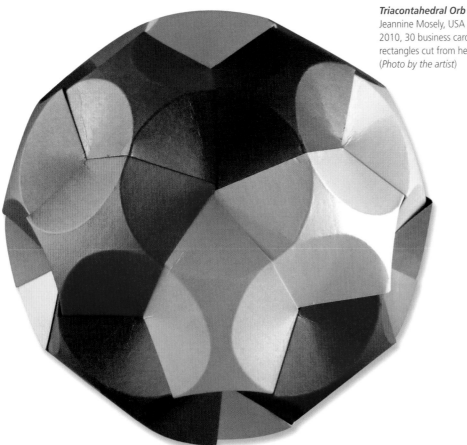

Triacontahedral Orb
Jeannine Mosely, USA
2010, 30 business card size
rectangles cut from heavy art paper
(*Photo by the artist*)

Dodecahedral Orb
Jeannine Mosely, USA
2010, watercolor paper
(*Photo by the artist*)

to as a self-similar pattern. Also known as expanding symmetry or evolving symmetry, fractals can be found in nature in seashells, ferns, lightning, snowflakes and even broccoli, all of which are made up of patterns that repeat as they grow or expand. In mathematics, one well-known fractal is the Menger Sponge, a cube that can be divided up into smaller cubes or multiplied into larger cubes following a specific repeating pattern. To create this fractal, the surface of each side of the cube is divided into 9 squares (so 27 smaller cubes), like a Rubik's Cube. Then the central cube on each side and in the very middle of the large cube are removed, leaving a total of 20 cubes and forming a level-1 Menger Sponge. Repeating the division of each of the 20 cubes in the same way results in a level-2 sponge, and then dividing the resulting cubes again will create a level-3 sponge.

It was the Menger Sponge that was at the heart of Mosely's first major origami installation. Mosely had loved origami since she was five years old, and later she discovered she had the rare ability to see spatial structures in her head. In 1994, while playing with her son, it occurred to her that one could fold fractals.

Below ***Herringbone Tessellation***
Jeannine Mosely, USA
2010, heavy art paper
(*Photo by the artist*)

Right ***Sails***
Jeannine Mosely, USA
2008, watercolor paper
(*Photo by the artist*)

Levels one, two and three *Business Card Menger Sponges*
Jeannine Mosely, USA
2006, business cards, installed at Machine Project, Los Angeles
(*Photo by Margaret Wertheim, Institute For Figuring*)

for years, it was her large-scale Menger Sponge that established her reputation as a major origami artist.

The city of Worcester, Massachusetts, soon learned of her work, and in 2008 she was commissioned by its First Night Worcester (MA) organization to develop a project as part of its New Year's Eve celebration. In preparation for this project, Mosely made a 3-D computer model of Worcester's Union Station. Assisted by First Night Worcester's Director Joyce Kressler, she recruited several hundred local school children and student volunteers from Worcester Polytechnic Institute to help fold. Together, they folded over 60,000 business cards into cubes and assembled them to create a 12-in (30.5-cm) wide, 6-ft (1.8-m) high and 7-ft (2.1-m) deep model of the station, one of the largest modular origami installations ever constructed. In 2012, she was invited to Los Angeles by Margaret Wertheim of the Institute For Figuring to create another large-scale fractal model for the University of Southern California (USC) Libraries. The model was based on the Mosely Snowflake, a fractal related to the Menger Sponge and discovered by Mosely herself. With the help of several hundred USC students, she constructed the model out of 49,000 business cards in a large installation that spread throughout the USC Libraries for several months.

Although Mosely is best known for her large-scale collaborative origami installations made with business cards, she also works on a more intimate scale. Although primarily modular origami sculptures and tessellations, mathematics figures prominently in these works too. Her orbs and buds, which are formed using curved creases in colored art paper, are examples of modular origami at its most refined. Her mastery of curved folding has enabled her to create such colorful and poetic forms as *Triacontahedral Orb* (2010), a modular work folded from thirty sheets, in which each of the orb's thirty faces is a recessed circle, like the craters of a perfectly symmetrical moon. Her

Around that time, the company she worked for had changed its address and had several thousand old business cards sitting in storage. She used a traditional folding method to create cubes out of business cards, and devised a way of linking and paneling the cubes to form structures that could be very large. In 1995, she launched a project to construct a level-3 Menger Sponge using these cubes. Ten years later, Mosely and about 200 volunteers had folded and assembled 66,048 cards into a Menger Sponge measuring 5 feet (1.5 meters) on each side. Although she had been creating origami models

Left *Origami Model of Union Station, Worcester, Massachusetts, USA*
Jeannine Mosely, USA
2008, 60,000 business cards
(*Photo by the artist*)

Right **Jeannine Mosely with the level-3 *Business Card Menger Sponge* at Machine Project USA, Los Angeles, 2006**
Jeannine Mosely, USA
(*Photo by Margaret Wertheim, Institute For Figuring*)

Dodecahedral Orb (2010), folded from twelve sheets of white heavyweight watercolor paper, is a work of such elegant simplicity and purity that the mathematics behind its creation is invisible to most eyes.

One of Mosely's most spectacular works of curved folding is her tessellation piece *Sails* (2008). Folded from a single sheet of white watercolor paper, the work is made up of a repeating pattern (like the fractals) of overlapping triangles, with concave sides that appear to float over smaller triangles with convex sides. The play of light and shadow over the patterned surface adds a poetic rhythm to this complex yet graceful work, evoking the billowing sails of yachts.

From her fractal-based installations to her modular and tessellation work, Jeannine Mosely does more than simply breathe life into numbers. By following mathematical principles as she folds her business cards and other papers into cubes, orbs, buds or sails, she breathes beauty, poetry and even a sense of community into them. With her spatial sensibilities, engineering and computing background and keen artistic skills, she blends art and mathematics in a way that expands both worlds exponentially and aesthetically.

Jeannine Mosely teaching
fractal folding to students
at USC, 2012
(*Photo courtesy of the artist*)

Right *Three Buds*
Jeannine Mosely, USA
2007, Canson art paper
(*Photo by the artist*)

Left *Red Bud*
Jeannine Mosely, USA
2007, Canson art paper
(*Photo by the artist*)

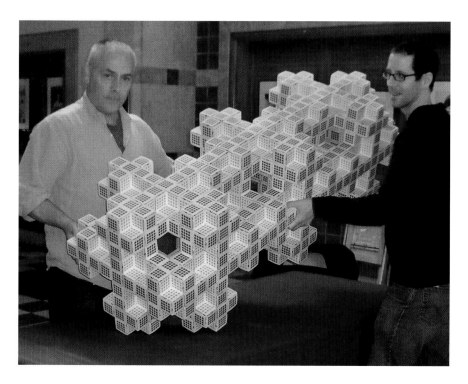

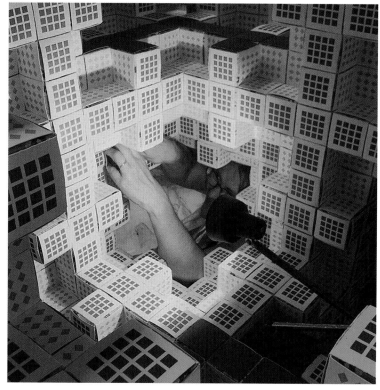

Above **One of six "tower modules" that make up the level-3** *Business Card Mosely Snowflake Sponge*
Jeannine Mosely, USA
2012, approximately 8,000 business cards, installed at the USC Libraries, Los Angeles, USA
(*Photo by Margaret Wertheim, Institute For Figuring*)

Right **The finished** *Mosely Snowflake* **fractal**
Jeannine Mosely, USA
2012, 49,000 business cards, installed at the USC Libraries, Los Angeles, USA
(*Photo by Margaret Wertheim, Institute For Figuring*)

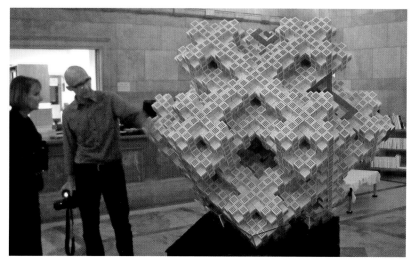

Above **"Warp core surgery" of** *Mosely Snowflake* **at the USC Libraries, Los Angeles, USA**
Jeannine Mosely, USA
(*Photo by Margaret Wertheim, the Institute For Figuring*)

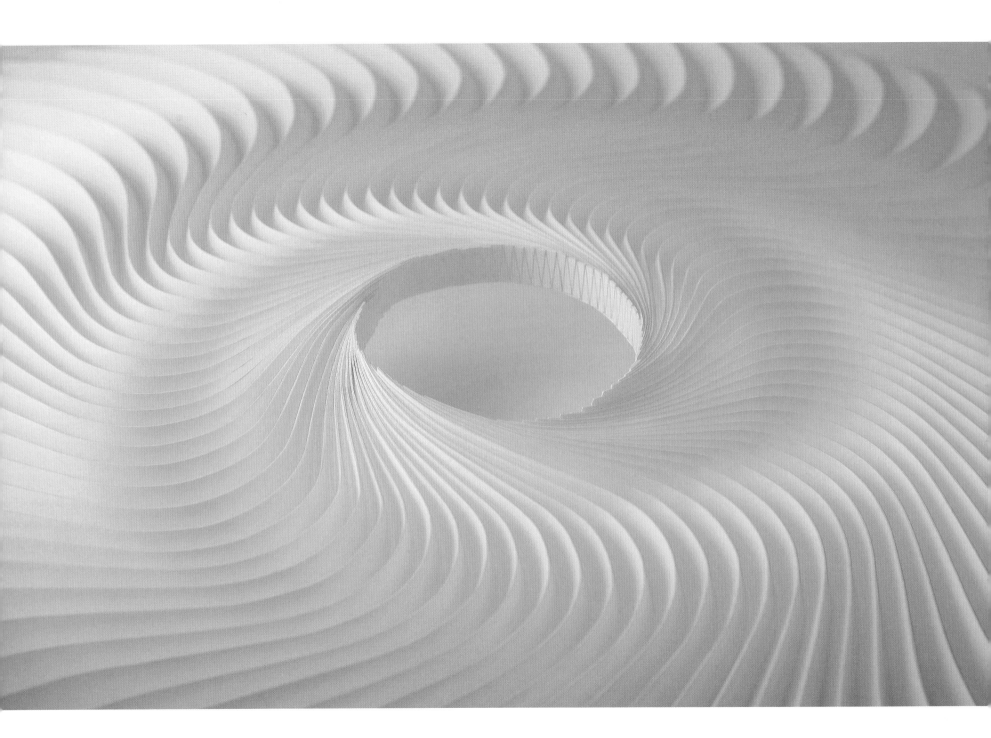

Uprise '14 (detail)
Yuko Nishimura, Japan
2014, Japanese *kyokushi* paper
(*Photo by Yousuke Otomo*)

Photo by Yousuke Otomo

YUKO NISHIMURA

origami expressions of the japanese spirit

For Japanese artist Yuko Nishimura (b.1978), folding is an expression of the spirit of the Japanese people in traditional daily life, from dressing to sitting, giving gifts and shaping space. When the Japanese first used paper over 1,000 years ago, they also folded it to honor the *kami*, the higher beings believed to reside in nature. For centuries, they have folded white strips of paper to mark the presence of the *kami* and attached them to wooden wands used to purify objects and spaces in Shinto rituals. Nishimura also sees relationships between paper folding and spirituality in the Japanese language. The characters 紙 meaning "paper" and 神 meaning "higher being" both read "*kami*," while the characters for "fold" (折) and "pray" (祈) share an important element and, by implication, some ancient association. As Nishimura folds her paper, she considers the connections between paper and the spirit, folding and praying, and roots her abstract origami sculptures in these ancient beliefs about nature and the spiritual forces that inhabit it.

Like all Japanese, Nishimura first learned origami as a child, but it was when she was enrolled in the Architectural Design program at Nihon University in Tokyo that she first began to explore the artistic potential of paper folding. One of her earliest folded paper works is the origami teahouse *Kami-an* (2000), which she created for her graduation thesis at Nihon University. Although she was not aware of it at the time, the diamond-shaped folding pattern she used was known as the Yoshimura Pattern because it had been discovered in the early 1950s by Japanese aeronautical researcher Professor Yoshimaru Yoshimura when studying the buckling of airplane fuselages after crashes. Nishimura's structure, folded from a single sheet of thick paper, was large enough to house the host and guest in a traditional Japanese tea ceremony. When Japanese tea practitioners performed a tea ceremony under the complex geometrical arch, it became a uniquely interactive installation. The teahouse or

tearoom is one of the most spiritual spaces in Japanese culture, one inspired by Zen Buddhist beliefs of the importance of mindfully living in the moment. It is here that the host and guest share a unique moment of giving and receiving, possibly the most sacred moment in Japanese secular culture. In this early work of Nishimura's, we see a keen awareness of the spirituality that has infused so many Japanese traditions. By folding such a culturally sacred space out of white paper, Nishimura not only evokes the sacred folded papers of Shinto but also conceptually unites folding, praying, paper and higher beings all in one curved paper structure.

Although Nishimura trained in architectural design, the majority of her works are wall-mounted abstract relief sculptures. For the circular works, she intricately pleats rectangular lengths of pure white paper in varying directions to form geometric patterning and then joins the ends of the paper to form a spectacularly textured

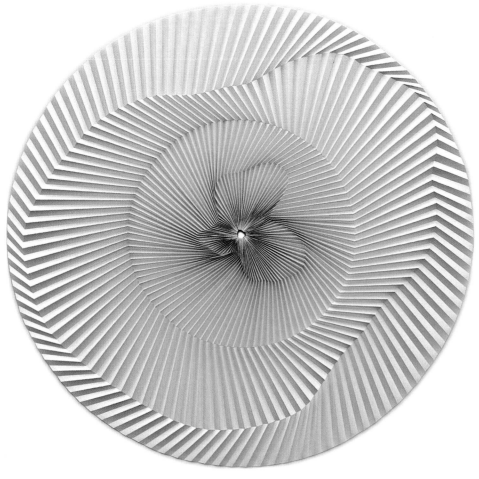

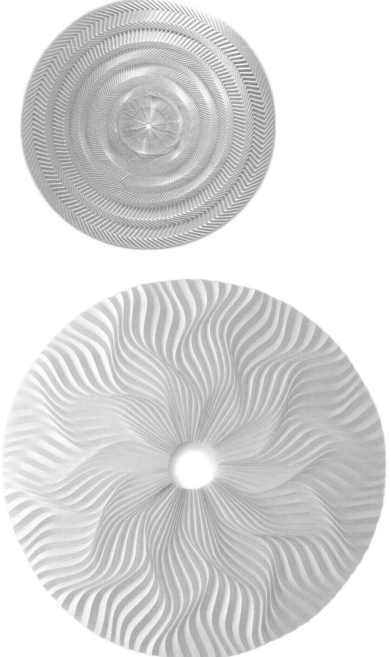

Above *Organic*
Yuko Nishimura, Japan
2006, Japanese *kyokushi* paper (*Photo by Yousuke Otomo*)

Above right *Sparkle*
Yuko Nishimura, Japan
2008, Japanese *kyokushi* paper (*Photo by Yousuke Otomo*)

Below right *Stir*
Yuko Nishimura, Japan
2014, Japanese *kyokushi* paper (*Photo by Yousuke Otomo*)

circle. In the square pieces, the pattern occupies the entirety of the square, leading our eyes back and forth across the paper's surface. She first folded these abstract reliefs in 2004 when she was a graduate student in the Department of Art at Tsukuba University in Ibaragi Prefecture. There, she continued her experiments with abstract origami sculpture and was awarded several prizes for her work in notable competitions, including the 54th and 55th Modern Art Exhibitions at Tokyo Metropolitan Art Museum in 2004 and 2005.

In these abstract reliefs, too, we sense a deep spirituality inhabiting the folds. Nishimura works principally with pure white paper, so that despite the complexity of the folded patterns the sculptures have the calm, soothing quality of white Buddhist mandalas. In fact, the repetitive pleating of "mountain" then "valley" folds is highly meditative for Nishimura, a creative process which she equates symbolically with the duality of forces that many philosophical traditions believe create and sustain the universe. "In origami, two types of folds—'mountain folds' and 'valley folds'—form two separate worlds," she explains. "These two worlds are created from light and shadow." In the *yin–yang* duality of the Taoist tradition, light and dark are opposing forces that work in harmony with each other to animate the universe. In Nishimura's reliefs, her folded geometric patterning allows light and shadow to play across the textured surfaces, imbuing the paper with life and evoking the complex energetic patterning in nature, such as the ripples on the surface of water or dappled sunlight.

Many of Nishimura's circular and square wall reliefs are named after light effects and natural phenomena. One of her earlier works, *Sparkle* (2008), is built up of concentric circles folded in alternating directions to create a zigzag effect and a powerful sense of depth as the eye follows the diminishing circles and vanishes deep into the center of the pattern. The piece is formed

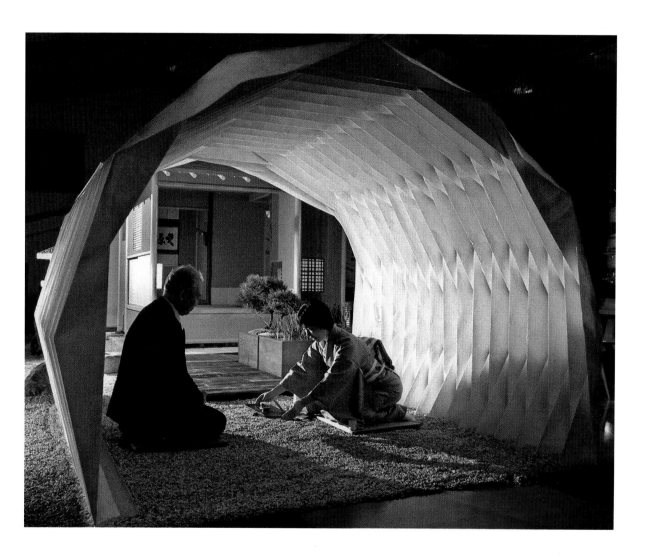

Kami-an Origami Tea House
Yuko Nishimura, Japan
2000, Japanese *kyokushi* paper
(*Photo by The Asahi Shimbun*)

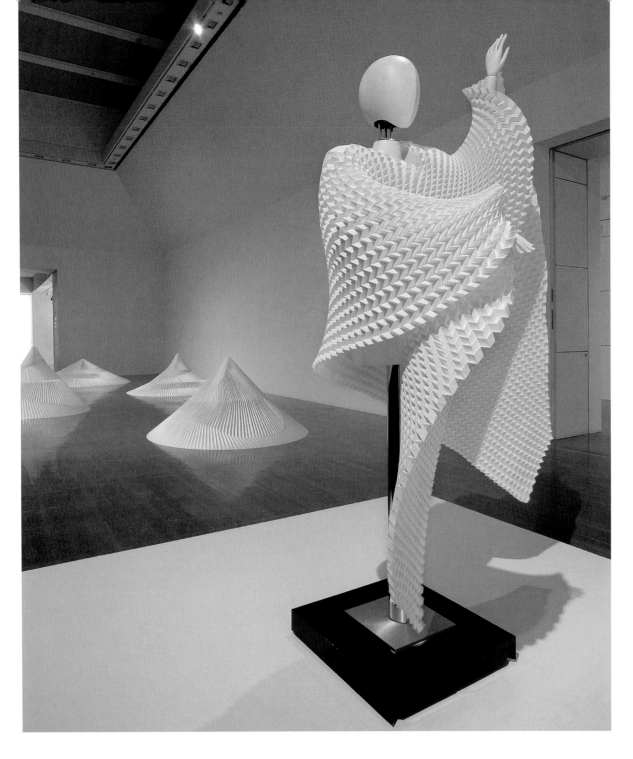

solely from paper, but through folding, Nishimura has allowed light and shadow to add drama and life to the work. In *Stir* (2007), radial folds ripple out from the center of the circle to form a sunburst that releases energy and light into the world. At the center, where the paper is at its densest, so too is shadow, suggesting an outward expansion of light. Again, the effect of energy, movement and drama is created entirely by light shining and *not* shining on the folded surfaces of the paper.

In many of her square reliefs, the sense of movement created relates to the light effects on the surface of water. In *Ripple* (2007), a series of curvy vertical folds running almost parallel to each other evoke the surface of a lake in the wake of a passing boat, while in *Wave* (2013), by varying the size and form of each of the geometric elements and positioning them very precisely over the surface, she creates an undulating linear pattern—best seen from a distance—that evokes the fluidity of waves lapping the shore.

Over the last fifteen years, Yuko Nishimura's unique approach to folded paper sculpture has been attracting increasing attention, gaining her exhibitions in Japan and the United States, Europe and Asia. She has also received commissions from car companies, luxury hotels and pearl shops for window displays. In 2009, she was one of a group of young Japanese artists featured in an exhibition sponsored by Japanese haute couture legend Hanae Mori. For this exhibition, Nishimura created an

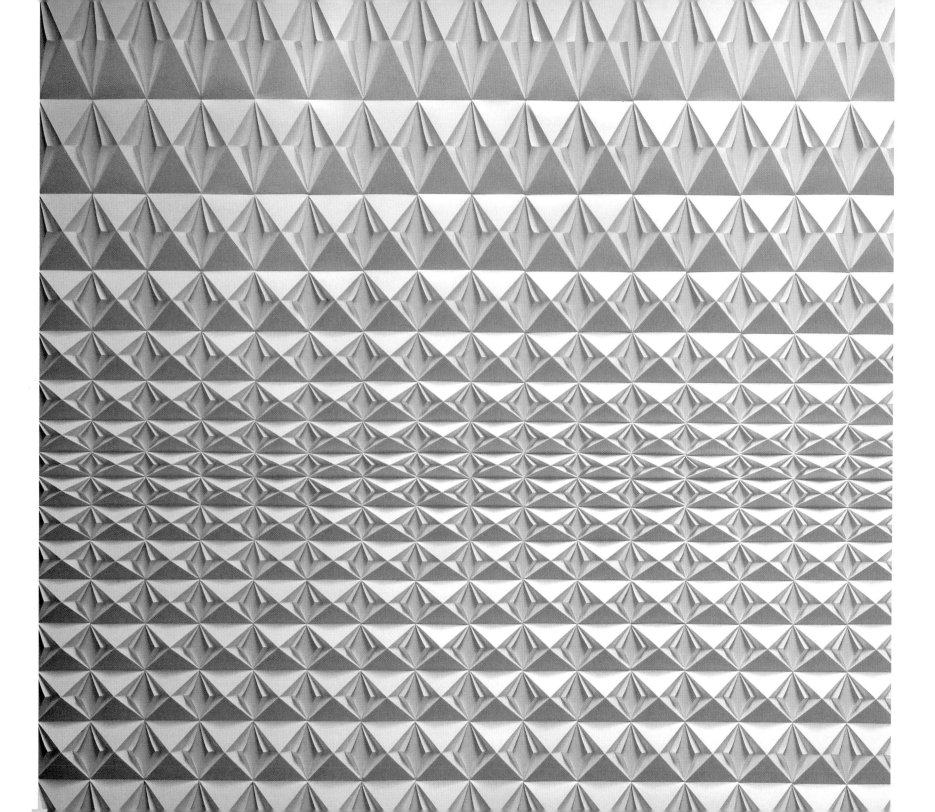

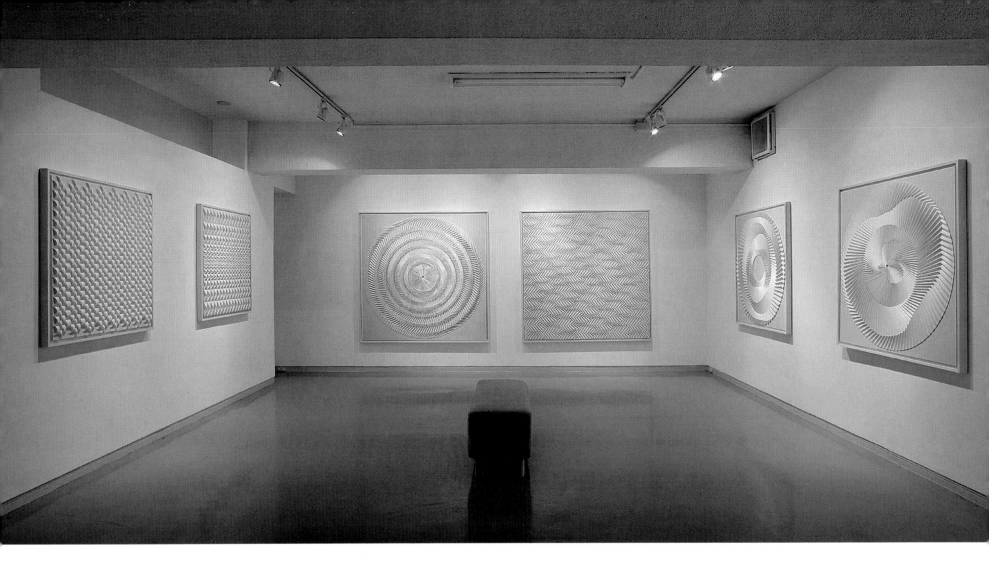

exquisite folded paper shawl that wrapped around the shoulders of a robotic mannequin. When it moved, the cloth swayed and swirled elegantly. She also created a series of large conical paper sculptures of varying widths, heights and geometric folded patterning. Perhaps these elegant forms are merely abstract folded paper sculptures, but they could equally well represent views of Japan's famous volcano, Mount Fuji. This mountain is not only Japan's most iconic peak but is

also one of its most sacred sites and popular pilgrimage destinations. The peak is believed to be inhabited by one of the most powerful *kami* in Japan, Sengen-sama, believed to embody the very spirit of nature. In these graceful cones, each individually textured by meticulously pleated crevasses, Nishimura unites folding and praying, mountains and valleys, light and shadow, paper and higher beings, poetically capturing with her hands and white paper the very soul of Japan.

Origami Wall Reliefs,*"Ori" no katachi* Exhibition, GALLERY b.TOKYO, Kyobashi, Tokyo
2005, Yuko Nishimura, Japan
(Photo by Yousuke Otomo)

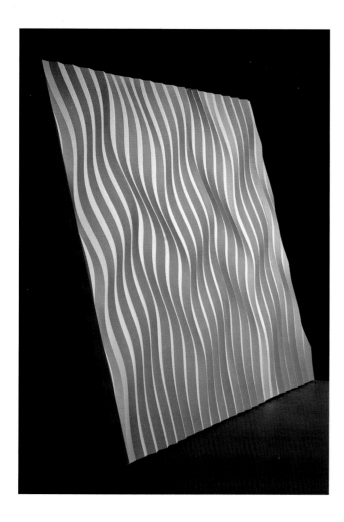

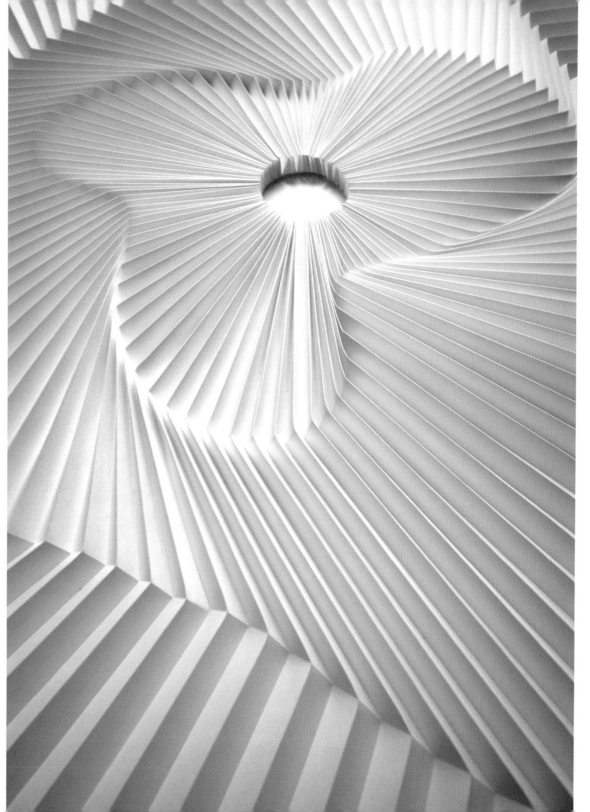

Above *Ripple*
Yuko Nishimura, Japan
2007, Japanese *kyokushi* paper
(*Photo by Yousuke Otomo*)

Right *Organic* (detail)
Yuko Nishimura, Japan
2008, Japanese *kyokushi* paper
(*Photo by Yousuke Otomo*)

Right *Frog on a Leaf*
Bernie Peyton, USA
2007, Leaf: rectangular sheet of
Fabriano backed with Thai mango
paper; Frog: square sheet of
back-coated *Shikibu Gampi Shi*;
Armature: wood, acrylic, nylon
thread, magnets
(*Photo by Robert Bloomberg*)

BERNIE PEYTON

Photo by Susanne Tilney

where origami meets environmentalism

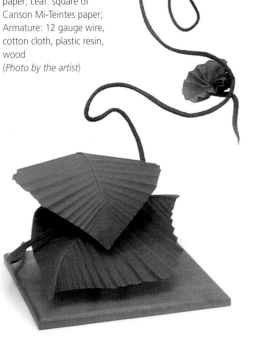

Out on a Limb
Bernie Peyton, USA
2010, Anolis lizard: square
of back-coated *Shikibu
Gampi Shi* paper; Vine
designed 2008: trapezoid
of back-coated *Chiri unryu*
paper; Leaf: square of
Canson Mi-Teintes paper;
Armature: 12 gauge wire,
cotton cloth, plastic resin,
wood
(*Photo by the artist*)

A dark green vine stem twists and winds its way upward, reaching hungrily toward the sunlight, its broad pleated leaves opening out to absorb life-giving rays through gaps in the jungle canopy. Part way up the vine, a small anolis lizard perches precariously on a slender limb hoping to remain unnoticed so that he is not eaten as he plans his next meal. The scene is depicted in an origami sculpture *Out on a Limb* (2010), created by artist Bernie Peyton (b.1950), a wildlife biologist who spent many years conducting field research on endangered species. Peyton's origami is strongly informed by his work as a biologist, in part because he has studied animals closely over decades but also because he is passionate about the conservation and protection of these creatures. He portrays his figures of birds and animals with tremendous character and places them in specific settings in more sculptural works like *Out on a Limb*, using variations in forms and thoughtful compositions to hint at the peril each

creature faces. Here, the interplay of the bold geometric leaf and the playful curling vine builds dramatic tension and concern for the safety of the lizard.

Through origami Peyton has been able to bring together the two passions of his life—art making and wildlife conservation. As a child he was fascinated by origami, and as a young man he at first embarked on a career as a painter and print maker. In 1976, he joined his college roommate on an 850-mile (1,368-km) canoeing adventure in the wilderness that changed his professional direction. Watching the white wolves that followed their progress along the river, Peyton became inspired to do something to save nature. For the next twenty-five years, he trained and worked as an environmental biologist, studying and attempting to help endangered species, most notably spectacled bears in Peru, whose habitat was threatened by deforestation. Just over a decade ago, he retired as a biologist to become an artist again and now applies his scientific

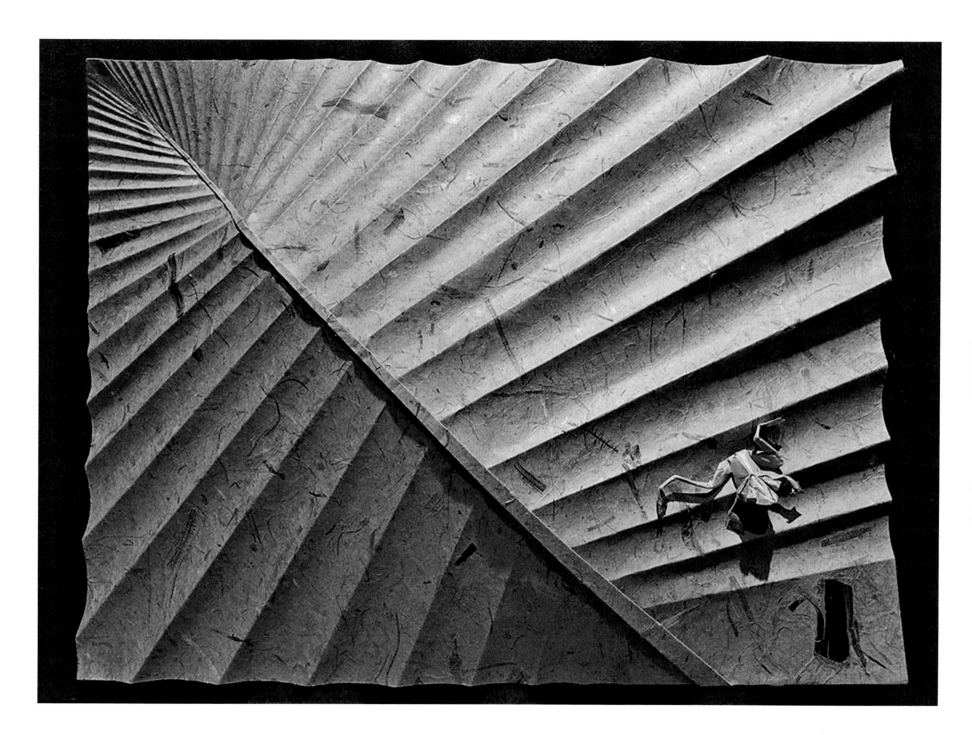

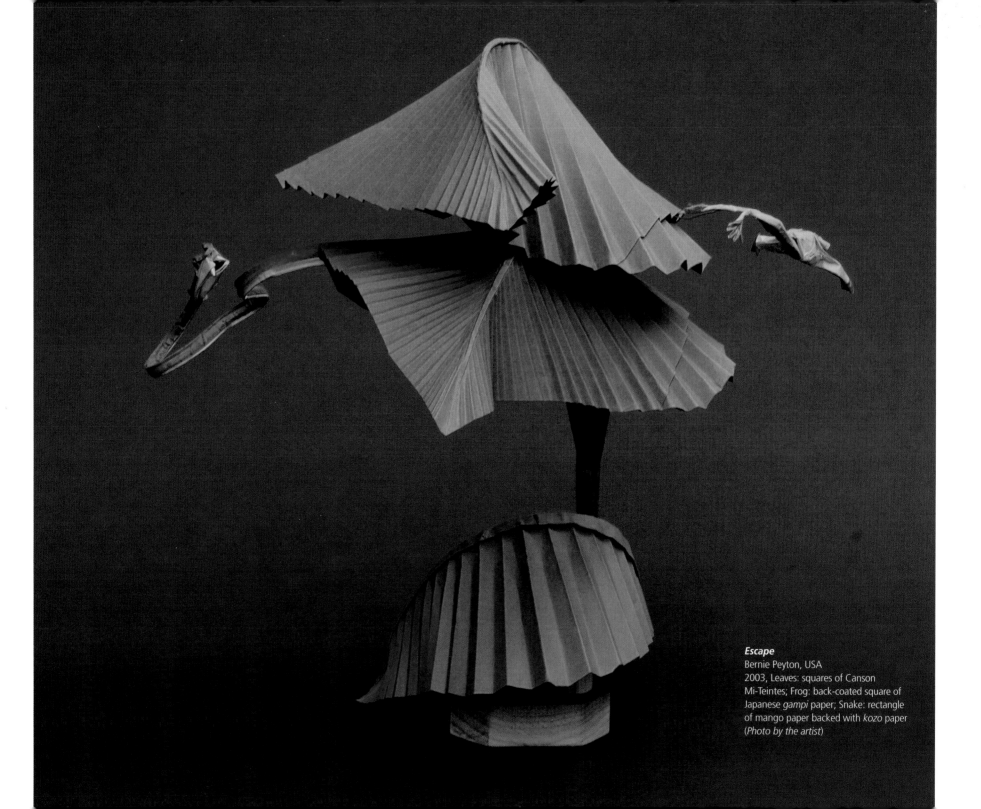

Escape
Bernie Peyton, USA
2003, Leaves: squares of Canson
Mi-Teintes; Frog: back-coated square of
Japanese *gampi* paper; Snake: rectangle
of mango paper backed with *kozo* paper
(*Photo by the artist*)

skills to designing the creatures he spent years studying.

For Peyton, because paper is fragile, it is the perfect medium to describe the fragility of our planet. Indeed, many of his delicate paper models of endangered animals and birds highlight the vulnerability of these creatures. Much as he did as a scientist, however, Peyton has strayed from the well-trodden path as an origami artist, and rather than striving to fold a figure from a square sheet with no cuts or glue, he favors process over technique and aims to produce unique portrayals of his beloved creatures. He often uses crimping rather than traditional folding to model his figures and create a sense of individual expression. He freely admits to back-coating his paper with resin and often constructs armatures from wire, thread, cloth and wood to create realistic environments for his endangered creatures. Consequently, many of his folded paper figures are more robust and durable than those of other artists, perhaps due to his conservationist desire to keep his paper creatures "alive" as long as possible.

Still part scientist, Peyton classifies his origami sculptures according to their habitat—Arctic, Desert, Pacific Coast and Tropical Forest. In his Arctic series, his most expressive figures are the polar bears, which he folds out individually or in groups in a variety of poses. Wet folded out of Canson paper, a thick French fine art paper, Peyton's groups of bears in his work *Polar Bears* (2000) are positioned so that they seem to interact with each other in an animated manner as if sensing danger,

an arrangement that is at once a well-balanced artistic composition and also a naturalistic scene that could only be rendered after years of close and caring observation of such creatures. Similarly, his walrus group in *Walrus and Iceberg* (2009), modeled from double-side red and white paper sensitively depicts the hulking tusked creatures huddling together for protection on a shrinking iceberg. Again, the aesthetic elegance of the composition and warm color scheme is darkened by the concern of the artist for the safety of these animals as climate change threatens their habitat.

Although human activity is less of a threat in desert regions and along the Pacific Coast, Peyton also captures the dangers animals face from non-human predators in works such as *Hawk and Jackrabbit* (2005),

Above right *Kiwi*
Bernie Peyton, USA
2014, bicolored uncut square of brown paper colored on one side with charcoal dust
(*Photo by the artist*)

Right *Owlets*
Bernie Peyton, USA
2005, squares of mango paper spray glued to tissue-backed foil
(*Photo by the artist*)

in which the magnificent raptor retracts its wings and prepares to swoop down to capture a fleeing jackrabbit. Similarly, his *Great Horned Owl* (2010), folded from roughly textured handmade paper and depicted with talons gripping its wooden stand, stares menacingly at us as if eyeing up a tasty mouse. In a much more tranquil coastal scene, *Fort Puffin* (2011), he depicts a community of the seabirds flying in and out of their nests positioned safely atop a rocky cliff top. Below a scene of a mother puffin feeding her children, a solitary bird huddles in a nook and appears to sleep.

Probably because most of Peyton's work as a biologist was spent in South America, his most spectacular and original works are the sculptures in his Tropical Forest series. In his work *Escape* (2003) we see nature in action. Here, amidst a lush rainforest setting formed from pleated jungle leaves, a red-eyed tree frog leaps into the air to flee an attacking vinesnake. In this dramatic work, Peyton uses his skills as an artist to portray a potentially real interaction between two wild creatures of the type that he undoubtedly observed as a scientist. However, Peyton the artist eclipses Peyton the biologist in several of his more recent works, in which natural forms are stylized and even abbreviated to create aesthetically intriguing sculptural compositions. The above-mentioned *Out on a Limb* is among this group, as are a number of variations on the vine theme, some of which, including *Vine* (2008), seem almost abstract in the geometry of the pleated red leaves and the swirling patterns formed by the stalk. A related sinuous sculpture is *Blunt Nosed Vinesnake* (2008), in which a brick red serpent weaves its way through vivid jungle leaves, mouth open as if ready to strike its unsuspecting prey.

Perhaps the most purely "artistic" of Peyton's works are the depictions of red-eyed tree frogs sitting on broad jungle leaves. In *Red-eyed Frog* and *Frog on a Leaf* (both 2007), Peyton creates a playful contrast between

Below *Cactus Makes Perfect*
Bernie Peyton, USA
2005, rectangles of thick green paper
(*Photo by the artist*)

Below right *Waterfall Bear* (detail)
Bernie Peyton, USA
2005, rectangle of Moriki *kozo* backed with
Thai lace
(*Photo by the artist*)

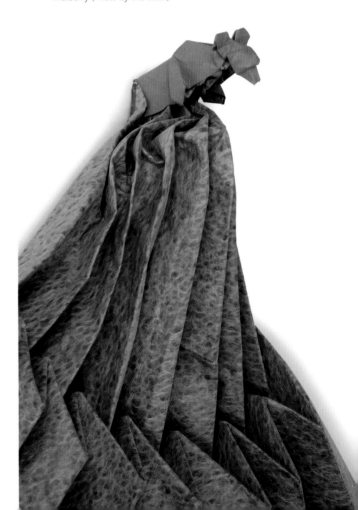

Opposite above left *Grizzly with Salmon*
Bernie Peyton, USA
1998, 24.5-inch (62.2-cm) square of elephant hide backed with *Kasugami* paper (*Photo by the artist*)

Opposite above right *Polar Bear*
Bernie Peyton, USA
1999, square of tissue foil (*Photo by the artist*)

Opposite below left *Walrus and Iceberg*
Bernie Peyton, USA
2009, Walrus: square and rectangles of Japanese *kozo* paper backed with bleached Thai mulberry; Iceberg: Canson Mi-Teintes (*Photo by the artist*)

Opposite below right *Get Wellephant*
Bernie Peyton, USA
2006, square of Moriki *kozo* backed with bleached Thai mulberry (*Photo by the artist*)

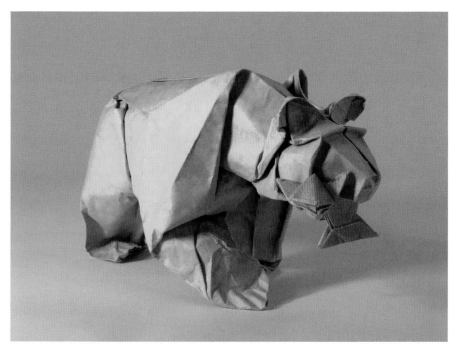

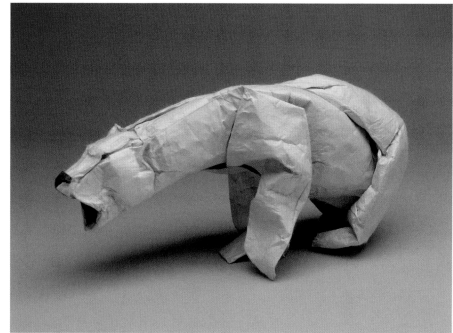

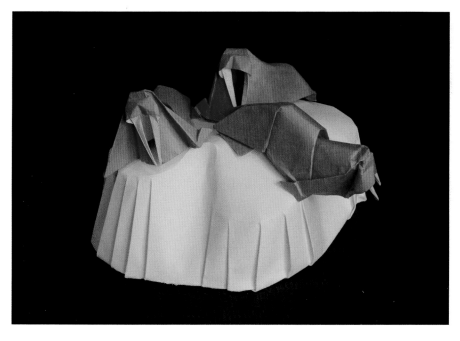

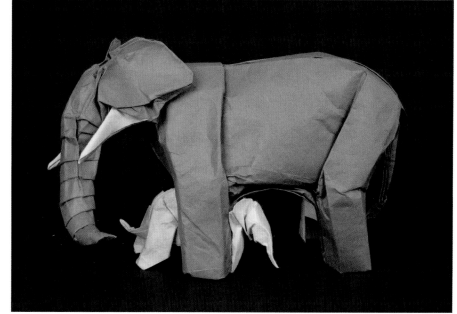

Below **Sun Bear**
Bernie Peyton, USA
2002, square of black paper
with hairy surface backed with
gold paper
(*Photo by Robert J. Lang*)

Left **Wolfish**
Bernie Peyton, USA
2015, square of elephant hide
(*Photo by the artist*)

158

Below ***Red-eyed Tree Frogs***
Bernie Peyton, USA
2007, Frogs: back-coated square of *gampi* paper;
Leaf: square of Canson Mi-Teintes backed with
Thai mango paper
(*Photo by the artist*)

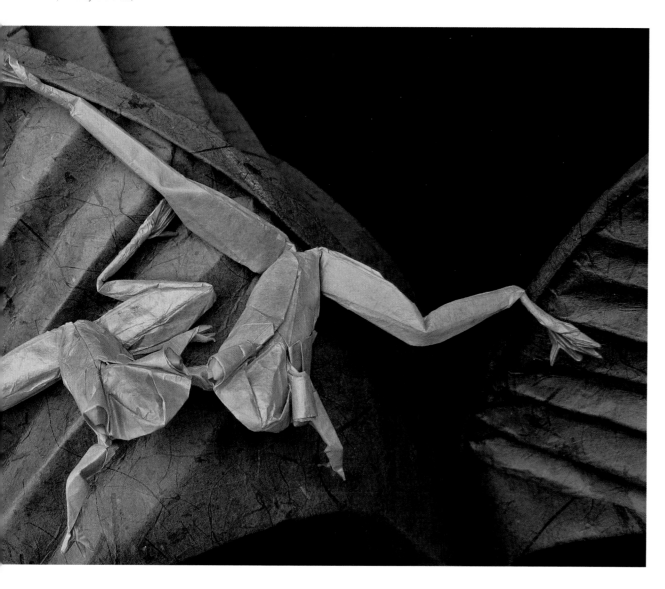

the naturalistically folded bodies and limbs of the tiny frogs and the large geometrically pleated leaves that form their background. For these works, his thoughtful selection of papers has added interest. The large rectangular leaves, folded from Fabriano paper backed with mango paper are textured with flecks of paper fibers of varying sizes, while the frogs are folded carefully from two sheets of back-coated Japanese *gampi* paper (green and red) so that the red accents on the eyes and feet of the frogs are visible.

In Peyton's mind, designing his own origami art has been very similar to doing science. "Both relied on former knowledge," he explains, "and discoveries were most often made in incremental steps." He adds that art requires "the same attitude toward exploration that I felt while paddling down the Back River. Although I can't cut trail like I used to, origami has given me many more peaks to climb." Just as in wildlife preservation, Bernie Peyton has explored mountain and valley folds in origami and has discovered there a rich world teaming with creatures, sometimes beautiful, sometimes menacing, occasionally both. As a wildlife biologist, Peyton sought to protect these creatures against the changes inflicted upon their environments by humans. Now an origami artist, he uses his observational experiences to recreate them in folded paper in new environments, giving them the support they need to preserve them in museums and private collections, perhaps longer than their living counterparts will manage to exist in the wild.

expressions of exuberance

Photo by Giang Dinh

The Kiss
HT Quyet, Vietnam
2009, watercolor paper
(Photo by the artist)

Vietnamese artist Hoang Tien Quyet, aka HT Quyet, (b.1988) thinks about origami from the moment he wakes up, while he is riding his bike and when he is sitting on the bus. He even dreams about origami. Quyet's love for paper folding, his endless curiosity about form and his unique artistic sensibility are apparent in his joyful designs of animals and birds. His swans, lions, rats and roosters are clearly works of origami, but the models possess a unique grace and flourish that have been attracting the attention of origami enthusiasts all over the world. Although his folding is grounded in traditional origami, a lot of his work is improvised, much in the vein of the late Eric Joisel (see page 72), who was greatly loved for his exuberant attitude and instinctive approach to folding and modeling paper. Like Joisel, Quyet creates models that not only possess the character of the creatures they imitate but also much of the exuberance and whimsical expression of the artist himself.

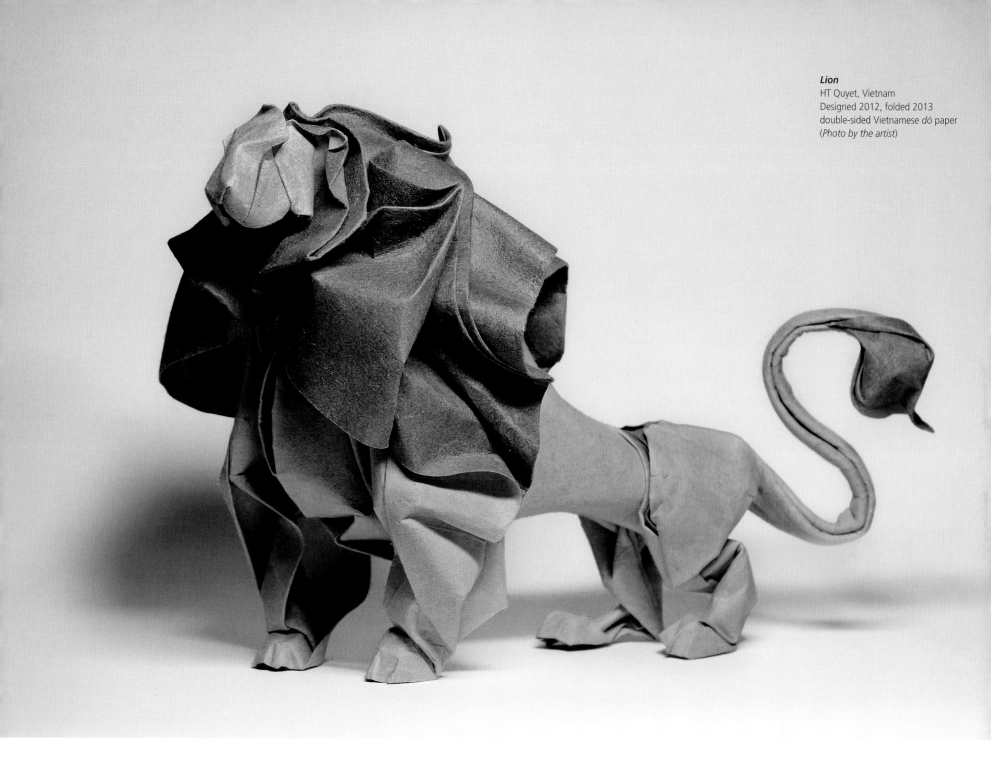

Lion
HT Quyet, Vietnam
Designed 2012, folded 2013
double-sided Vietnamese *dó* paper
(*Photo by the artist*)

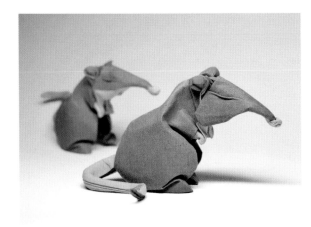

Left **Rats**
HT Quyet, Vietnam
2013, Vietnamese *dó* paper
(*Photo by the artist*)

Below **Pig**
HT Quyet, Vietnam
2015, watercolor paper
(*Photo by Giang Dinh*)

Quyet has been folding paper since he was five or six years old when a cousin taught him how to fold a plane and a boat. At the age of seven he was given a photocopy of an origami book by a neighbor, which enabled him to start folding on his own. The joy of being able to create forms out of paper was instilled in him then and has remained with him ever since. Years later, Quyet studied economics at university but admits he was not a very good student. However, he took some drawing classes in college and considered studying to become an architect, even passing the exam to enter architecture school, though he stayed the course with his economics degree. Since graduation, however, he has devoted himself to being an origami artist, selling some of his models, exhibiting internationally and receiving several commissions both in Vietnam and from abroad. While he admits it is not easy to live as an origami artist, he is determined to do what brings him joy and to share that joy with others. Although paper folding has likely been practiced in Vietnam for centuries, there is little interest in origami in the country, a fact that Quyet laments and hopes to change. He joined the Vietnamese Origami Group, a small community of mostly young folders

Unicorn
HT Quyet, Vietnam
Designed 2012, folded 2013,
Vietnamese *dó* paper
(*Photo by the artist*)

who are in touch online. Some, including Quyet, meet weekly in Hanoi. He hopes that through his origami he can encourage others to start folding.

Much of Quyet's work, like that of Vietnamese-American origami artist Giang Dinh (see page 24), is folded from thick watercolor paper and modeled using the wet folding technique developed by Akira Yoshizawa in the mid-twentieth century. By wet folding the paper, Quyet is able to soften the edges of folds and angles of his folded forms and create the rounded, often curvaceous models for which he is gaining increasing renown. One of his most admired works is his *Dancing Swan* (2009), which he wet folded out of watercolor paper. In contrast with Giang Dinh's models, which typically feature minimal folding and looser, more open forms, Quyet's swan is tightly modeled in places, most notably in the long slender neck. This tightness, however, contrasts exquisitely with the curvaceous unfurling of the swan's wings as the elegant bird appears to break into a joyful dance. Sharing the grace of the swan, but with a touch of menace and humor, is his model of a cobra, also folded from watercolor paper. Playfully entitled *The Kiss* (2009), the sculpture depicts a king cobra with its head raised as if preparing to strike the viewer, but the head is folded forward so that it forms a heart shape within the cobra's hood, which is elegantly balanced by the upward curve of the snake's tail. Here, Quyet's smooth, rounded folding has created an elegant, appealing creature. By giving the piece the art-historically cheeky title *The Kiss*, Quyet adds a touch of humor that might just persuade the viewer to accept the deadly kiss of this cobra.

Right *Dancing Swan*
HT Quyet, Vietnam
Designed 2009, folded 2013,
Vietnamese *dó* paper
(*Photo by the artist*)

Above *Hummingbird*
HT Quyet, Vietnam
Designed 2009, folded 2013, handmade
Origamido paper
(*Photo by the artist*)

Right *Foxes*
HT Quyet, Vietnam
2014, photocopy paper back-coated with craft paper
(*Photo by the artist*)

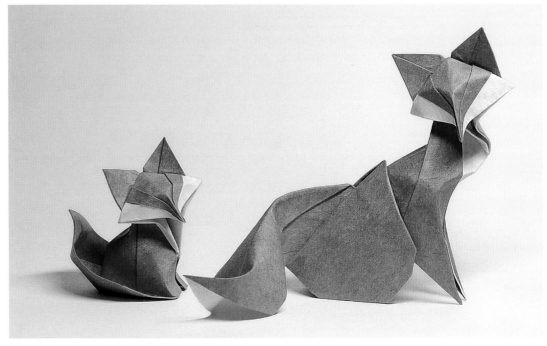

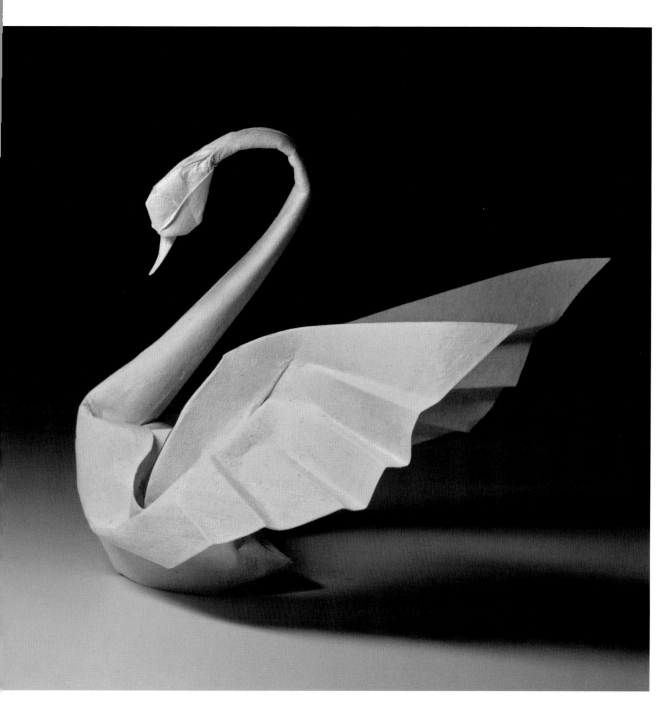

Although Quyet enjoys working with watercolor paper, he has recently been creating models from *dó* paper, a traditional Vietnamese paper made from the bark of the *Rhamnoneuron balansae*, a small tree or shrub native to China and Vietnam. "It's a nice paper but quite difficult to use," explains Quyet. "I need to restrengthen it before using, such as adding more glue, hand painting colors, gluing two or more layers to have the thickness I need." His model *Rooster* (2014) was folded from *dó* paper, allowing him to create the body, wings and legs of the bird in white, similar to his swan and cobra. Although the model was formed from a single square of paper, he was able to form the head, including the comb and wattle, by folding the paper back to reveal its red underside, created by gluing together a red and a white sheet of *dó* paper. Here, the puffed-up chest and tossed-back head of the rooster might also hint at Quyet's own pride at being able to create such an expressive portrayal of this bird.

Even more majestic than his figure of the rooster is his *Lion* (2012), a model that he has been developing for six years. Folded from *dó* paper (green on one side and yellow on the reverse), the lion exemplifies Quyet's design process. Using a combination of wet folding and improvised modeling, he completed his first version of the lion in 2009 but went on to create further versions in 2012 and 2014. He personally admits to preferring the 2012 version and claims, "There is still room for development and I would remake other versions in the near future. Each version brings me new ideas to develop a new one." This lion, although highly stylized in the gently curving swirls of his mane and graceful curl of his tail, nonetheless possesses the majesty and power of the real beast in the solid, muscular legs and the regal, yet thoughtful, expression he wears on his face.

Quyet has admitted in a recent interview with Laura Rozenberg for Origami USA's *PAPER* magazine that his lion is not just one of his favorite designs but one of the

Cats
HT Quyet, Vietnam
2008, watercolor paper
(*Photo by the artist*)

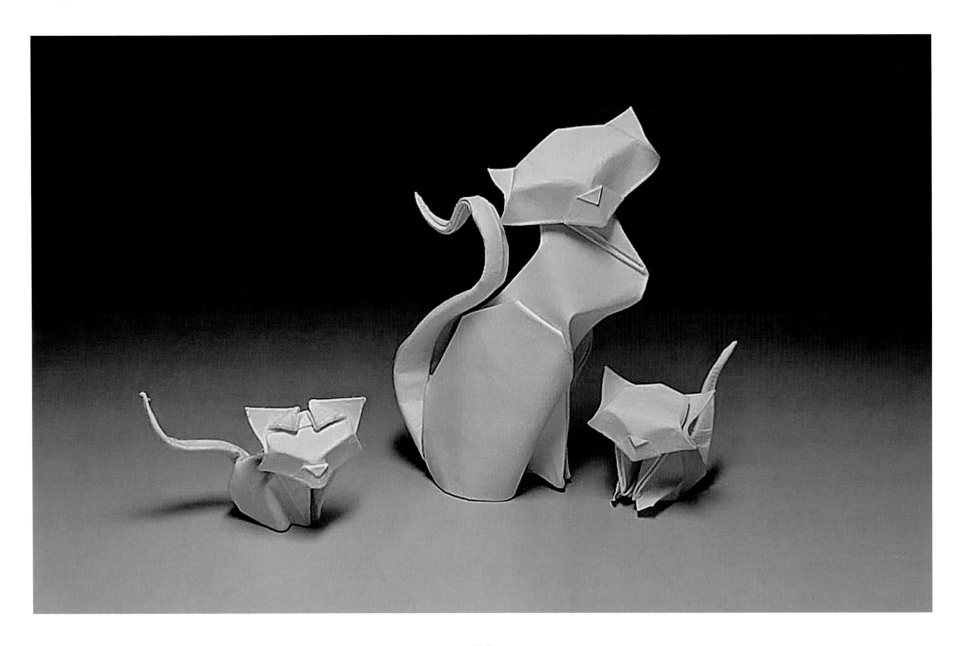

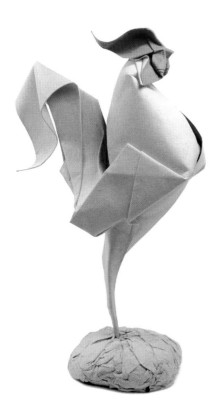

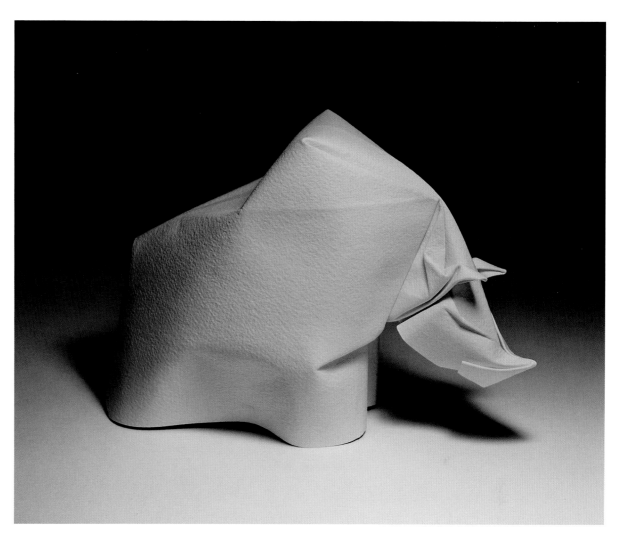

figures that he would most like to be. It is the connection that he feels with the creatures he designs that makes Quyet such a unique origami artist. The utter happiness he derives from his life as an origami artist, his need to fold every day (and some nights too, in his dreams), and the many hours, weeks and even years he might spend nurturing a single model are evidence of a profound love affair occurring between Quyet and his paper folding. His intense dedication to his art coupled with a playfulness born from the sheer joy he derives from folding allow him to create works that many other folders want to emulate but that cannot easily be diagrammed or copied. His works are not simply expressions of rare artistic talent and nimble, persuasive fingers but also of an exuberant spirit driven passionately to create.

Above **Rhino**
HT Quyet, Vietnam
2015, watercolor paper
(*Photo by the artist*)

Above left **Rooster**
HT Quyet, Vietnam
2014, double-sided Vietnamese *dó* paper
(*Photo by the artist*)

creases, cuts and kineticism

Photo by the artist

Opposite *Swire*
Matt Shlian, USA
2013, installed at Swire Hong Kong
Fox River Coronado 100# text weight paper
(*Photo by Andy Reynolds*)

Matt Shlian (b.1980) has always been curious, so curious that it has never been enough for him to learn how to cut and fold structures out of paper. Once created, the forms beg new questions like, "How can I make this structure move?" or "How can I create a similar structure using a different technique?" Trained as a fine artist, Shlian is a paper engineer and, as such, comfortably bridges the worlds of art and science, often collaborating with scientists both in their worlds and his own. Much of Shlian's work is a far cry from what might typically be described as origami, but as a paper engineer he is acutely aware of the importance of a single fold in the creation of a paper form. "Beginning with an initial fold, a single action transfers energy to subsequent folds," he explains in his artist statement, which blends artistic and scientific ideals. Although Shlian relishes the creative creasing of the origami world, his curiosity pushes him to mechanize his forms, to deconstruct and reconstruct them in ways that trick viewers into believing they are folded from a single sheet of paper when they are not.

When Shlian enrolled in art school, he initially planned to major in ceramics. However, once an art student, like a kid in a candy store he was tempted to try a bit of everything and was soon taking classes in glass blowing, printing, video and performance art. He eventually graduated with a dual major in ceramics and print. Many of his printed works were not simply printed, however, but cut and folded so that they became three-dimensional structures that invited touch and interaction. After graduation, his curiosity did not diminish. If anything, it increased, and he continued to experiment with cutting and folding paper in increasingly complex ways. He worked for a while as a commercial paper engineer designing pop-up cards before returning to art school to earn an MFA in Print Media and Paper Engineering. For the last ten years, Shlian has been developing his paper engineering skills further as an artist and teacher at the University of Michigan, while also collaborating with scientist colleagues who see his creations as a metaphor for scientific principles. Curious about the many inter-sections between their fields, he finds in their work a basis for further artistic inspiration.

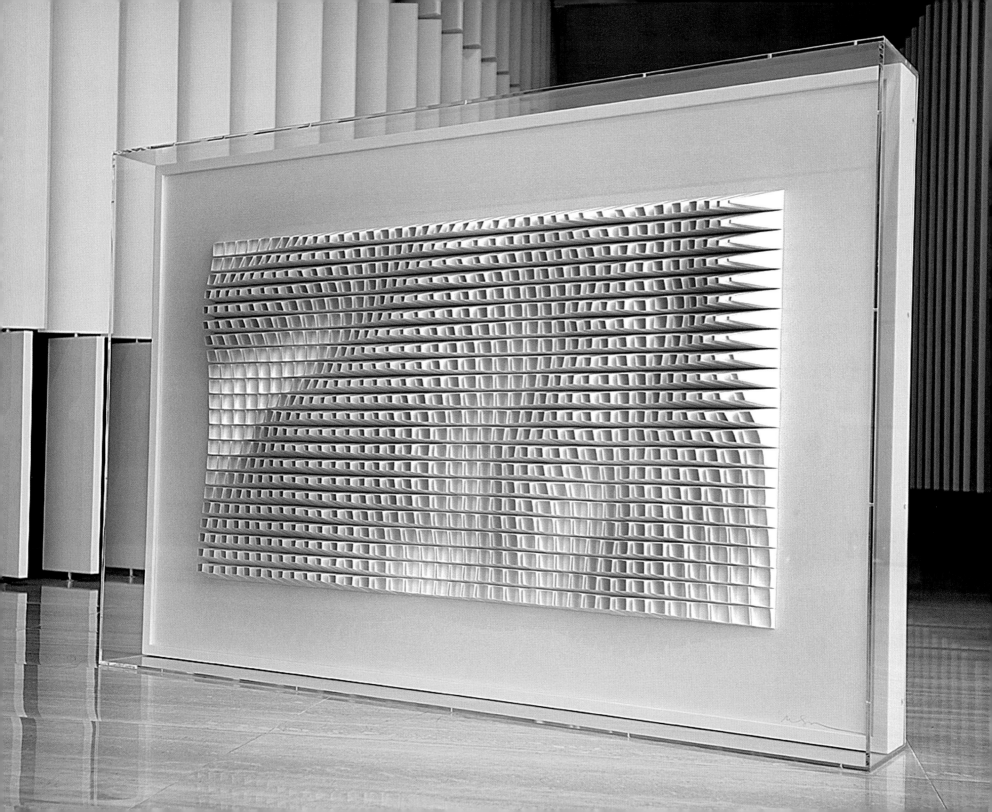

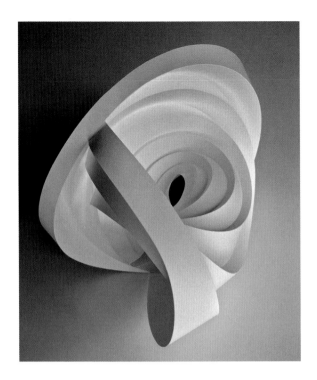

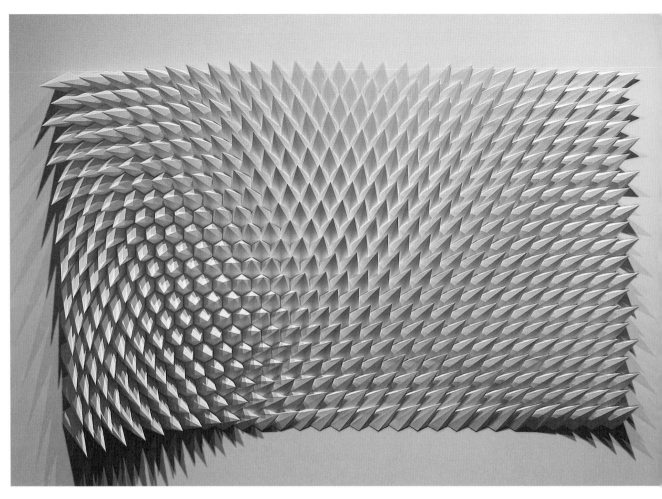

Some of Shlian's simplest works are among his most poetic. In his series *We are building this ship as we sail it* (2010), he uses curved creasing, a technique explored in the 1970s by similar artist-scientists, Ron Resch (1939–2009) and David Huffman (1925–1999), now favored by such contemporary origami artists as Erik and Martin Demaine (see page 16) and Jeannine Mosely (see page 136). In Shlian's elegant asymmetrical works, the shadows cast on the pure white paper surface to add richness and volume to these abstract forms. The title of the work, borrowed from a poem by former US Poet Laureate Kay Ryan, suggests that the willowy white forms may be evoking the rippling sails of a ship at sea, while also hinting at the struggles, fears and unpredictability in any creative process or endeavor. In fact, in his artist statement, he claims, "My work is created because I cannot visualize its final realization." Two years later,

Above left ***We are building this ship as we sail it***
Matt Shlian, USA
2010, Fox River Coronado
100# text weight paper
(*Photo by the artist*)

Above ***Anarchic Hand***
Matt Shlian, USA
2014, paper on board
(*Photo by the artist*)

in a similar work, *Ship Building* (2012), he twists a pleated sheet into a well-balanced but sensual form, more open and relaxed than the earlier series, perhaps suggesting he has sailed further in his journey toward mastery of the technique.

Shlian's more complex folded sculptures incorporate origami tessellations. Tessallations are a relatively recent origami style in which elements of the design are repeated across the surface, with no gaps or overlaps, to create a geometric pattern. In *Figure Four Pleat* (2014), *Chiral Pleat* (2014) and *Unlean in Black* (2014), he uses basic tessellation patterns to fold sheets of Tyvek into bold abstract forms that are textured with complex geometric designs. At the same time, the forms possess a highly organic sensibility, evoking spiraling shells or the dense petals of a chrysanthemum in full bloom. With some of these works, Shlian's curiosity did not allow him to stop at creating a sculpture. For a similar tessellated form, *Unlean Against Our Hearts* (2011) (also named for a line in a Kay Ryan poem, "Blandeur"), Shlian wondered what it would look like if it could move. Taking his work as a paper engineer to a logical conclusion, he created a kinetic origami sculpture. By mechanizing the two acrylic disks on which the two ends of the folded form were positioned, he caused them to turn slowly in opposite directions, forcing the sculpture itself to rotate gently and its zigzag folding pattern to pulsate like a radiant sunburst. The volume and motion of this piece becomes all the more meaningful when Ryan's poem about the dulling, flattening and blanding of our world is considered.

Shlian had previously created kinetic paper sculpture in a work entitled *Misfold* (2009). For this work, he folded two large Tyvek versions of his smaller paper work *Strain* (2009—see page 174) and positioned them folded flat several feet apart on the floor. The two sections were connected at the top with a long string that was run over a ceiling beam. A motor positioned

Top ***Wave*** (from *Process Series 2*) (detail)
Matt Shlian, USA
2013, heavyweight drawing paper (*Photo by Cullen Stephenson*)

Above ***Sleeper***
Matt Shlian, USA
2013, Fox River Coronado 100# text weight paper
(*Photo by the artist*)

Top ***Float*** (from *Process Series 2*) (detail)
Matt Shlian, USA
2013, heavyweight drawing paper (*Photo by Cullen Stephenson*)

Above ***Orbit*** (from *Process Series 2*) (detail)
Matt Shlian, USA
2013, heavyweight drawing paper (*Photo by Cullen Stephenson*)

SHLIAN × **SHINOLA**

Shinola (installed at Shinola
Flagship store, Detroit,
Michigan)
Matt Shlian, USA
2013, Canson Mi-Teintes
drawing paper
(*Photo by the artist*)

out of view and pulleys in the ceiling pulled the string
upward, one side at a time, causing the irregular, spiky
folded forms to open outward and upward in a
spectacular angular dance.

While Shlian's kinetic folded paper sculptures are
remarkable and perhaps unique in the realm of origami,
it is perhaps in his deconstruction and reconstruction
of origami patterning where he is creating some of his
most innovative work. Origami tessellations as well
as origami crease patterns, the folding lines left in
the paper when a model is unfolded, seem to be the
inspiration for some of his more recent designs, like
Shinola (2013), installed at the Shinola Flagship Store in
Detroit, which appears to have been created by folding.
However, rather than folding this elaborate geometric
pattern using tessellation, Shlian has built up the
pattern from individually folded modules. These
patterns come from a study of Islamic tile and
tessellation form and from an exploration into nano-
structures. The process can be seen more clearly in
his relief sculptures *Apophenia* (2013), named after
the human tendency to perceive meaningful patterns
within random data. In this series of four framed relief
sculptures, made in collaboration with Sharon Glotzer,
a professor of Material Sciences at the University of
Michigan, modular polyhedral forms—diamonds and
hexagons—are shaken up and allowed to form nesting
arrangements, or patterns on the surface. As the forms
are shaken up again, they land in different patterns. The
final pattern in the series, like that of *Shinola*, appears to
have been folded from a sheet of paper. "This research

SHLIAN × LEVI'S

Above *Shlian for Levis*
Matt Shlian, USA
2012, Fox River Coronado
100# text weight paper
(*Photo by Whitney Dinneweth*)

Left to right *Aleotoric 3, 2, and 1*
Matt Shlian, USA (in collaboration with
Michael Cina)
2012, soy-based ink prints on archival
text weight paper
(*Photo by Cullen Stephenson*)

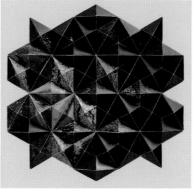
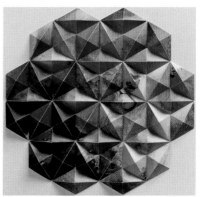

Below and bottom *Strain*
(closed and opened)
Matt Shlian, USA
2009, Fox River Coronado
100# text weight paper
(*Photo by the artist*)

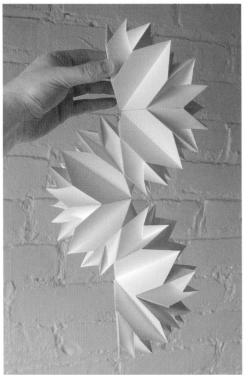

into visualization of pattern intrigues me," says Shlian. "It questions the macro/micro patterning of nature, the structures we find on the nanoscale and directly compares it to architecture and ornamentation."

Shlian's 2014 work *Self Assembly* perhaps represents one of the most interesting takes on origami. In what appears to be a paper cut-out of an origami crease pattern, Shlian has created a skeleton-like relief sculpture that possesses the volume of a folded sheet of paper without much paper. Where the folding lines should be are only thin strips of paper, and where the paper should be is empty space. By cutting away the flat areas between each fold, Shlian has removed all but the crease pattern. Although many origami artists, most notably Robert Lang (see page 96) and Sipho Mabona (see page 104), have recently been exploring the potential of crease patterns as works of art in their own right, in this daring sculpture Matt Shlian has contributed to the world of folding paper a conceptual work that represents the very heart of origami—a model of the folds themselves. It will be fascinating to see where his curiosity will lead him from here.

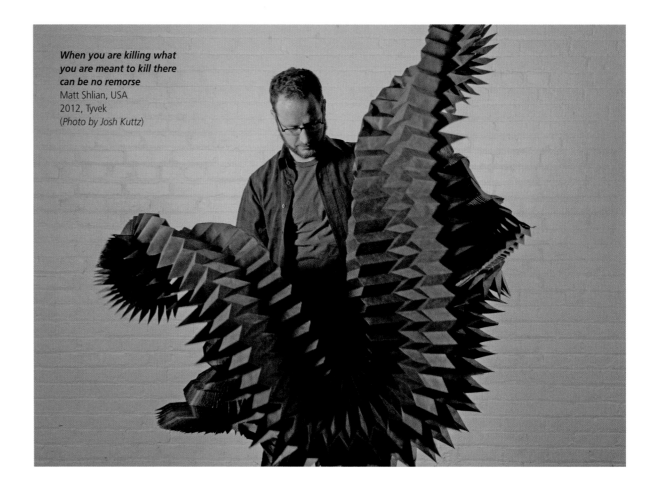

When you are killing what you are meant to kill there can be no remorse
Matt Shlian, USA
2012, Tyvek
(*Photo by Josh Kuttz*)

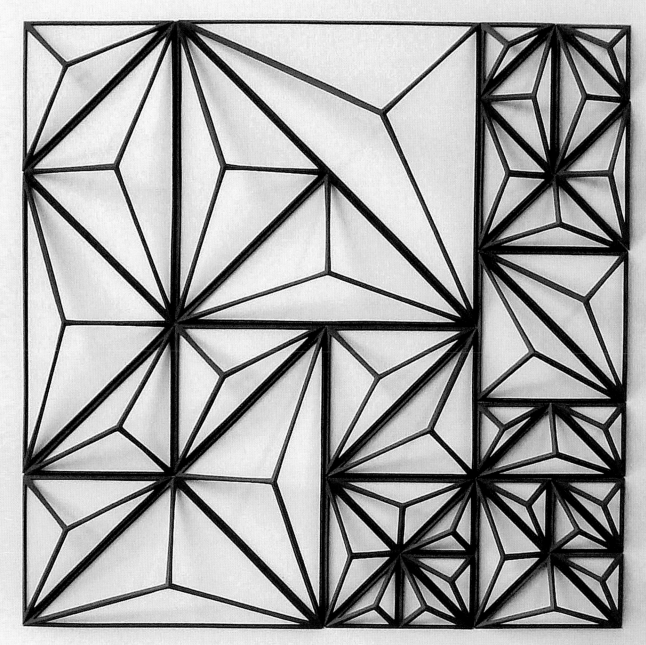

Self Assembly
Matt Shlian, USA
2014, paper
(*Photo by the artist*)

paper poetry in motion

THE PLEATED SCULPTURES AND INSTALLATIONS OF RICHARD SWEENEY

Photo by the artist

There is something powerfully poetic about Richard Sweeney's (b.1984) pleated paper installations. Long ribbons of pleated white paper hang in mid-air, twisting and turning in an elegant rhythm to the tune of some silent cosmic symphony. Whether the pieces are suspended in a stairwell, extending across a shop window or occupying the expanse of a museum gallery, his sculptural works are at once soothing and dynamic. The whiteness and lightness of the long sheets of paper suggest the tranquility of floating clouds being nudged through the sky by a gentle breeze. All the while, the rhythmic pleating and the dramatic curves along the length of the paper hint at a formidable energy stored within, ready to be released at any moment, like a bird's wing unfolding or a serpent uncoiling. In both his sculptural works and his large-scale installations, Sweeney manipulates his sheets of paper through folding and twisting so that they infuse the spaces they occupy with a sense of music and motion.

Sweeney took a different path to paper folding than many origami artists. Born in Huddersfield, England, he knew at a young age that he wanted to pursue a career in art. He studied sculpture at Batley School of Art and Design and then three-dimensional design at

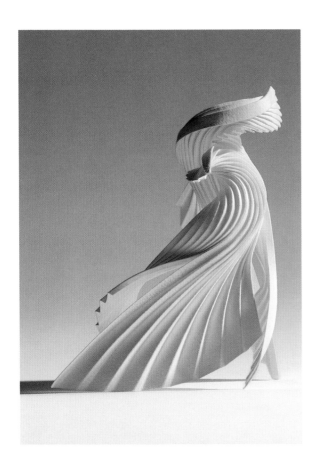

Left *Embrace*
Richard Sweeney, UK
2013, watercolor paper
(*Photo by the artist*)

Manchester Metropolitan University where he learned to manipulate paper by hand to create 3-D design models. Over his short but vibrant career since graduation, Sweeney has worked in design, photography, craft and sculpture. In his sculptural works, he typically combines hand crafting—primarily cutting and folding paper—with computer-aided design and CNC (computer numerical control) manufacturing techniques to explore the unique properties of paper and discover the range of sculptural forms the medium allows.

Sweeney works in a range of sizes, often employing curved pleating techniques similar to those used by origami artists such as Erik and Martin Demaine (see page 16). Some of his most lyrical works are his smaller abstract sculptures in which he pleats single sheets of paper and allows them to assume sensuous, elegant forms. His 2010 work *03M (Partial Shell),* for example, is folded out of watercolor paper into a gracefully swirling organic form that is essentially abstract but

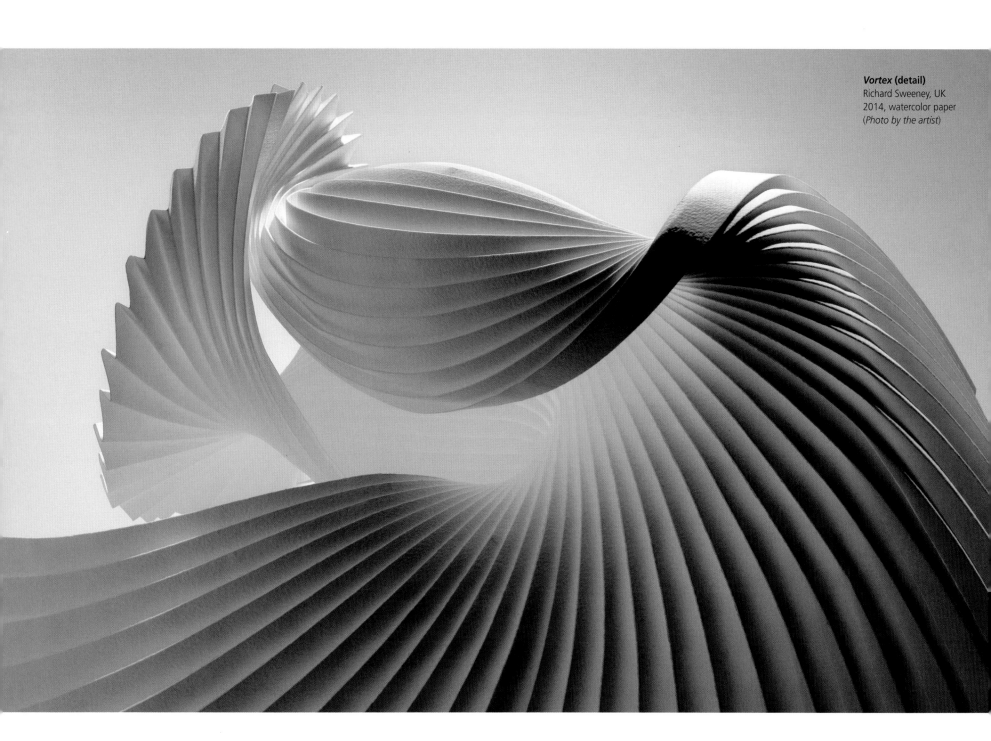

Vortex **(detail)**
Richard Sweeney, UK
2014, watercolor paper
(*Photo by the artist*)

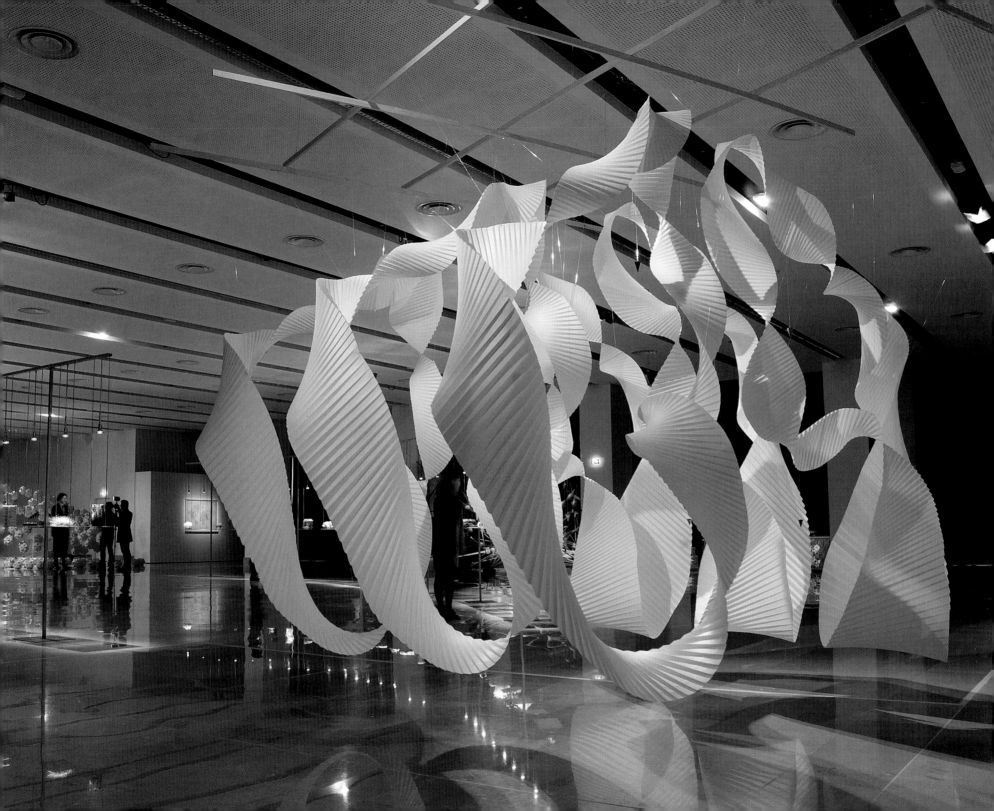

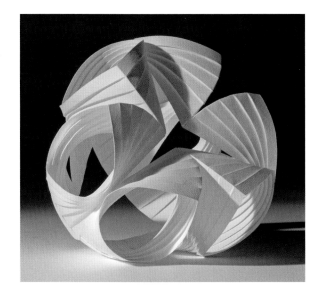

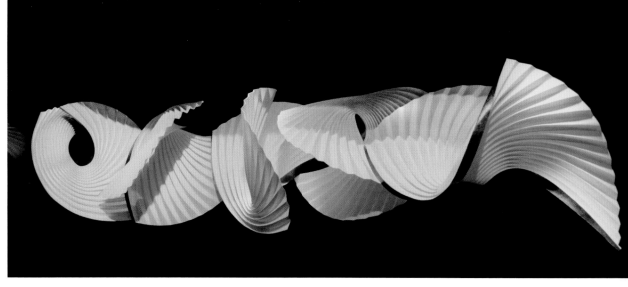

Left *Untitled (Seed)*
Richard Sweeney, UK
2011, watercolor paper, adhesive
(*Photo by the artist*)

Above *Flight,* installation for Bosideng, London
Richard Sweeney, UK
2012, watercolor paper, copper leaf, monofilament nylon.
(*Photo by the artist*)

Below *Partial Shell*
Richard Sweeney, UK
2010, watercolor paper
(*Photo by the artist*)

Opposite *Untitled,* installation created for the Paris
edition of Miniartextil held at Le Beffroi, Montrouge
Richard Sweeney, UK
2013, paper, adhesive, monofilament nylon.
(*Photo by the artist*)

is reminiscent of the curl of a seashell. When Sweeney was first developing his curved pleated work in his *Motion Forms* series, he had trouble getting the forms to hold their position. "I could create wonderful flowing shapes by manipulating the pleat in my hands," he explains, "but this shape would be lost when the paper sprung back to its original form." At this point, Sweeney remembered the wet folding technique used in origami. "I was aware of its use amongst the origami fraternity, and some especially good examples from Giang Dinh [see page 24]. I knew that wet folding could hold paper in shape. I went about experimenting with this, and eventually used the technique in almost all of my subsequent work in the series."

For similar works, *Vortex I* and *Vortex II*, both created in 2012, he twisted the pleated paper even more deeply to capture the dynamic vortical flow of a liquid, gas or plasma in the solid medium of paper. Although their physical form is frozen and still, a great sense of

energy and motion is suggested in the pleats and twists used to form the works. Similarly, the sculpture *Fluid Dynamic* (2013), formed from several pleated sheets of paper joined with adhesive, possesses the grace and gentle energy of a fluid that has been released from a container and allowed to flow freely. His 2014 work *Dancer* explores the idea of grace in motion further. Although abstract in form, this curved crease paper sculpture suggests the lithe, fluid motion of a dancer in swirling white robes swaying and bending to music.

Natural forms, particularly botanical elements, such as flowers and seeds, have also provided the inspiration for some of his folded paper sculptures. In his 2011 and 2012 works *Seed* and *Seed II*, he interconnects pleated sheets of watercolor paper to form modular works. In these elegant forms, which are both geometric and naturalistic, squares, triangles and circles intersect to form pods that contain life-bearing seeds. In a more naturalistic botanical sculpture, *Bloom I*, also created

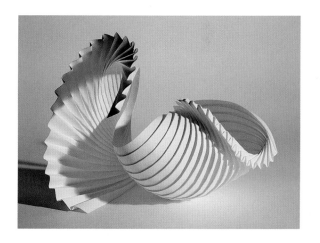

Right **Untitled**
Richard Sweeney, UK
2012, watercolor paper, adhesive
(*Photo by the artist*)

Far right **Octahedron**
Richard Sweeney, UK
2010, watercolor paper, adhesive
(*Photo by the artist*)

Far right below **Beta Sheet,** **installation**
at the Stamp Staircase, Somerset House,
London
Richard Sweeney, UK
2008, paper, adhesive, monofilament nylon
(*Photo by the artist*)

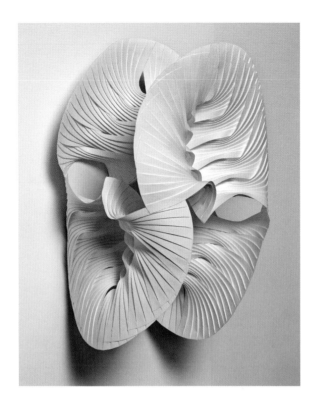

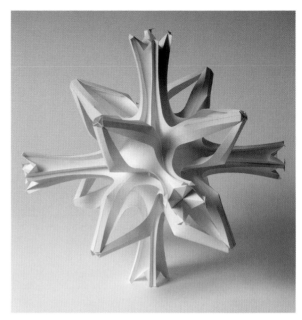

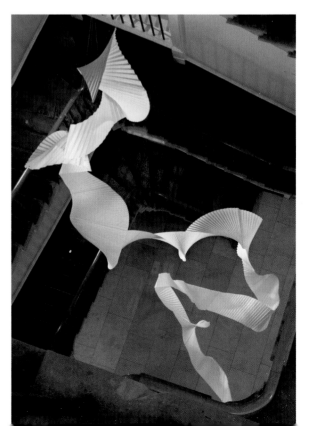

in 2012, Sweeney uses very structured pleating, tighter at the center and looser at the edges, to create a morning glory-like flower that appears to have only just fully opened its petals to the daylight.

Sweeney's smaller-scale works have gained him considerable attention in the short time that he has been a working artist. In 2010, he was commissioned to fold a limited edition of 500 sculptures as gifts to mark the birthday of Queen Rania of Jordan, and in 2013 he was part of an exhibition of contemporary craft and design held at No. 10 Downing Street, the residence of the British Prime Minister. However, it is his larger-scale installation work that is gaining greater attention in museums and art galleries around the world. Since graduating from Manchester Metropolitan University in 2006, he has been commissioned to create large sculptural works in Italy, France, Denmark, the United Kingdom and the United States. For these installation pieces, he typically suspends large sections of pleated paper, often wrapping around each other, from the ceiling of galleries and public spaces.

One such work, *Beta Sheet*, was commissioned in 2008 by The Crafts Council, a national development agency for the contemporary crafts in the UK, for display in the Stamp Staircase at Somerset House,

London. For this commission, Sweeney filled the 65.6-ft (20-m) deep stairwell in the center of the spiral staircase with a twisted, continuous ribbon of pleated paper measuring 20 meters in length, hung using nylon, steel eyelets and rivets. According to Sweeney, "The final form of the piece was not predetermined, but composed on an ad hoc basis within the staircase space, the inherent tensions within the paper dictating the form." Sweeney created a more complex vertical work, *Column*, in 2012 for an exhibition called *Miniartextil* at the Villa Olmo in Como, Italy. For this work, he suspended multiple pleated sheets from a metal frame attached to the high ceiling of the villa. The sheets spiraled downward toward the tiled floor below, billowing and cascading through space like a column

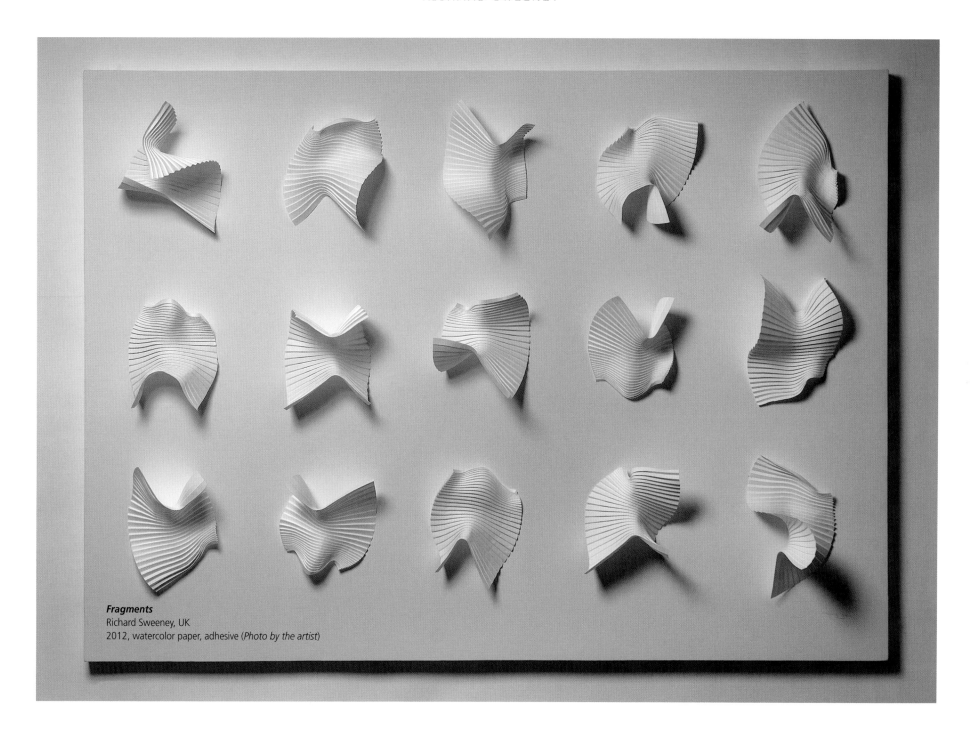

Fragments
Richard Sweeney, UK
2012, watercolor paper, adhesive (*Photo by the artist*)

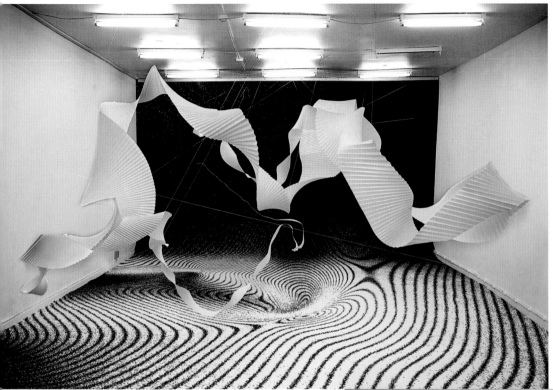

that the white of the paper contrasts boldly with the black walls around it, the sculpture balances both grace and strength.

It may be a stretch to call Sweeney's works of sculpture "origami," but there is much in their construction that relates to Japanese paper folding, both traditional and modern. His works possess the magical effect created by folding a flat sheet of paper into something three-dimensional and surprising, and the precision required in folding to achieve the desired form. He also incorporates the wet folding origami technique pioneered by Akira Yoshizawa and employed by many origami artists to manipulate the paper so that it retains the form. A talented sculptor who approaches folded paper as a medium to create something aesthetically unique and uplifting, Richard Sweeney may not be folding paper cranes. Nonetheless, his spectacular abstract sculptures folded in pure white paper also clearly have the power to fly.

of swirling smoke, recalling the spiraling vortices of his smaller abstract sculptures, but with the added drama of its scale, the classical setting and spectacular lighting.

In the same year, Sweeney was also commissioned to create a horizontal installation for the Chinese down clothing company Bosideng for their London store. Without the gravity that aided him in his vertical installations, Sweeney nonetheless created a similarly dynamic installation *Flight* that extended across nearly 6.5 ft (2 m) of the store's interior in a case behind the reception desk. The light, curvaceous work elegantly evoked the wings of the company's logo and thus indirectly referenced the feathers used to create the down that fills the company's jackets. Expertly lit so

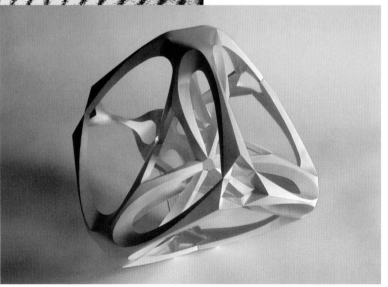

Above left *Beta II*, **installation for the BOX window gallery, Denmark**
Richard Sweeney, UK
2010, paper, adhesive, monofilament nylon
(*Photo by the artist*)

Left *Tetrahedron*
Richard Sweeney, UK
2006, paper, adhesive
(*Photo by the artist*)

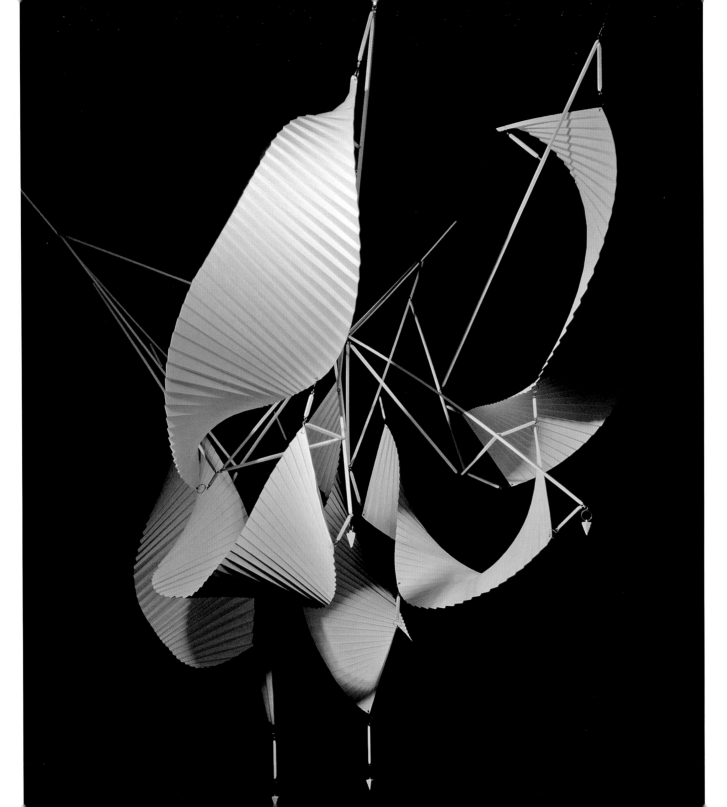

Air
Richard Sweeney, UK
2014, paper, wood, metal
fixings, cotton cord
(*Photo by the artist*)

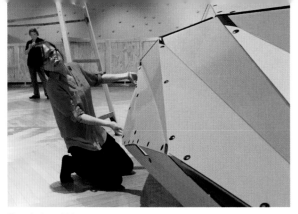

life, the universe and everything else

IN THE FOLDED SCULPTURES OF JIANGMEI WU

Like a giant pleated shell twisting and unfurling across the gallery floor, Jiangmei Wu's origami installation *Ruga Swan* (2013) is a work of tremendous energy and grace. It is at once sculptural and architectural, but it is also origami. Wu is one of a number of designers who have been exploring the potential applications of paper folding in architecture, interior design and also fine art. Inspired by centuries of research in diverse areas of science and mathematics, she has created installations and illuminated paper sculptures that are visually breathtaking but at the same time pose profound questions about the spaces we inhabit, the nature of our relationships and even the origins of life and the universe.

Wu grew up in China in the 1970s, at a time when children did not have many toys and so they made their own using bottle tops, feathers, rubber bands and other found objects. Wu remembers using paper from newspapers, magazines and old notebooks and

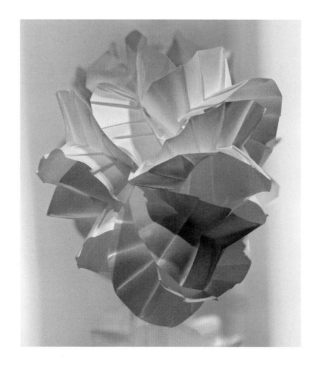

folding it into airplanes, balloons, birds and baskets. She grew up fascinated with the art and science of folding paper. During her first year in the College of Architecture and Urban Design and Planning in Tongji University in Shanghai, she was asked to design a structure from a single piece of paper without cutting it, and at that point she fell in love with design.

Wu continued her academic training in art and design in the United States, primarily in interior design and graphic design and has since worked in interior design, architecture, urban planning, web design and graphic design. Currently an assistant professor in design at Indiana University Bloomington, Wu also works as an artist and designer and is exploring how folding can be expressed mathematically, physically and aesthetically. She is also studying how it can be done with different materials and techniques, and how these aspects work together with the conceptual space in which they occur.

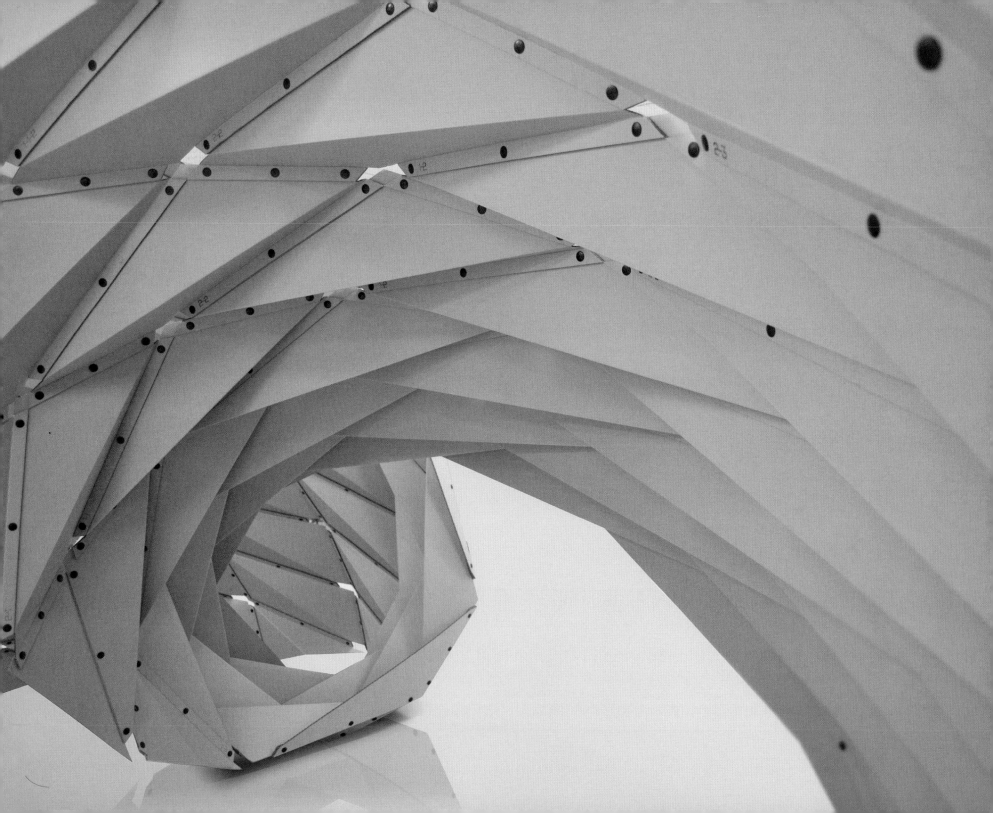

Anemoi (detail), *Folded Light Art*
**installation, International
Art Festival Toyota City, Japan**
Jiangmei Wu, China/USA
2015, high-tech *kozo* paper
(*Photo by the artist*)

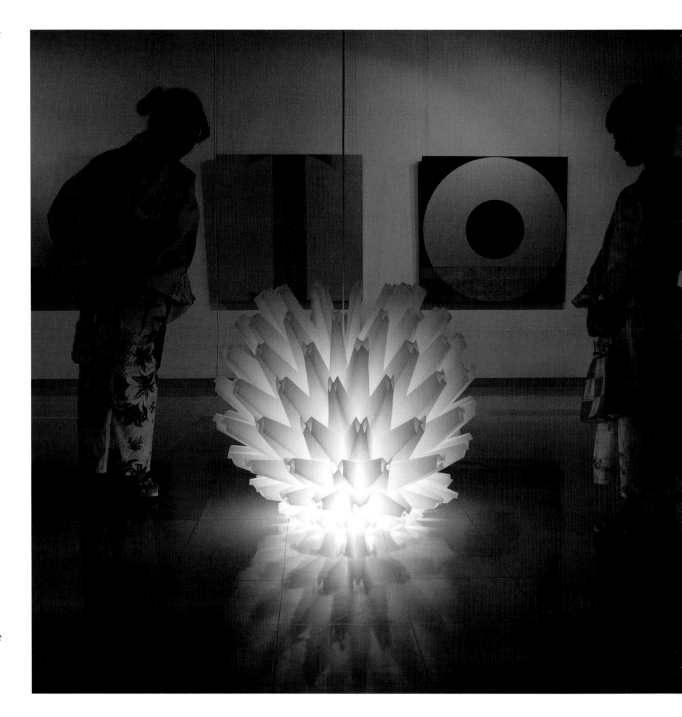

Recently, Wu has been working with the concept of skin, and in particular interior skin. In architectural design, skin is a metaphor for building envelopes that provide flexible layers of protection and are often dependent upon rigid structural supports. In contrast, interior skin refers to all interior surfaces, from walls, ceilings and floors to upholstery and curtains. As part of Wu's study of the skin concept, she has been folding paper to create three-dimensional interior skins from a single piece of two-dimensional material. In her installation *Ruga Swan* (*ruga* is the Latin for "a fold, crease or wrinkle"), the folded forms have rigid properties and at the same time are flexible. They are deployable and can be collapsed again into smaller compressed forms suitable for transport and storage. Wu based the crease pattern of *Ruga Swan* on the Yoshimura pattern, a diamond pattern discovered in the early 1950s by Japanese aeronautical researcher Professor Yoshimaru Yoshimura when studying the buckling of airplane fuselages after crashes. Wu chose this pattern for its ability to produce an approximated arc form with great structural stability. In *Ruga Swan*, she deployed the pattern in an irregular manner to create a versatile and flexible architectural skin. Using parametric tools, computer simulations and small-scale paper models, Wu and her student-assistants, working with Noblitt Fabricator based in Columbus, Indiana, laser cut over a hundred panels of corrugated paper

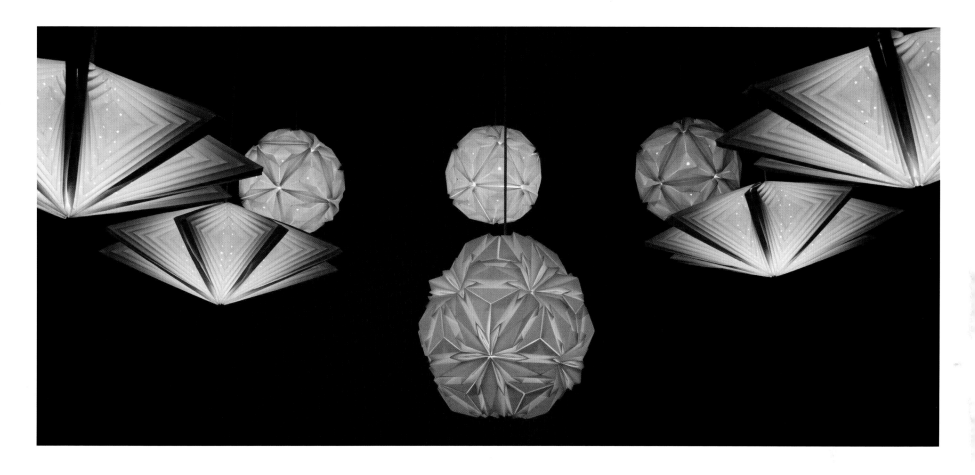

Orion **installation (detail), Ivy Tech John**
Waldron Arts Center, Bloomington, Indiana
Jiangmei Wu, China/USA
2013, acid-free paper
(*Photo by Random Run*)

and then creased and folded them by hand. They then joined these panels together using plastic rivets into two almost identical flat sheets each weighing about 26 lbs (11.8 kg), and then suspended and folded them into two sections joined together to create the final structure, which is solid and stable but containing the memory of movement and the potential for future folding and unfolding.

While *Ruga Swan* was born from crease patterns in crashed airplanes, her earlier installation, *Life Matrix* (2013), was inspired by fold patterns in the miniscule building blocks of life. In this work, she folded 125

sheets of Tyvek using patterns similar to a DNA double helix and the pleated sheets found in hydrogen bond interactions among strands of amino acid. A total of 125 white origami puffs (see page 184), suspended in a cloud-like cluster from the gallery ceiling as if floating in space, were each made with the same basic pattern, but are all unique like the self-folding proteins found in all aspects of life. With this work, Wu poses the question, "Could the hidden relationships between spatial characteristics of a subject, namely the tectonics, visual and tactile qualities, and its functionality, be revealed in the forms, patterns and logic of the folds?"

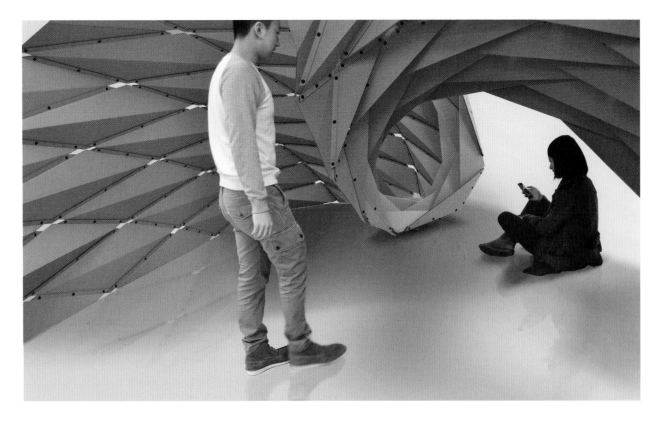

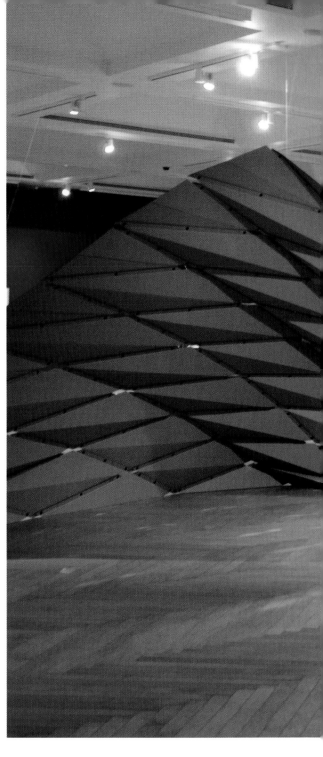

The inspiration for a similarly elegant installation, *Harmonices Mundi* (*The Harmony of the World*) (2014), came from a 1619 book by the German mathematician and astronomer Johannes Kepler, in which he discusses the harmonious relationships between geometrical forms and physical phenomena. In the *Harmonices Mundi* installation, thirty-six asymmetric stellated polyhedra folded from 648 pieces of paper were arranged in a square, like a lake full of exquisite white water lilies. Each "lily" was wired with a motion sensor so that they all moved subtly in response to the hand gestures and other motions of visitors. Inspired by Kepler, Wu wonders, "Could the harmony of the geometric forms be achieved through certain physical movements?"

Above **Installing *Ruga Swan* at the artist's studio, Indiana University, Bloomington, Indiana**
Jiangmei Wu, China/USA
2014, SafeCorr grey acid-free corrugated board
(*Photo by the artist*)

Opposite ***Ruga Swan*, installation, Clay Center for the Arts and Sciences of West Virginia**
Jiangmei Wu, China /USA
2014, SafeCorr grey acid-free corrugated board
(*Photo by the artist*)

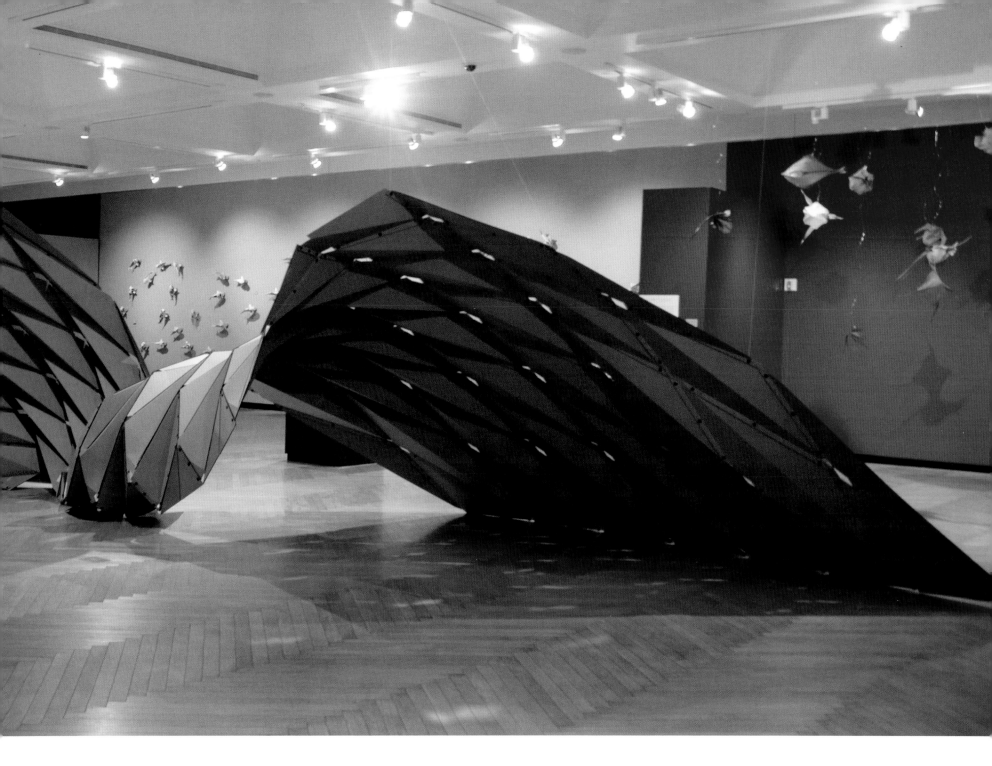

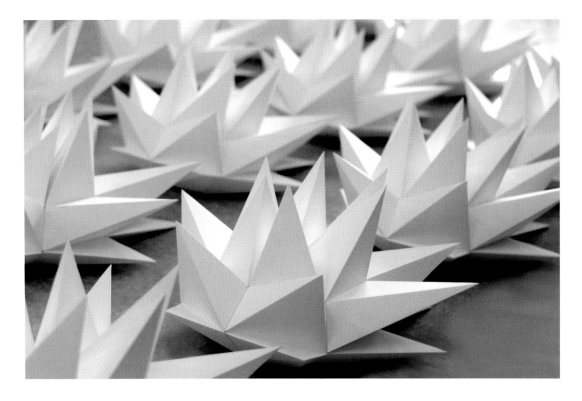

In her explorations of folded paper, Wu also works with light. Her *Folded Light Art* collection of sculptures, installations and functional lamps is inspired by geometric surface textures found in nature, such as seashells, plants and other organisms. The natural geometric forms are graphically abstracted using original origami compositions, folded from Japanese *kozo* (paper mulberry bark) paper or Tyvek and then lit with LED bulbs. As examples of origami-inspired design, the collection has gained world-wide attention and has been published in many design magazines internationally, including *Elle Decoration*, *DesignBoom*, *MocoLoco*, *Inhabitat*, *Gizmodo*, *Espaces Contemporains* and *Wallpaper**. However, she has also exhibited a number of illuminated works as installations, most notably in the work *Orion* (2013), in which a series of illuminated globes, each folded with a unique pattern, are suspended in a dark space and lit to resemble stars or planets. With this work, Wu explores the idea embraced by some scientists that the universe, at both the macroscopic and microscopic scales, "folds" rather than "builds." With these illuminated and folded sculptures, she poses the question, "Could the hidden secret of self assembly of cosmic structure be revealed through the crease patterns of folding?"

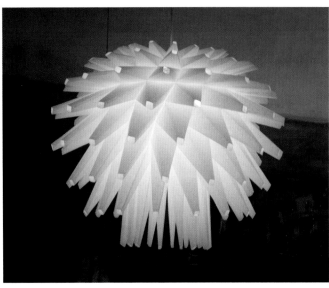

Above *Harmonices Mundi* (detail), installation, Indiana University, Bloomington, Indiana
Jiangmei Wu, China/USA
2014, acid-free paper
(*Photo by Amy Tan*)

Left *Anemoi* (detail), *Folded Light Art* installation, International Art Festival Toyota City, Japan
Jiangmei Wu, China/USA
2015, high-tech Japanese *kozo* paper
(*Photo by the artist*)

Although Jiangmei Wu only began creating her origami art works in the last few years, her experience in architecture and design have given her a unique perspective on the potential of origami to express complex concepts artistically. Folded from a range of materials depending on the scale and function of the pieces and inspired by the work of a broad spectrum of scientists and artists, her work has recently joined that of more established origami artists in pushing the boundaries of scale and subject matter of origami. Her sculptures and installations invite us to contemplate the role of folding not only in art, architecture and design but also in life, the universe and everything.

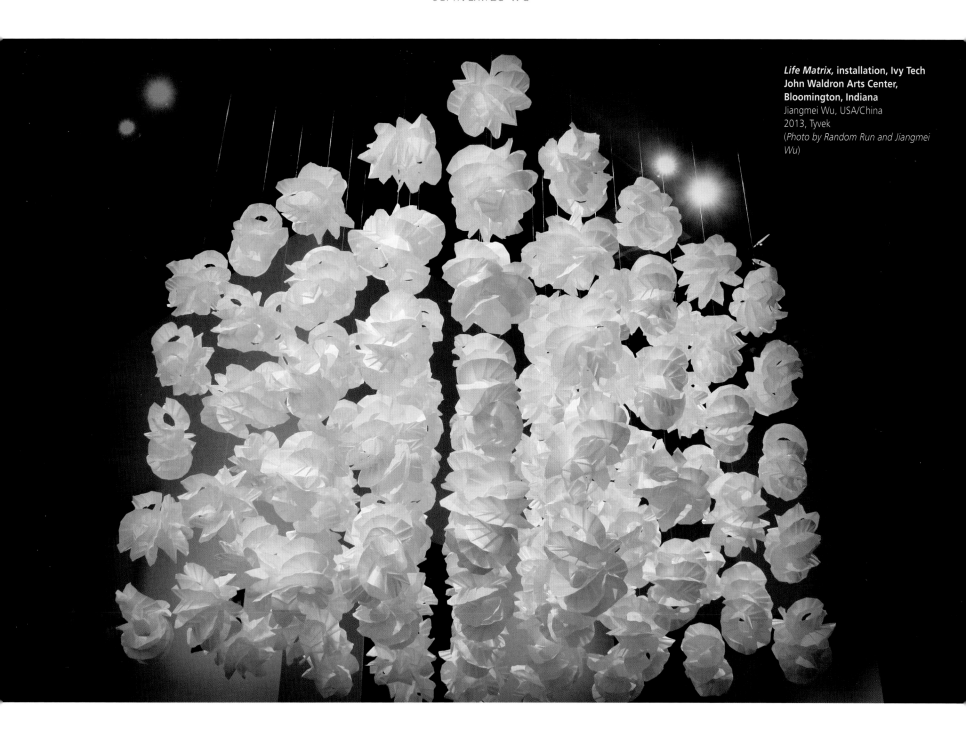

Life Matrix, installation, Ivy Tech
John Waldron Arts Center,
Bloomington, Indiana
Jiangmei Wu, USA/China
2013, Tyvek
(*Photo by Random Run and Jiangmei Wu*)

Acknowledgments

I would like to thank Tuttle for their interest in a book about contemporary origami artists. As the world leader in publishing origami instructional books, they understand the level of interest in origami. I am also grateful to the staff of International Arts & Artists, who have championed exhibitions of origami art and supported this book in many ways. I am thankful to all of the artists featured in this book for generously answering my many questions, correcting my errors and contributing photographs of their work. I am also grateful to David Brill, Keiko Fukai and Alain Joisel for providing help with my essays about Tomoko Fuse, Yuko Nishimura and Eric Joisel, respectively, and to all of the photographers who allowed us to reproduce their images, in particular to Paulo Mulatinho and Silke Schröder for helping with images. I would also like to thank Robert J. Lang for his wisdom and encouragement during my exploration of the world of origami.

Thank you to my husband David and my son Theo for their support while I worked on this project. I dedicate this book to both of you.

Published by Tuttle Publishing, an imprint of Periplus Editions (HK) Ltd.

www.tuttlepublishing.com

Copyright © 2017 Meher McArthur

ISBN: 978-0-8048-4677-6

Library of Congress cataloging in process.

DISTRIBUTED BY
North America, Latin America & Europe
Tuttle Publishing, 364 Innovation Drive, North Clarendon, VT 05759-9436 U.S.A.
Tel: (802) 773-8930; Fax: (802) 773-6993
info@tuttlepublishing.com | www.tuttlepublishing.com

Japan
Tuttle Publishing, Yaekari Building, 3rd Floor, 5-4-12 Osaki, Shinagawa-ku, Tokyo 141 0032
Tel: (81) 3 5437-0171; Fax: (81) 3 5437-0755
sales@tuttle.co.jp | www.tuttle.co.jp

Asia Pacific
Berkeley Books Pte. Ltd.
61 Tai Seng Avenue #02-12, Singapore 534167
Tel: (65) 6280-1330; Fax: (65) 6280-6290
inquiries@periplus.com.sg | www.periplus.com

20 19 18 17 05 04 03 02 01

Printed in China 1611RR

TUTTLE PUBLISHING® is a registered trademark of Tuttle Publishing, a division of Periplus Editions (HK) Ltd.

ORIGAMI ART EXHIBITION CATALOGS AND FILM

Gould, Vanessa (director), *Between the Folds*, Green Fuse Films, NYC, 2012 (available through PBS.org)

Hangar-7, Salzburg (ed.), *Masters of Origami at Hangar 7: The Art of Paperfolding*, Ostfildern-Ruit, Germany: Hatje Cantz Verlag, 2005

McArthur, Meher and Robert J. Lang, *Folding Paper: The Infinite Possibilities of Origami*, Washington DC: International Arts & Artists, 2012 (Hardcover, Tuttle, 2013)

Mingei International Museum, *Origami Masterworks: Innovative Forms in the Art of Paperfolding*, San Diego: Mingei International Museum, 2003

ARTISTS' WEBSITES AND BLOGS

Joel Cooper (USA)
joelcooper.wordpress.com

Erik Demaine and Martin Demaine (Canada/USA)
erikdemaine.org
martindemaine.org

Giang Dinh (Vietnam/USA)
giangdinh.com

Vincent Floderer (France)
le-crimp.org

Tomoko Fuse (Japan)
No artist website, but she is featured on David Brill's blog: brilliantorigami.com/2015/09/16/freising-spacefolding/and on Silke Schröder and Paulo Mulatinho's site: origami-galerie.de

Miri Golan (Israel)
foldingtogether.org

Paul Jackson (UK/Israel)
origami-artist.com

Beth Johnson (USA)
bethjohnsonorigami.com

Eric Joisel (France)
ericjoisel.com

Goran Konjevod (Croatia/USA)
organicorigami.com

Michael G. LaFosse and Richard L. Alexander (USA)
origamido.com

Robert J. Lang (USA)
langorigami.com

Sipho Mabona (South Africa/Switzerland)
mabonaorigami.com

Vincent Floderer (France)
le-crimp.org

Mademoiselle Maurice (France)
mademoisellemaurice.com

Linda Tomoko Mihara (USA)
origamihara.com

Jun Mitani (Japan)
mitani.cs.tsukuba.ac.jp/en/

Jeannine Mosely (USA)
No artist website

Yuko Nishimura (Japan)
yukonishimura.com

Bernie Peyton (USA)
berniepeyton.com

Hoang Tien Quyet (Vietnam)
htquyet.origami.vn

Matt Shlian (USA)
mattshlian.com

Richard Sweeney (UK)
richardsweeney.co.uk

Jiangmei Wu (China/USA)
foldedlightart.com

About Tuttle: "Books to Span the East and West"

Our core mission at Tuttle Publishing is to create books which bring people together one page at a time. Tuttle was founded in 1832 in the small New England town of Rutland, Vermont (USA). Our fundamental values remain as strong today as they were then—to publish best-in-class books informing the English-speaking world about the countries and peoples of Asia. The world has become a smaller place today and Asia's economic, cultural and political influence has expanded, yet the need for meaningful dialogue and information about this diverse region has never been greater. Since 1948, Tuttle has been a leader in publishing books on the cultures, arts, cuisines, languages and literatures of Asia. Our authors and photographers have won numerous awards and Tuttle has published thousands of books on subjects ranging from martial arts to paper crafts. We welcome you to explore the wealth of information available on Asia at **www.tuttlepublishing.com.**

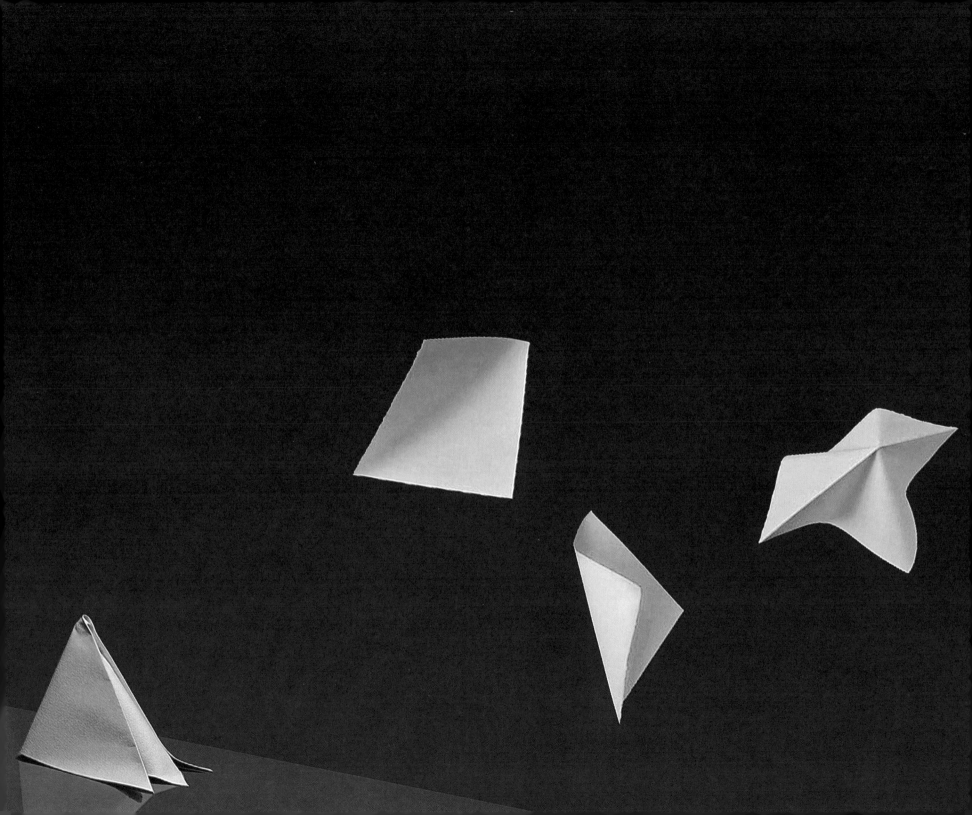